Ocean

Hatteras

Barrier Islands

...ston

Savannah

Jacksonville

Palm Beach

Miami

Intra-Coastal Waterway

Key West

Coastal Images
of America

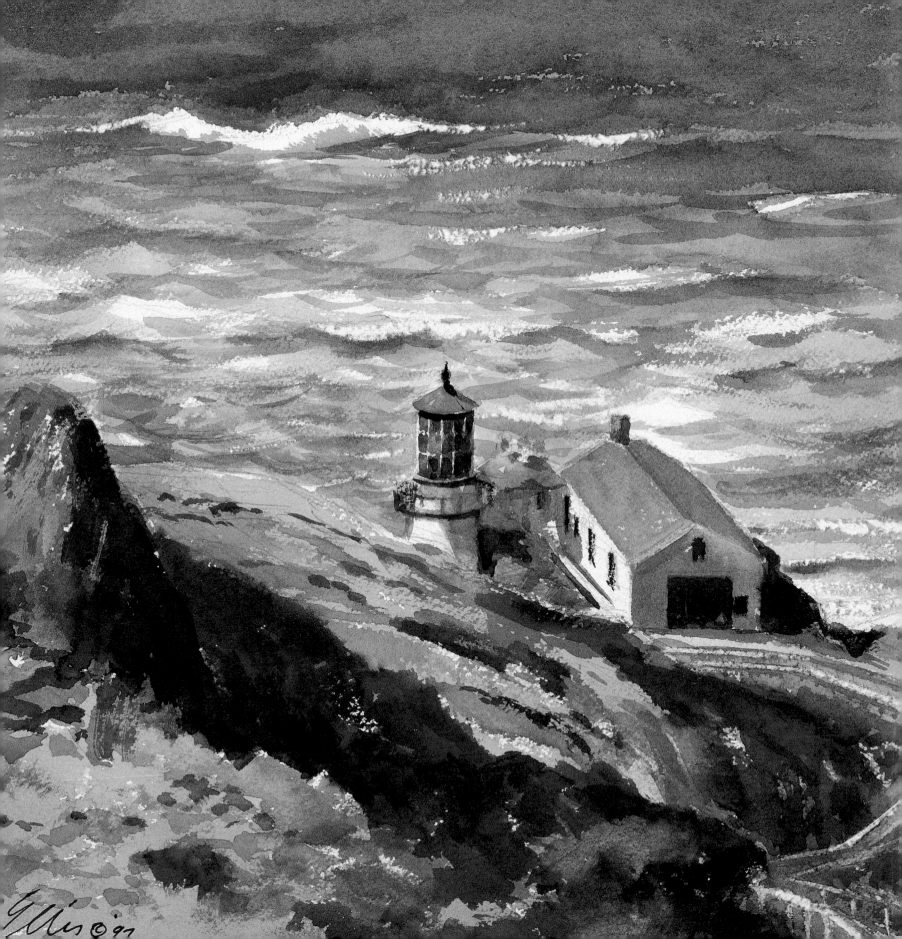

Coastal Images
of America

Paintings by Ray Ellis
Text by Robert D. Ballard

Abbeville Press Publishers
New York London Paris

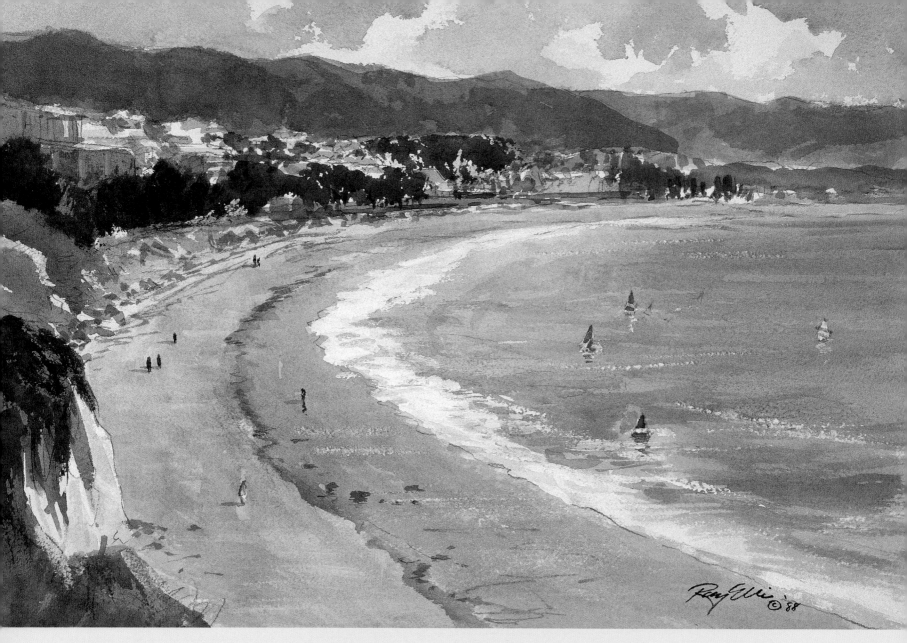

Front cover: *Morning in Trinidad Harbor* (see p. 142). Back cover: *The Live Oak* (see p. 94).
Endpapers: *Map of the Coastal United States*, 1997. Frontispiece: *Point Reyes Light*, 1997.
Watercolor, 12 x 15 in. (30.5 x 38.1 cm). Above: *Beach at Santa Barbara*, 1988. Watercolor,
10 x 15 in. (25.4 x 38.1 cm).

Editor: Susan Costello
Designer: Molly Shields
Production Editor: Owen Dugan
Text Editor: Mary Suffudy
Production Manager: Lou Bilka
Picture Editor: Treesa Germany
Photographs: Michael Kraft, Ross Meurer, Robert D. Rubic (p. 40), Bob Schellhammer

First edition
10 9 8 7 6 5 4 3 2 1

Library of Congress Cataloging-in-Publication Data
Ellis, Ray G.
 Coastal images of America / paintings by Ray Ellis ; text by Robert D. Ballard.
 p. cm.
 Includes index.
 ISBN 0-7892-0313-8
 1. Ellis, Ray G.—Catalogs. 2. Atlantic Coast (U.S.)—In art—Catalogs. 3. Atlantic
Coast (U.S.)—Description and travel. I. Ballard, Robert D. II. Title.
ND1839.E43A4 1998
759.13—dc21 97-42919

Contents

Coastal Images of America

The East Coast

The West Coast

Preface

I'm delighted that the superb paintings and watercolors that Ray Ellis did originally for our series of books on America's coasts have found a home in a single volume along with a number of fascinating new pictures.

The achievement is considerably augmented by the new text by our mutual friend, Bob Ballard—certainly the most adventuresome and successful deep sea explorer of the Twentieth Century.

This volume will be a treasure to read and a treasure to keep.

WALTER CRONKITE

Foreword

After a voyage to Antarctica several years ago, I realized that I had experienced the good fortune of painting on all seven continents. My life has been rich with travel, but the thought occurs to me as I enter my 77th year that the places I love the best are right here in the United States, in particular our shoreline areas.

People so often ask me which is my favorite part of the coasts or which are my favorite paintings. That is like asking who my favorite child is. Each has its own special qualities—the endless marshes, waterways, and wildlife of the southeast coast; the great ruggedness of the Maine coast and the hundreds of islands offshore; the wide sandy beaches of the middle and south Atlantic; the long spectacular coastline of California's Big Sur; and the larger than life monoliths that dot the northwest coast. All of these inspired many paintings. To name a specific area or a favorite painting would be impossible.

With *Coastal Images of America*, Abbeville Press has taken the best of my paintings of America's coasts from the three books I did with Walter Cronkite and added many new ones. Bob Ballard's fascinating text is the icing on the cake. I am thrilled to leave this legacy of the country I love so much.

RAY ELLIS

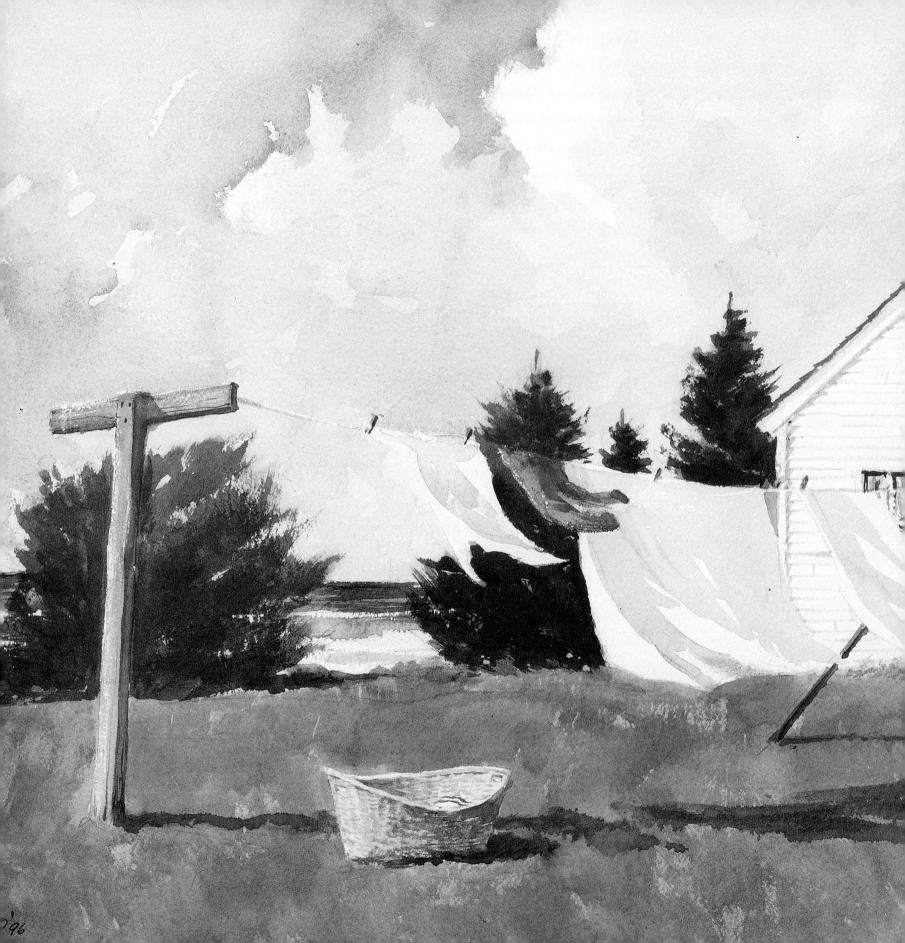
'96

The Water's Edge

The water's edge by the sea is where all the elements of our planet, which make it unique, come together. Blending like paints on an artist's canvas, they create scenes of vast diversity. To walk along the shores of America from the rocky coast of Maine to the coral sands of Key West, from the deep blue-green waters of Puget Sound to the rolling surf off San Diego, is to experience spectacular beauty as well as the volatile side of Mother Nature.

Along some of our shores violent waves crash into rocky outcrops like cannonballs against a castle's stone buttresses, while at other times in other places the ocean is serene and gentle, its waves of frothy foam rushing up sandy beaches then disappearing beneath the surface without a trace. The heartiest of creatures live here and many more come to feed upon them, their shells designed to weather either assault.

Since mankind first walked the surface of the planet, he must have been drawn to its craggy shores and sandy beaches, attracted by a symphony of sounds, by wondrous smells, and by the lure of surprise and mystery. When the first settlers reached the shores of America, they were impatient to head inland in hopes of finding land to claim as their own. But in

To visit Ragged Island is to step back in time, so we were reminded as our hostess hung out her laundry to dry in the stiff ocean breeze. Wash Day (Ragged Island) *(detail), 1996. Watercolor, 14 x 22½ in. (35.6 x 57.2 cm).*

recent years that migration has reversed itself as more and more Americans are preferring to live at the water's edge.

Like the country itself, our east and west coasts have distinct characteristics. The East is old and subdued while the West is young and full of energy. The origins of this difference can be traced to our continent's prehistoric past.

The east coast was born many millions of years ago, when dinosaurs roamed the earth, leaving their footprints in the red sands of the Connecticut Valley. As the Americas and Africa separated—eventually to form the Atlantic Ocean—seawater began flowing into the giant rift in the earth's outer skin. The separation of North America and Africa tore open and exposed the roots of the ancient Appalachian Mountains, which had been created eons earlier by the collision of those same continental giants.

In the course of millions of years after the Atlantic Ocean was created, countless rainstorms and mighty glaciers scoured the land, reducing once-tall mountains to worn remnants. The granite heart of the mountains was further subjected to weathering and subsequent erosion as torn fragments of those tall peaks were washed down rivers toward the sea and formed the beautiful sandy beaches of the Atlantic that dip gently beneath the ocean waves. The geologic forces that wrenched the earth apart to form the Atlantic are dormant now, although perhaps they will awaken again at some point in the distant future.

In the West, on the other hand, geologic disruptions still effect change as the Pacific Ocean floor continues to either crash into or glide past the edge of the continent, causing frequent earthquakes and such periodic volcanic eruptions as the deadly explosion of Mount St. Helens. Within sight of western shores, tall snow-covered mountains rise skyward, a stark contrast to the low-lying coastal plains of the East.

The difference in character between east and west coasts can be seen not only in the rocky surfaces that underpin their shorelines, but also in their contrasting climatic forces. The winds that lash the west coast blow in from the sea, but not before they race across the vast Pacific Ocean, building up truly gigantic waves that lose little of their energy before they crash against the rocky western shorelines. Wave heights of up to ninety-five feet (29 m) have been recorded along these coasts. Of course eastern shorelines can be dramatic in terms of wave action as well—notably during hurricane season, or in winter when nor'easters slam onto shore. But hurricanes and nor'easters

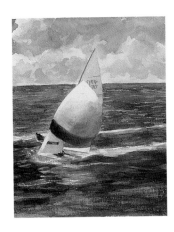

Detail from 470s Downwind, 1996.
Watercolor, 13¾ x 21 in. (34.9 x 53.3 cm).

OVERLEAF:
This little light on the Savannah River near
Tybee Island is surrounded by great expanses
of marshland. During the trials and finals of
the sailing Olympics held in Savannah in
1996, hundreds of sailboats passed this light
en route to ocean race courses.
Cockspur Island Light, 1995.
Oil, 22 x 32 in. (55.9 x 81.3 cm).

quickly come and go, whereas in the West the powerful, pulverizing action of waves is relentless.

Although the west coast surpasses the east in terms of the energy of its waves, the East experiences far greater extremes of weather. Both coasts have weather systems dominated by the westerly flow of air. Western shores benefit from moisture-laden winds that have traveled across a sea surface having relatively moderate temperatures year-round. Up to 200 inches (508 cm) of rain fall each year in the Pacific Northwest, giving that region the heaviest continental precipitation north of the rain forests of Guatemala. As the winds journey east, however, they travel across the North American continent heated in summer and cooled in winter by more extreme land temperatures, resulting in equally extreme weather patterns. Along eastern coasts, August days are typically humid and sultry. In February, by contrast, sea ice is driven onto frozen beaches while rain forests along the north coast of North America testify to its mild temperatures year-round.

And finally, to this mix we add ourselves and our ability to change the natural character of the water's edge. The first people to inhabit our shores crossed the Bering Strait during the last ice age when the sea's surface dropped and a land bridge was created. As it supplied water to the advancing continental ice sheets, the sea drew back its watery apron to provide a footpath for our wandering relatives, who crossed from Siberia to Alaska and then made their way down along the west coast. These first inhabitants did little to modify or mold the landscape of the West, choosing instead to live in harmony with nature. Not until the seventeenth century, when the Europeans arrived, did human activity begin to rapidly transform shoreline habitats. Cutting down the beautiful virgin forests to build and heat their homes and to support a growing maritime commerce, the Europeans began to make changes that have continued and accelerated to this day.

Still, despite man's often harmful tampering, our shorelines continue to provide homes and refuges to humans and animals alike. But few of us have been lucky enough to have much time to walk along the watery boundary of our great country—to see, touch, hear, smell, and taste its unique character. Now, thanks to the skillful eye and artful hand of Ray Ellis, we can all make this journey time and time again as we walk along the water's edge through the wonderful paintings exhibited here.

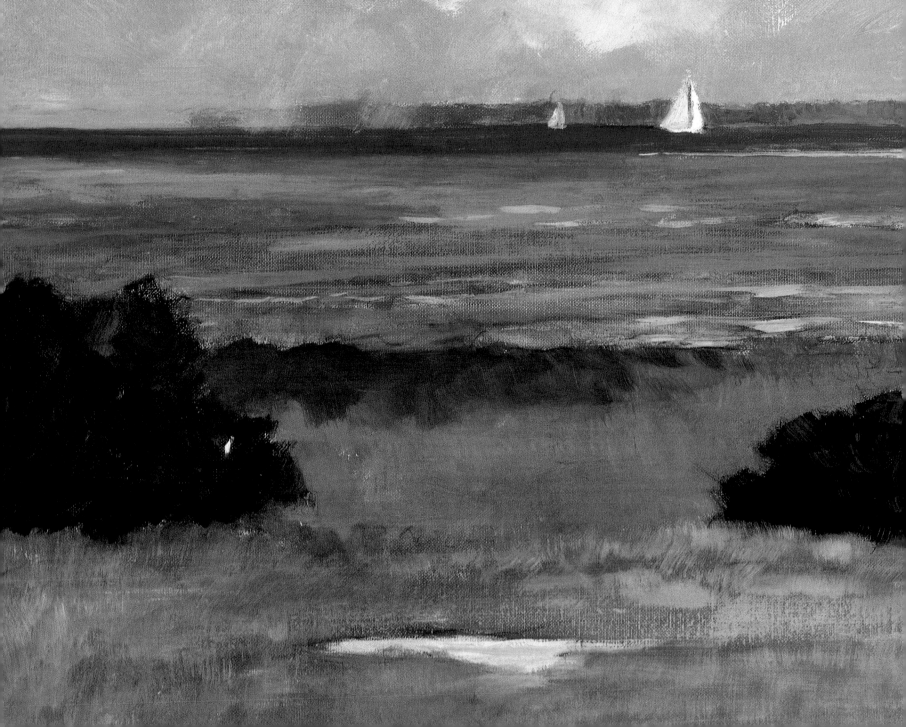

The East Coast

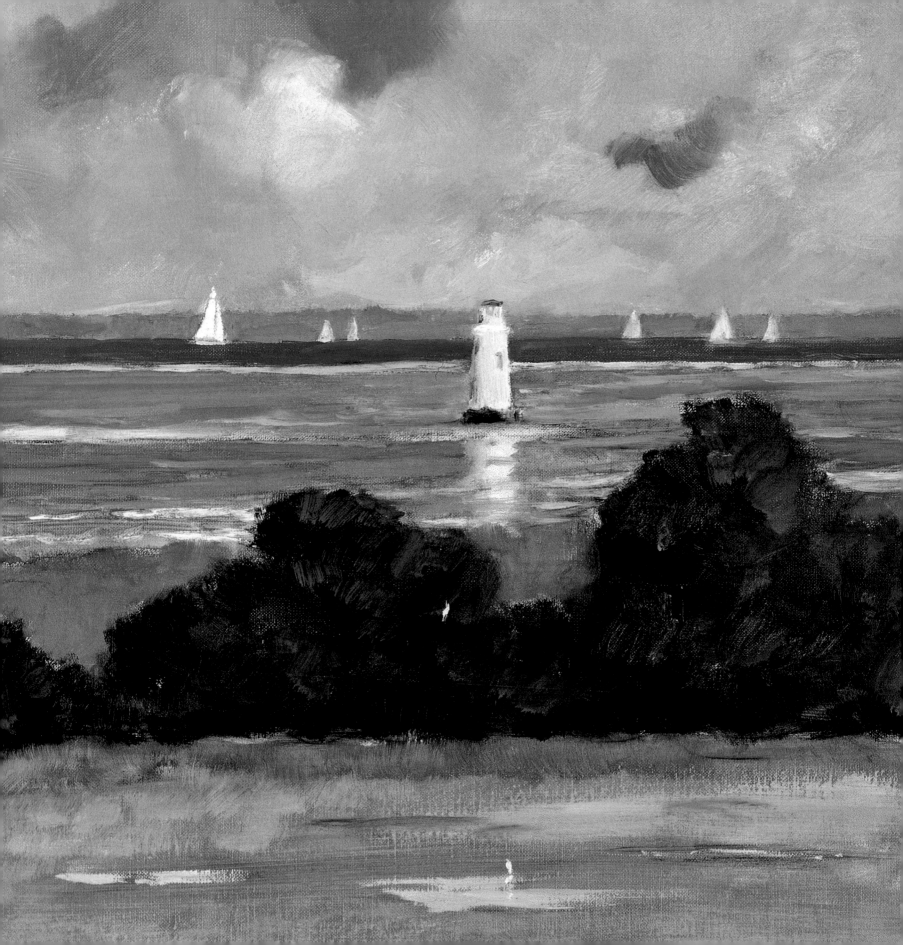

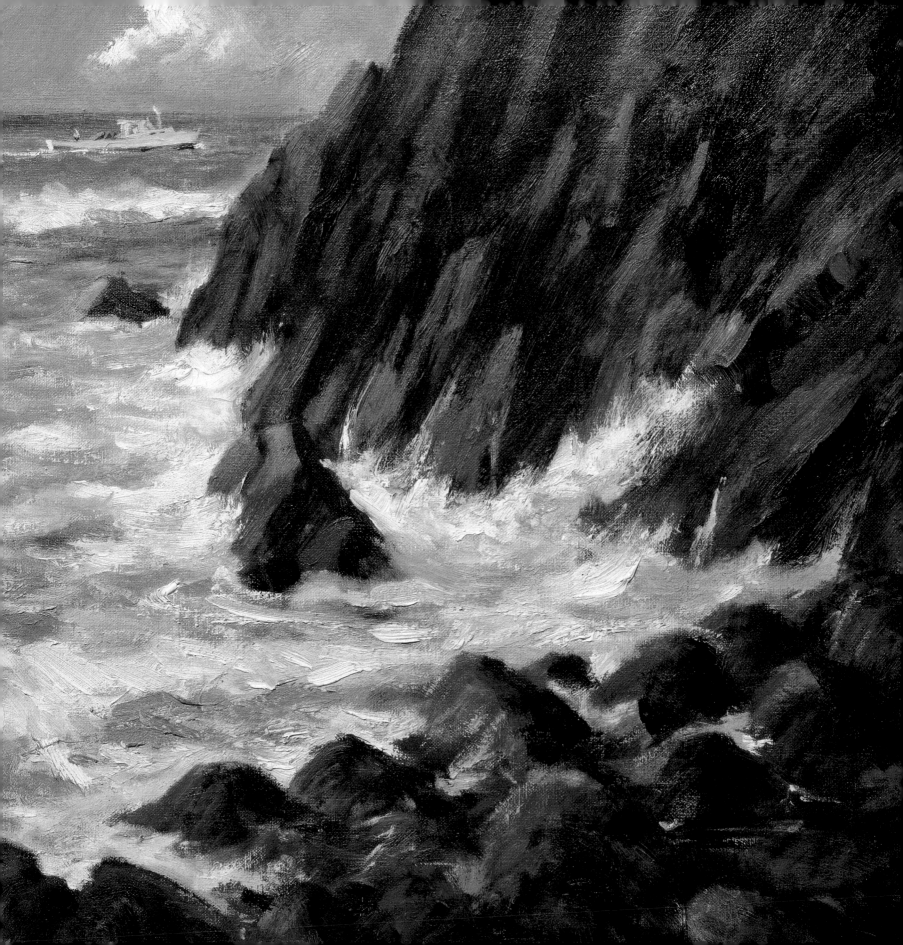

New England's Rocky Shoreline

Maine to Connecticut

The sun first rises in America on the rocky coast of Maine. Though periodically draped in fog or a blizzardy cloud of snow, each day more often than not will be brightened by crystal-clear skies, regardless of the time of year. The coast of northern New England is unique in America. Seldom will you find the ancient remains of a once-mighty mountain range exposed along the shoreline. Eons ago the Appalachian Mountains reached to the heavens like the lofty peaks of the Himalayas, but now all that is left is their crystalline core—worn, rounded granite knobs that form a rocky coast.

Maine's many islands are barren remnants of this eroded mountain range, which in its final attempt to stand tall had to resist the bulldozing energy of glaciers. These glaciers advanced from the frozen heart of Canada, following river valleys until they reached the sea a mere few thousand years ago. Their giant ice sheets sculpted the landscape we see today.

As this barren landscape plunges into the cold waters of the Gulf of Maine it provides a home to one of Maine's most famous residents, the lobster. More than three thousand lobstermen extract their living from the sea, harvesting more than twenty-three million pounds (10 million kg) of this tasty creature each year. The solitary routine of the lobsterman begins

Nothing is more awesome than the pounding of the surf on the headlands of the Maine coast. As I sat doing the watercolor sketch for this oil, I heard only the sound of crashing waves, screeching gulls, and, very faintly, the engine of a passing lobster boat.
Rocky Coast *(detail), 1996.*
Oil, 16 x 20 in. (40.6 x 50.8 cm).

each spring as lobster pots made of wooden laths are repaired and made ready for their summer at sea. Each lobsterman has favorite—and secret—sites that are passed from one generation to another. In order to place their pots in just the right spots, these hardy mariners must at times draw close to surf pounding against rocky ledges. During the short summer the lobstermen tend their lines of traps in crisp morning air as the mating calls of loons echo over the water's surface.

At the Maine coast's northernmost limit is the town of Eastport and Cobscook Bay, where at times a twenty-five-foot (7.62 m) tide rises and falls every twelve hours. The tides flush the bay with clean nutrient-rich seawater, which in turn guarantees a lucrative salmon fish-farming industry. Taking advantage of the tremendous tide, local fishermen can easily haul their boats out of the water to clean and repair the hulls. But they must work quickly before the incoming tide reclaims them.

Down the coast at Eastern Egg Rock in Muscongus Bay, colonies of puffins leave their icebound world of the north to breed and raise their young on jagged cliffs in warm short summers. Maine is a haven to many seabirds, including terns, which congregate in large colonies like those at Petit Manan Wildlife Refuge. The waters off Maine may be cold and dark, but they are also rich in the nutrients that support the bountiful marine life on which these birds feed.

Near Jonesport, Moose Peak Light guides countless mariners who each summer enter the nearby maze of coves and islands. Dropping anchor, these visitors can watch the sun setting on a pristine environment that through the millennia has been little affected by human activity.

The most famous scenes of coastal Maine are of Mount Desert Island, locale of Acadia National Park and Bar Harbor. From the summit of Cadillac Mountain there is a magnificent view of a glaciated landscape that includes the largest fjord on the east coast of America—Somes Sound.

Maine's visitors and residents include the affluent as well as those with modest incomes. There are Rockefellers ensconced in a mansion

These beautifully marked birds are fun to watch. No one could mistake their haunting cries.
Loon, 1985.
Watercolor, 9 x 13½ in. (22.9 x 34.3 cm).

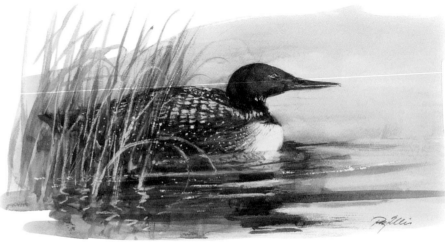

on Seal Harbor and, at the other end of the economic spectrum, there are the tourists who ride the ferry *Bluenose* from Bar Harbor to Yarmouth, Nova Scotia in hopes of sighting whales along the way.

From the rocky coast of Maine due south to the sandy beaches of Cape Cod is less than a hundred miles (160 km) as the seagull flies, but these two places could not be more different. Formed by an encircling arm of sand and gravel dropped by retreating glaciers, Cape Cod Bay was subsequently reshaped by waves and currents that smoothed and rounded its features.

The ponds, or "kettles," that dot the Cape's surface were formed by large blocks of ice mixed in with boulders and sand that the glacier could no longer carry on its back as it retreated northward. Detached and isolated, the blocks of ice eventually melted, leaving holes in the landscape that are now filled with freshwater; an important source of drinking water for the Cape's inhabitants.

Lacking the hard rock surface typical of Maine's coast, Cape Cod is locked in a losing battle with the sea, which will one day reclaim this territory. Each winter the assault begins anew as the waves created by nor'easters and violent hurricanes slash these sandy shores and shift them to the north and south. In this way the curling fingers of Provincetown and the shoals off Monomoy Island are continuously reshaped. These constantly moving sands frustrate the sailors who are forced to navigate the dangerous shoals, finding safe passage one year only to run aground in the same spot the next.

To be caught at sea during a nor'easter is a frightening experience. Storms have claimed the lives of many fishermen over the years, sailors who pushed their luck a little too far and disappeared in an unforgiving sea of fury. The winter winds that lash the shore can be bitterly cold, causing fingers to become quickly frozen and unable to tend the lines. When there are storm warnings, it is best to heed them, foregoing a day's catch in exchange for a safe, cozy harbor.

In the summer a temporary truce with the weather and rough seas is declared as millions of visitors, human and winged, flock to Cape Cod to enjoy its beautiful sandy beaches. According to legend, the first Europeans to gaze upon the grassy dunes of the northern cape were Vikings, who in 1004 slipped into the protective waters of Cape Cod Bay to haul their boats

up onto the beach for repairs. That protection is sought to this day by Provincetown's fishing fleet as well as by whale watchers returning from an afternoon on Stellwagen Bank.

The tall granite tower that rises above the village of Provincetown was not erected to commemorate the arrival of the Vikings, however. It stands in celebration of an event that took place hundreds of years later. On November 11, 1620, after sixty-three days of being tossed about on a violent sea, the Pilgrims found refuge in this harbor.

Although they found a land well-wooded with "oaks, pines, sassafras, and juniper," the Pilgrims stayed only a month before the beckoning white cliffs of Plymouth, on the west side of the bay, lured them to their final destination. Still, the woods of Cape Cod were not forgotten. Seventeen years later a group of Puritans came back to establish Cape Cod's first permanent village, Sandwich. Initially supporting a small colony of families, it was a bucolic retreat that has retained its charm over the centuries.

The best-known inn in present-day Sandwich was named for the mid-nineteenth century statesman and orator Daniel Webster, who along with other notable people was attracted to the Cape because of its famous trout streams. Today, a short distance down the road from the Daniel Webster Inn you can visit the state's fish hatchery, which continues to stock local trout streams.

While visitors to the Cape may know little of this history, they come by the millions each summer to enjoy the long, sandy beaches of the Cape Cod National Seashore. They come for surf fishing for blues and striped bass, or for a lobster bake against sand dunes under a rising moon. They also come to take a ferry out of Woods Hole heading to the outer islands.

During the summer the populations of Martha's Vineyard and Nantucket Island explode. It's a love-hate relationship for many of the year-round residents whose livelihoods are dependent upon tourism but who cannot wait for the season's end when the crowds dissipate, so that they can enjoy the Indian summer by themselves. Between the Islands and Cape Cod (which locals refer to as "the Mainland") is Nantucket Sound. Its protected waters are a favorite place for people with boats of all sizes and powers, from cigarette boats speeding over the waves to catboats that seek a quiet cove and a peaceful afternoon of clamming. Another popular hideaway is Cuttyhunk, a pile of glacial boulders, sand, and sea grass at the end of the

Elizabeth Islands, which separate Vineyard Sound from Buzzard's Bay and the entrance to the Cape Cod Canal.

A stone's throw from Cuttyhunk is Newport Neck, the summer playground of billionaires. The mansions that adorn this rocky shoreline create an ambiance more characteristic of Europe than America. Mansions like the Breakers, which was modeled after a northern Italian Renaissance villa, may leave you breathless, especially when you learn that its famous occupant, Cornelius Vanderbilt, spent only ten weeks a year in this marbled edifice that took 2,500 workers over two years to build.

The air of Newport is filled not only with the buzz of summer society but also with the sound of the starter's cannon on the Committee Boat signaling the beginning of another sailing race where the sleek bows of J-boats cut through the water heading for the first marker buoy. For years the home of the America's Cup race, Newport's waters are graced by countless yachts that crowd its beautiful harbor each summer. In the waters off Rhode Island one also encounters fishermen out of Point Judith in search of giant bluefin tuna, and tourists eager to board ferryboats for the short ride to Block Island, an artist's haven.

Newport, which has a proud naval history, was home to our first Naval Academy—now in Annapolis. Newport is still the location of the War College, where naval officers from around the free world come to plot strategies for sea battles they hope never to fight.

Although it is the smallest state in the Union, Rhode Island possesses hundreds of miles of picturesque coastline. The scenic route winding its way in and out of Narragansett Bay will take you to such harbors as Wickford, where John Updike set his novel *The Witches of Eastwick.*

Following the coastline of New England west past the lighthouse at Watch Hill, one enters the more protected waters of Long Island Sound, which, like Nantucket Sound, is the delight of yachtsmen.

Thousands of years ago Long Island Sound was a vast freshwater lake hundreds of feet above sea level, and its shores were

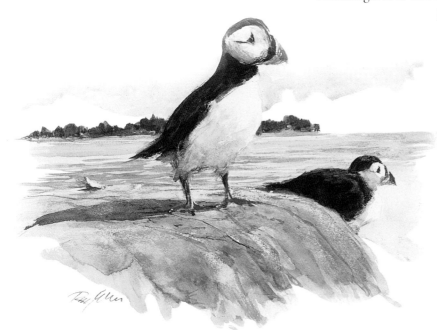

Matinicus Rock, the farthermost island off the coast of Maine, is one of the few nesting grounds on the eastern seaboard for this comical but handsome bird. I think that none of God's creatures has more sheer fun than the puffin.
Puffins, *1985.*
Watercolor, 9 x 13 ½ in. (22.9 x 34.3 cm).

populated by various Native American tribes. The seacoast was then almost two hundred miles (320 km) to the south. But as the icesheet that covered northern New England melted and the seas rose, a large inland sea that we know today as the Sound was eventually created, and the Native Americans who had populated the shores of the lake were forced to higher ground to the North.

When the first colonists arrived, the Native American population of Connecticut numbered some ten thousand. The ownership of land was an alien concept, imported by the settlers, whose numbers grew as the Native American population diminished. The relationship between the Native Americans and the European settlers was never good. Indians were killed by settlers in bloody massacres. The Pequot Nation, whose village was along the river near Mystic, was virtually exterminated in an assault by settlers in 1637. They also died—in possibly greater numbers—of European diseases against which they had no natural defenses.

Some two hundred years later, thousands of young men sailed from Mystic to California, lured there by the promise of gold. The journey by clipper ship from Mystic to San Francisco took at least two months.

The sea has always lured people—real and fictional—to risk their lives. Whether it was Captain Ahab searching for Moby Dick aboard the *Essex*, Nathaniel Palmer leaving Stonington in search of seals but instead discovering Antarctica, Portuguese fishermen out of New Bedford, or today's naval officers who disappear beneath the waves after leaving their submarine base in Groton/New London—whatever the reason, the sea has always had a strong pull on all within her grasp.

The "Jonesport" is known far and wide as the epitome of the Maine lobster boat. I spent some time in Jonesport in 1984 and was intrigued with this hauled vessel being rebuilt at the boatyard. I consider this my hallmark painting of Maine.
Rebuilding at Jonesport, 1985.
Oil, 40 x 48 in. (101.6 x 121.9 cm).

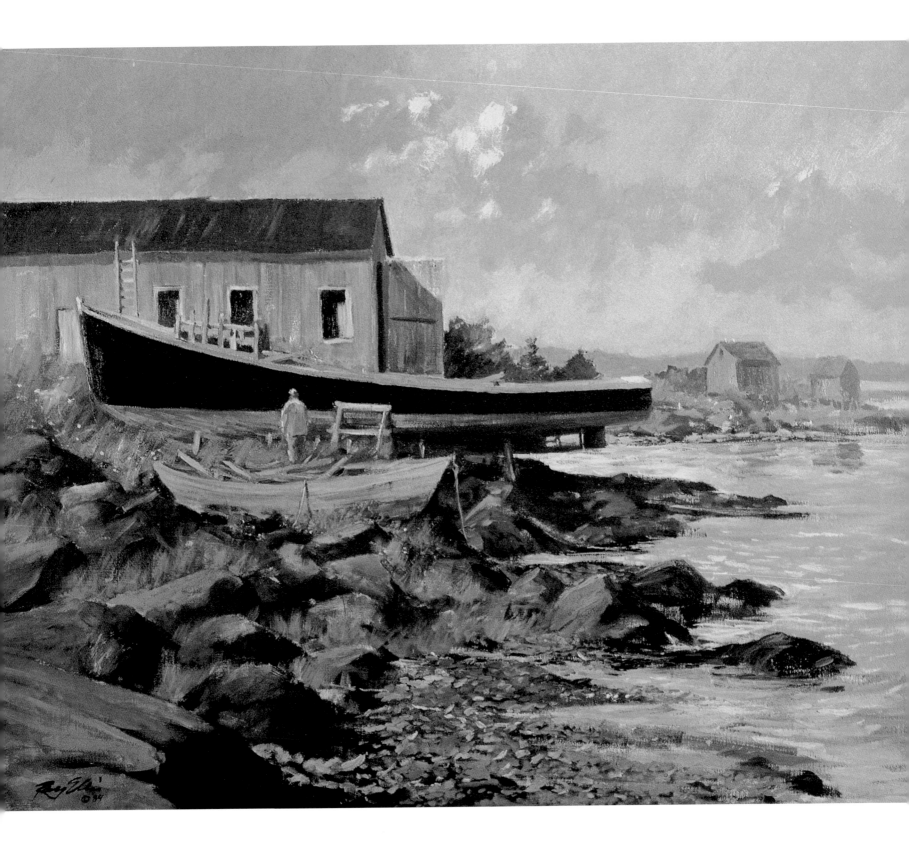

*Although I have painted coastal scenes for many years, my first visit to Ragged Island, Maine, was the
catalyst for portraying America's coasts. One can find many scenes like this on most of Maine's islands.
This plein air watercolor reaffirms to me that for capturing light and the essence of the moment
nothing is better than painting on the spot outdoors.*

Island Overlook (Criehaven), *1973. Watercolor, 17 x 33 in. (43.2 x 83.8 cm).*

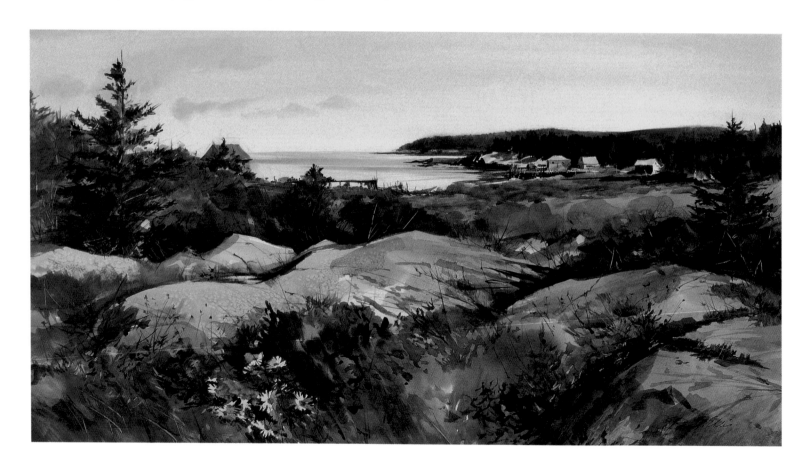

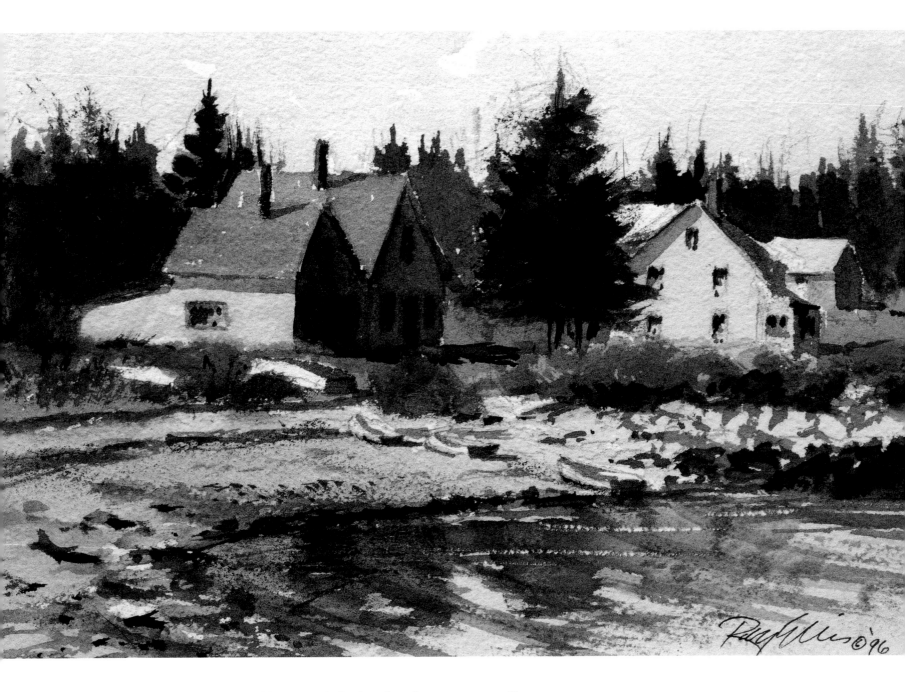

*This was one of the first scenes I ever did on Ragged Island. Early in this century, a post office was
located in one of these twin buildings. I painted this watercolor with my small palette on a recent trip.*
Criehaven (Ragged Island), 1996. Watercolor, 5½ x 8½ in. (14 x 21.6 cm).

Tidal pools fascinate me. In and around them one finds a variety of shells as well as many species of aquatic insects and colorful wildflowers. I loved the reflections of the rocks and pines in this particular pool.

Tidal Pool, 1985. Watercolor, 14 x 16 in. (35.6 x 40.6 cm).

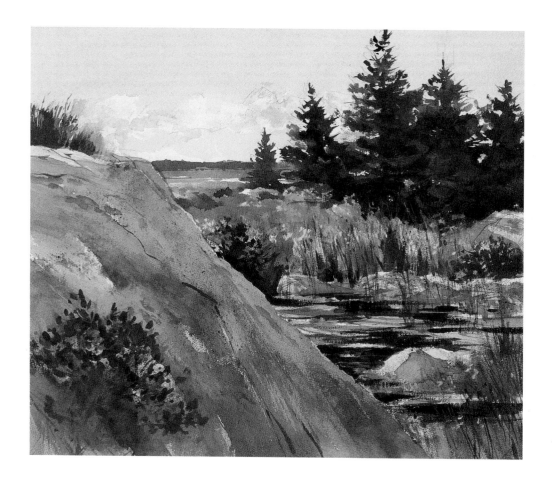

Ragged Island, where I painted this scene, is only a mile long and the farthermost inhabited island off the Maine coast. Many mornings during visits there I have been awakened by the sound of a boat's engine as a lobsterman works in close to the ledges to pick up his traps. In this painting, the early morning sun breaks through the fog to highlight the lobsterman's foul-weather gear and the tips of the rocks through the trees.

Working the Ledges, 1985. Watercolor, 21½ x 29 in. (54.6 x 73.7 cm).

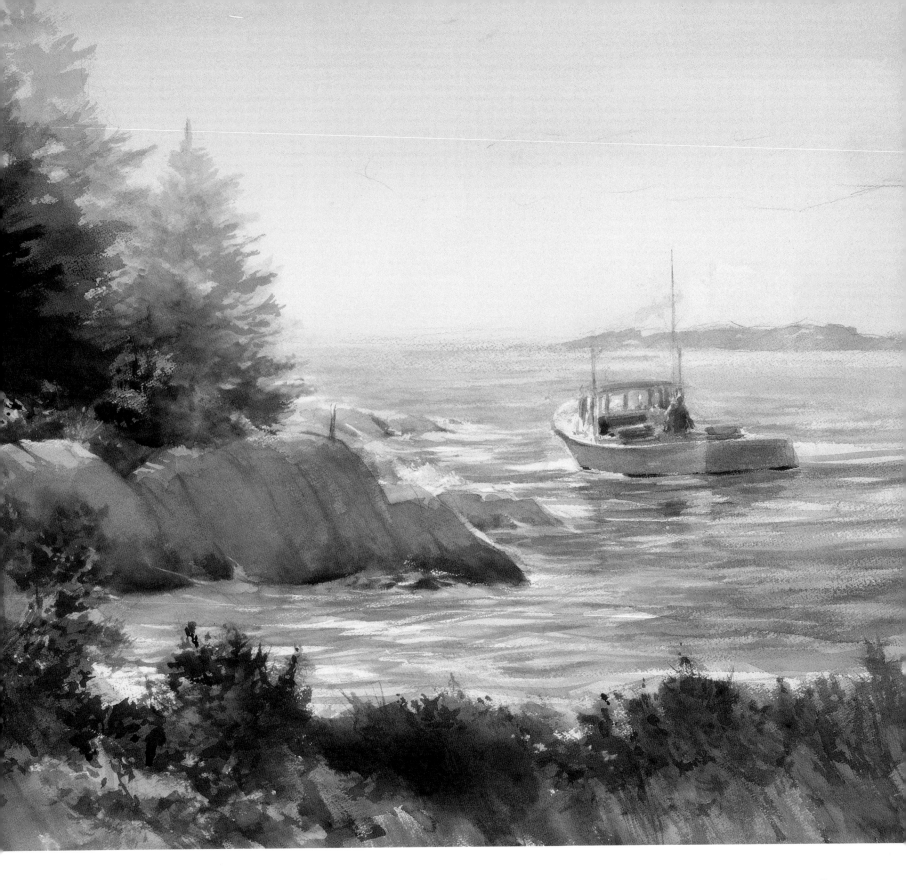

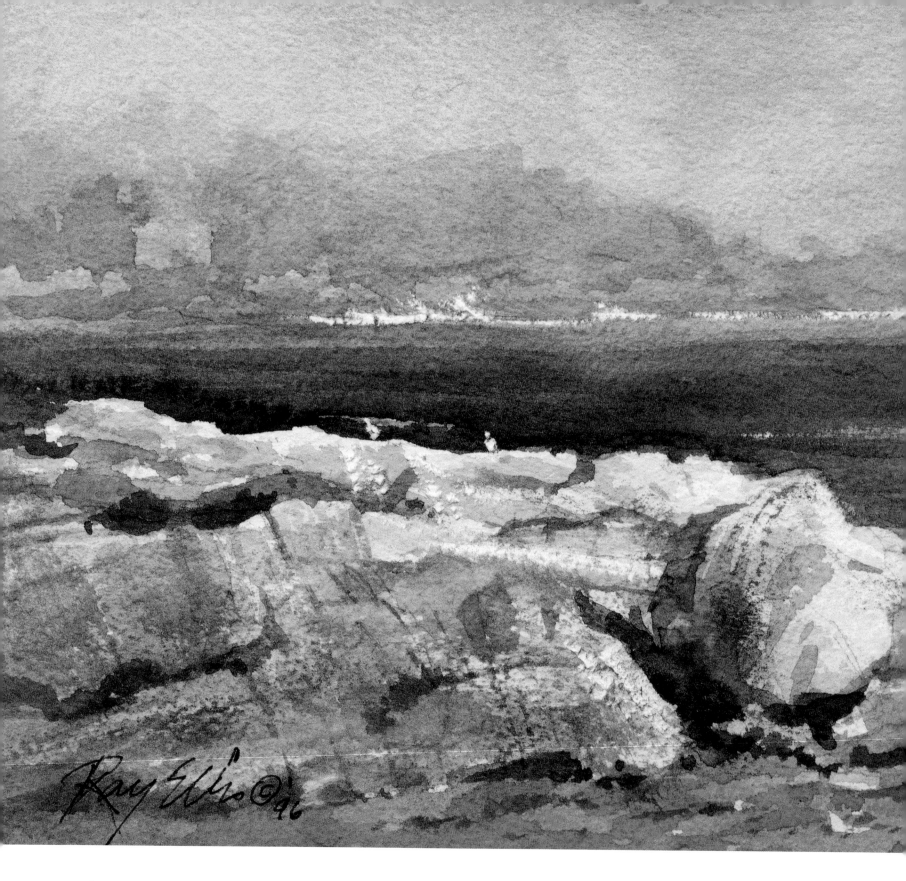

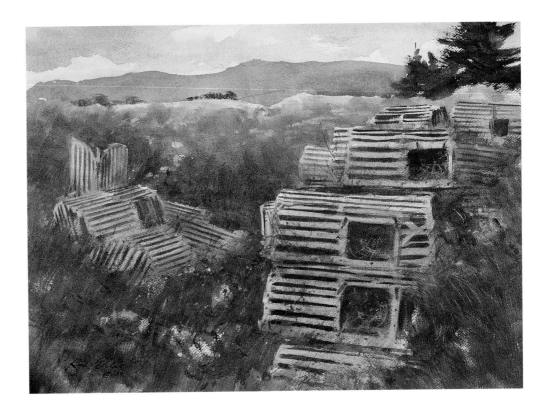

LEFT:

During a recent visit to Ragged Island in late summer of 1996, my wife Teddie and I walked out to a point for a picnic. I sat on the rocks and created this watercolor impression with my small pocket palette.
Seal Cove, Sun, Mist, *1996.*
Watercolor, 5¼ x 7¾ in. (13.3 x 19.7 cm).

ABOVE:

Old wooden lobster traps have a certain charm to them. The patterns they create when stacked in a field or on the docks are almost abstract. Unfortunately, a good portion of the old traps have been replaced by new wire cages.
Lobster Traps, *1985.*
Watercolor, 14 x 20 in. (35.6 x 50.8 cm).

OVERLEAF:

Painting turbulent surf, particularly along the Maine coast, is always a challenge. In this spontaneous watercolor, I tried to capture the feeling of the ever-changing motion of frothy, breaking waves.
Boiling Surf, *1977.*
Watercolor, 17 x 28 in. (43.2 x 71.1 cm).

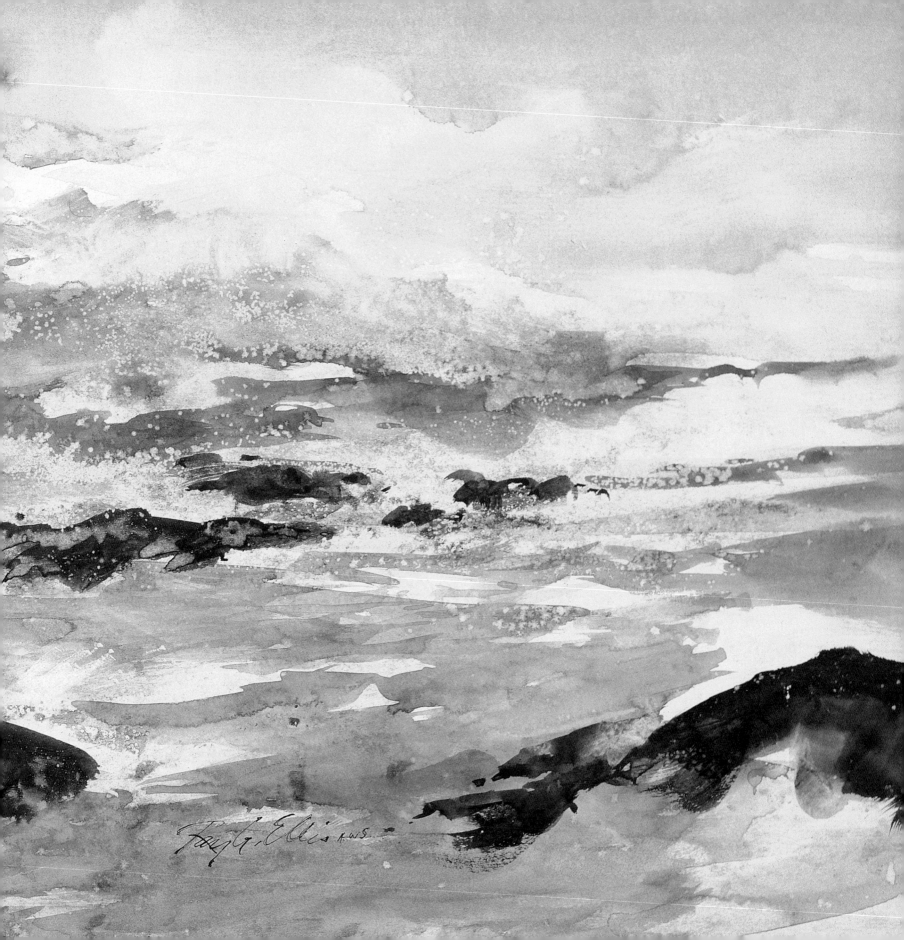

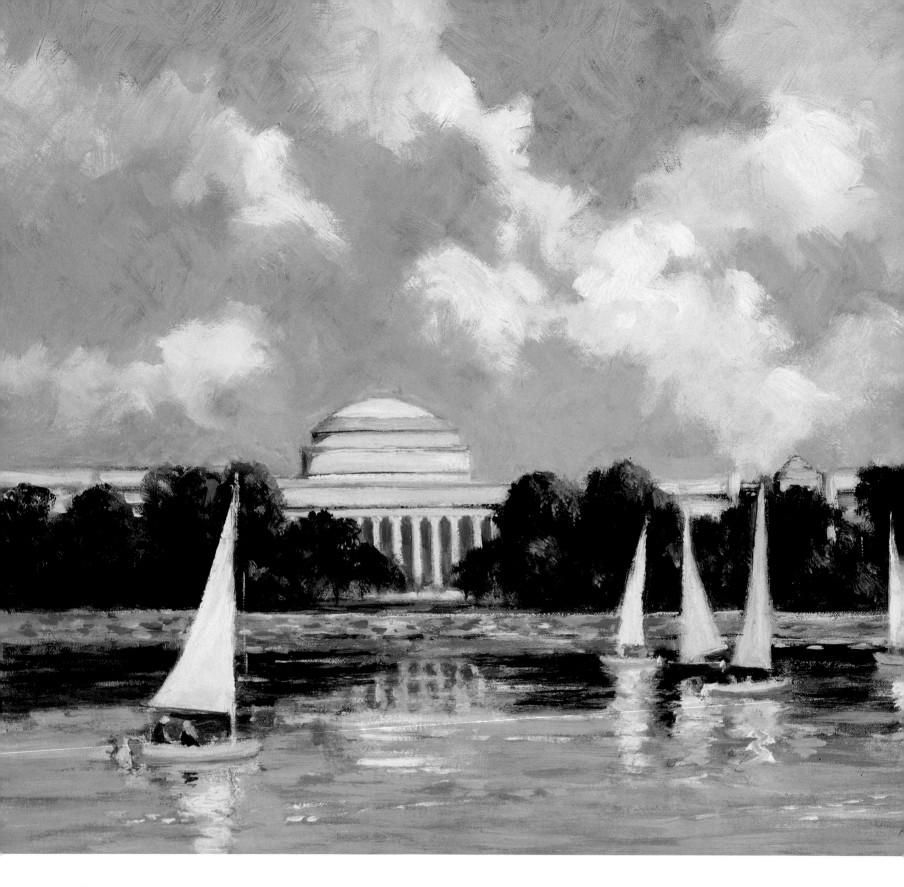

This ferry, which transported passengers and cars between Woods Hole, on Cape Cod, and Martha's Vineyard, was retired from service some years back but many islanders remember her with great fondness.
The Naushon, *1985. Watercolor, 6 ½ x 14 in. (16.5 x 35.6 cm).*

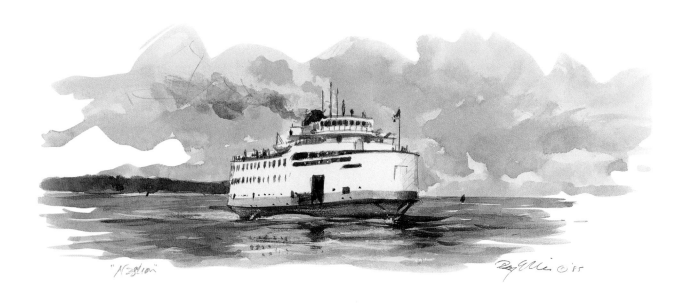

This building on the campus of Massachusetts Institute of Technology on the Charles River overlooks one of the best vistas in Boston. These small sailboats are a familiar sight.
The Dome at M.I.T., 1996. Oil, 16 x 20 in. (40.6 x 50.8 cm).

This was a great subject to paint with the moored sailboats surrounded by marsh and wildflowers.
Woods Hole Inner Harbor, *1996.*
Oil, 16 x 20 in. (40.6 x 50.8 cm).

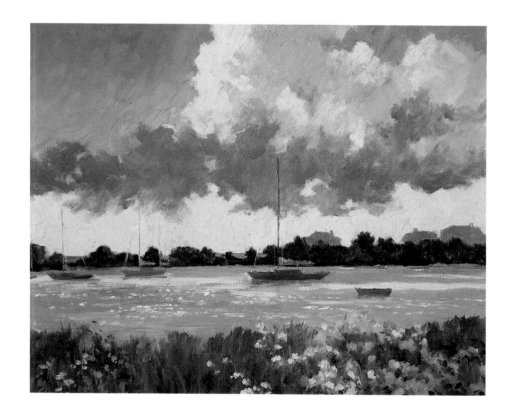

Some of the most beautiful oceanfront homes in New England are perched on the peninsula near the inner harbor of Woods Hole. They look out over Buzzards Bay, where the sunsets are spectacular.
Penzance Point, *1996.*
Oil, 40 x 60 in. (101.6 x 152.4 cm).

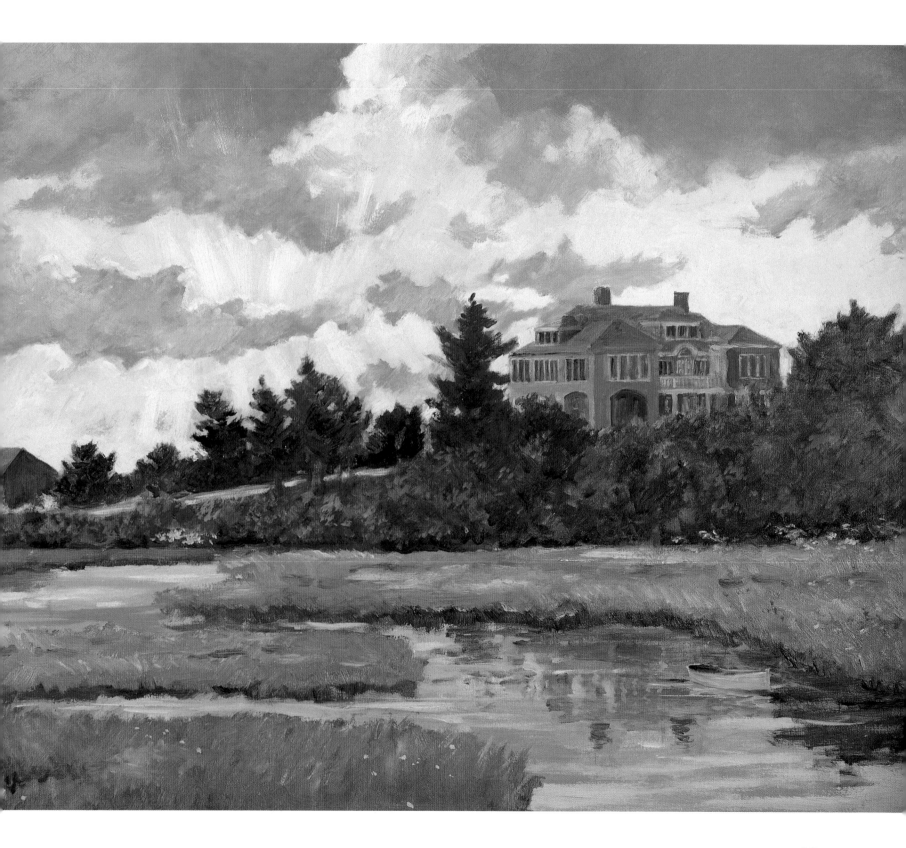

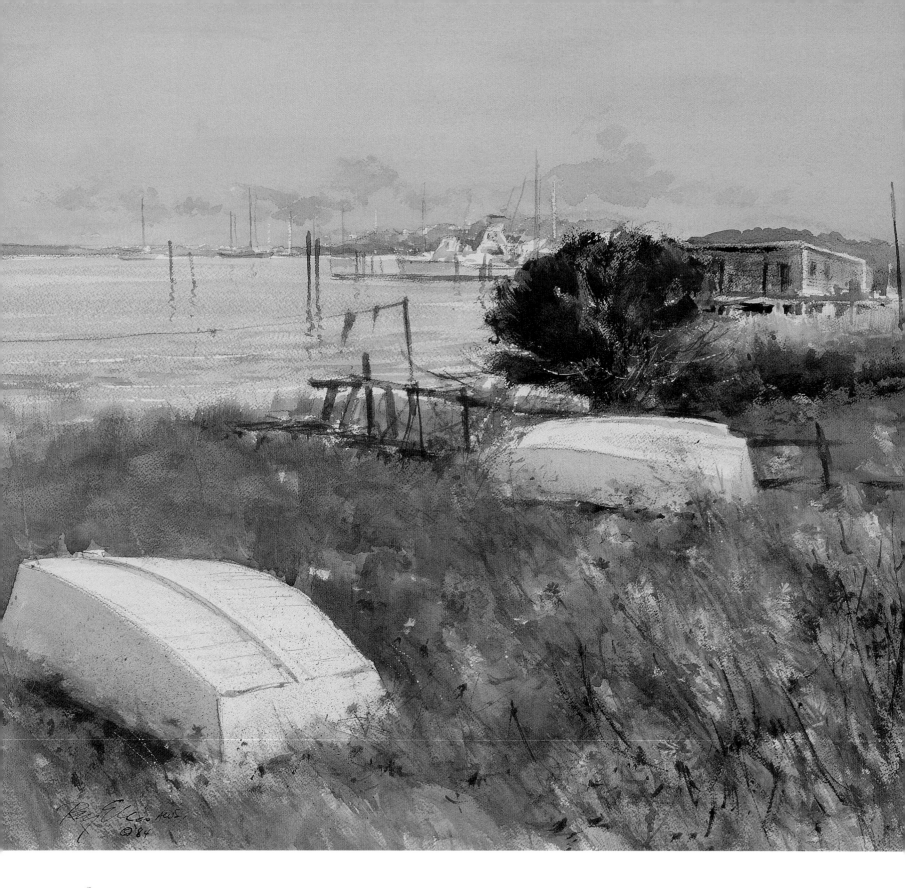

OPPOSITE:

*Over the years I have sailed several times
from Martha's Vineyard to Cuttyhunk, an
island in the Elizabeth Islands chain. While a
popular and well-visited spot in summer, it is
inhabited by only a few hardy folk in winter.
These dinghies, beached along the harbor
amidst wildflowers, caught my eye as a perfect
composition for a watercolor.*
Beached Dinghies *(detail), 1984.*
Watercolor, 21¾ x 24 in. (55.2 x 61 cm).

OVERLEAF:

*Catboats may not look as graceful and sleek as
other sailboats, but their shallow draft makes
them ideal for maneuvering into a deserted
cove for a summer picnic on the beach.*
Off Cape Pogue, *1997.*
Oil, 30 x 48 in. (76.2 x 121.9 cm).

BELOW:

*Tidal currents run swiftly through Menemsha
Inlet. Here fishermen prepare a boat to leave
on the outgoing tide.*
Menemsha Fishermen, *1994.*
Watercolor, 15 x 25 in. (38.1 x 63.5 cm).

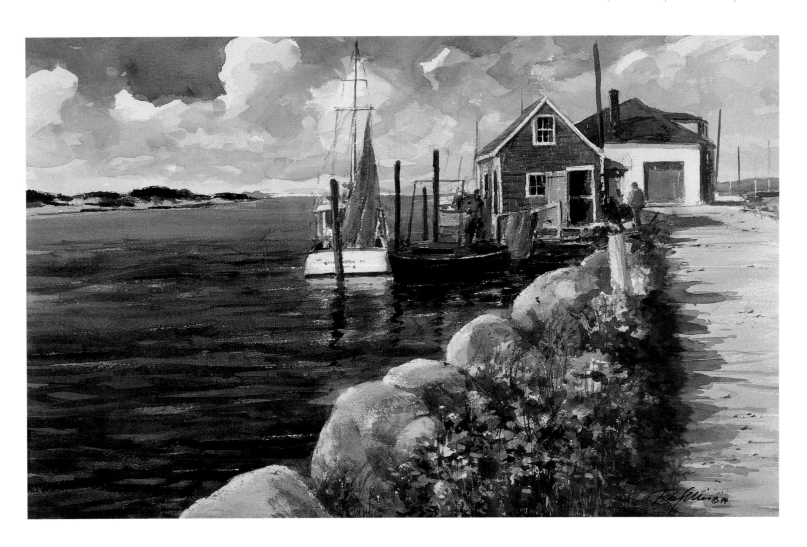

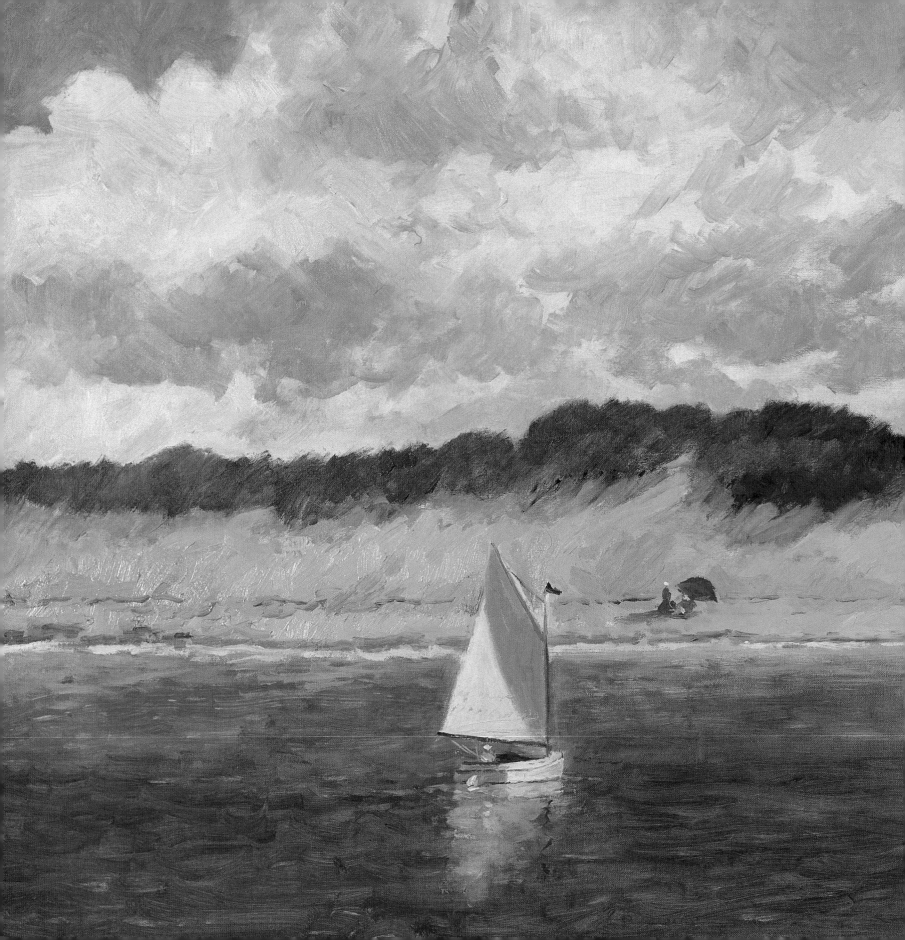

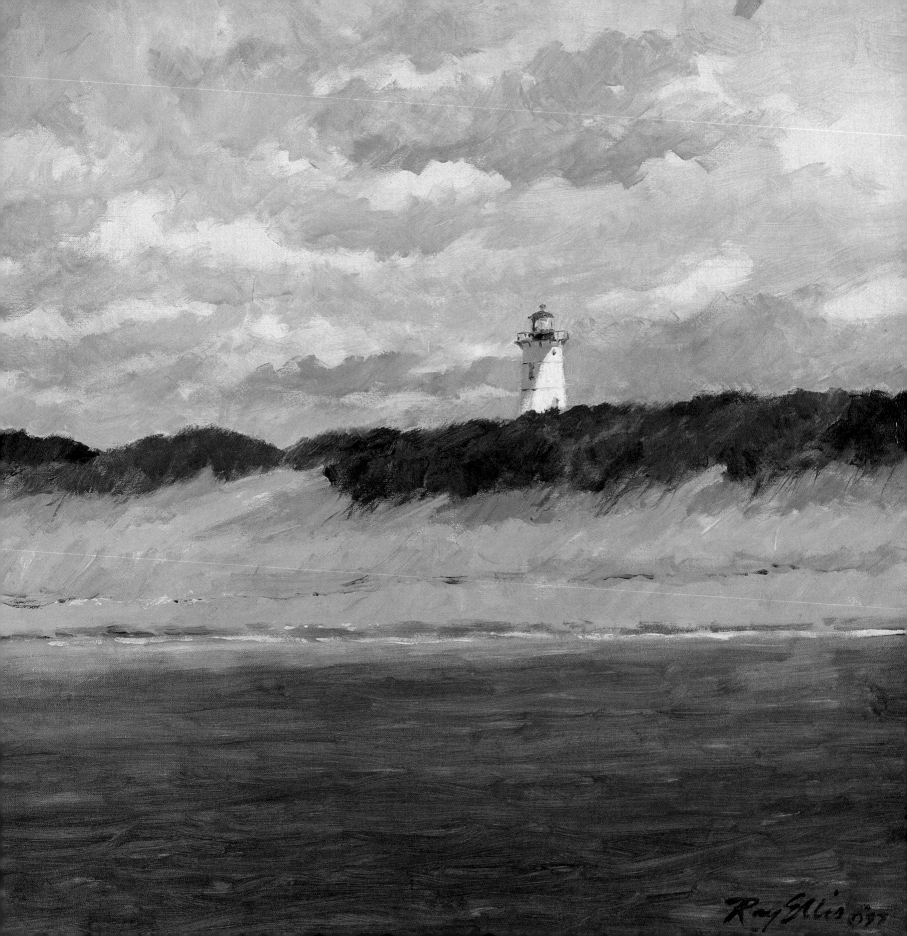

A popular Vineyard fishing spot is at Squibnocket Beach, especially in the moonlight. Part of the old pier, which existed back when men often fished in jackets and ties, still remains.
Moonlight—Old Bass Stand, *1994. Oil, 18 x 24 in. (45.7 x 61 cm).*

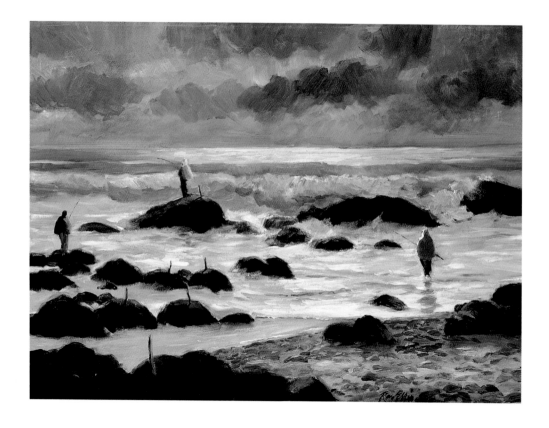

This rock out at Gay Head is well known to Vineyard surf fishermen.
Fishing at Spirit Rock (Gay Head, Martha's Vineyard), *1997.*
Oil, 10 x 16 in. (25.4 x 40.6 cm).

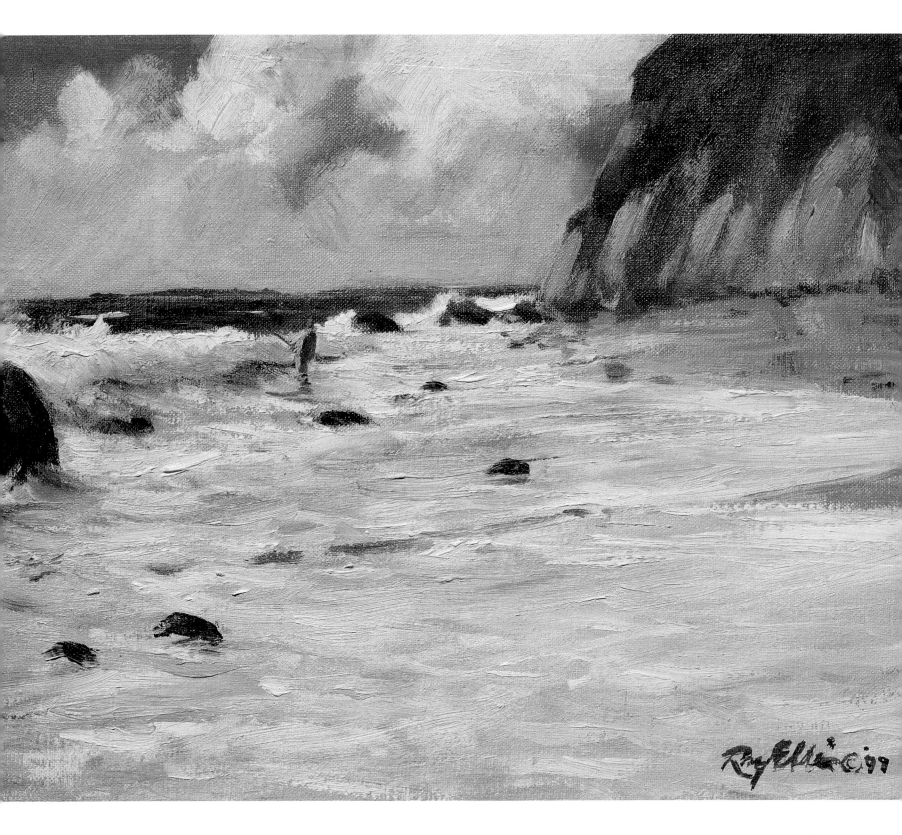

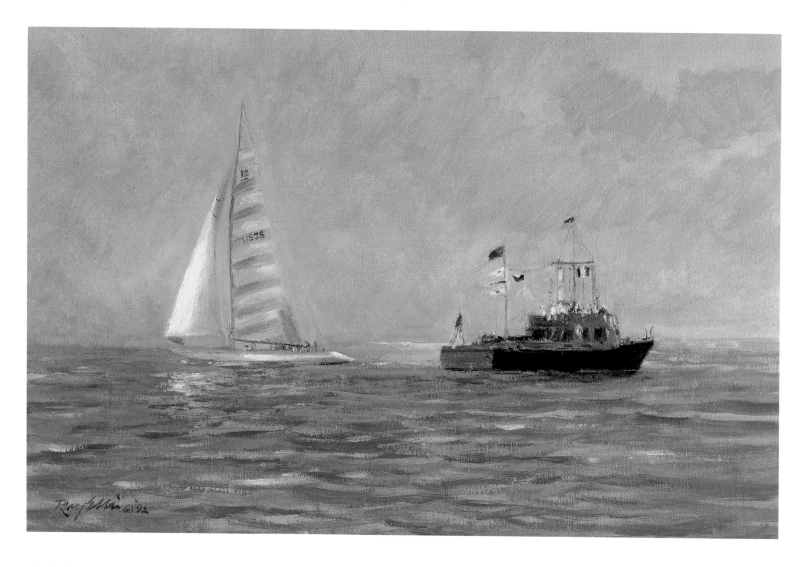

I had always wanted to paint the finish of the America's Cup race. My opportunity finally came in Newport in 1983, the year that Liberty *was defeated by* Australia II. *I did this painting recently from an original sketch.*

Parting Friends — The Finish, *1992. Oil, 12 x 16 in. (30.5 x 40.6 cm).*

BELOW:

Up the tidal creeks small boats can be seen high and dry, scattered at their moorings on the mud flats.
Low Tide, Duxbury *(detail)*, 1985. Oil, 11 x 14 in. (27.9 x 35.6 cm).

OVERLEAF:

Anyone who loves the lore of the sea as I do must love Mystic Seaport. We have stopped there many times, and invariably I do a sketch or a painting.
Mystic Harbor *(detail)*, 1986. Watercolor, 10½ x 25 in. (26.7 x 63.5 cm).

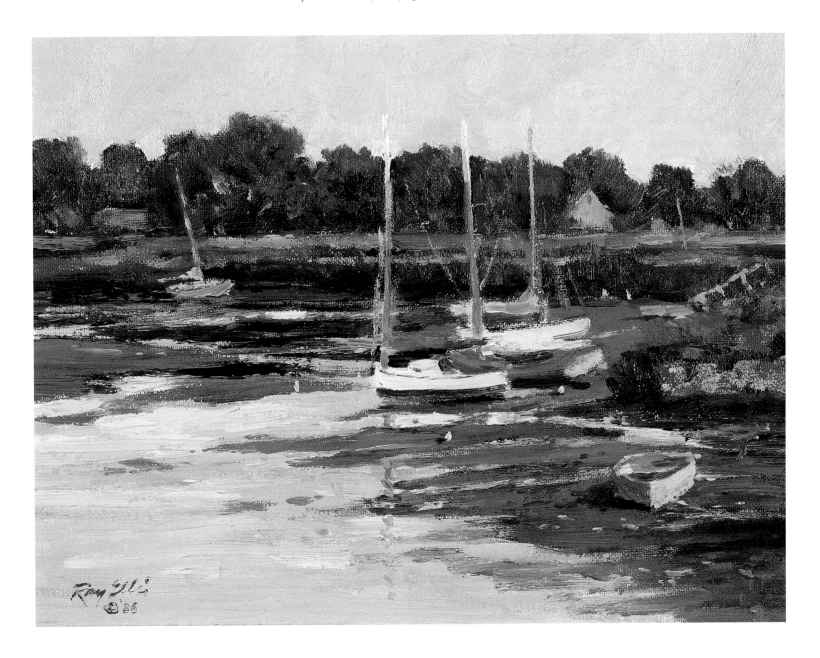

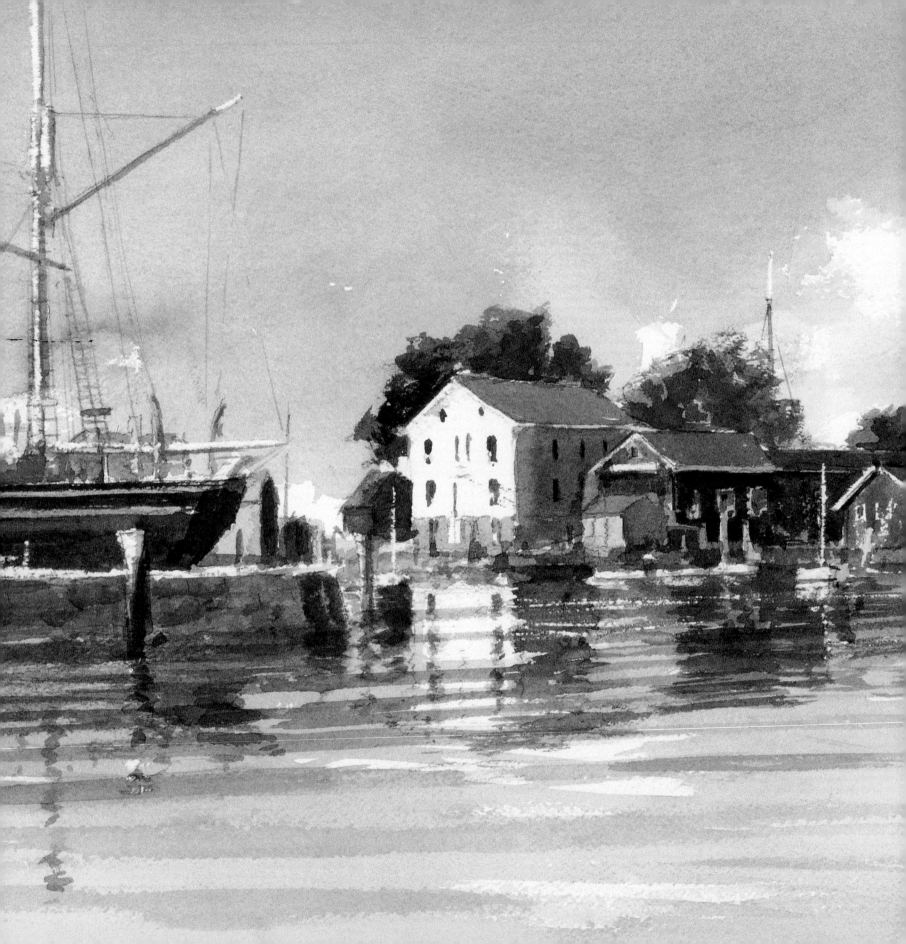

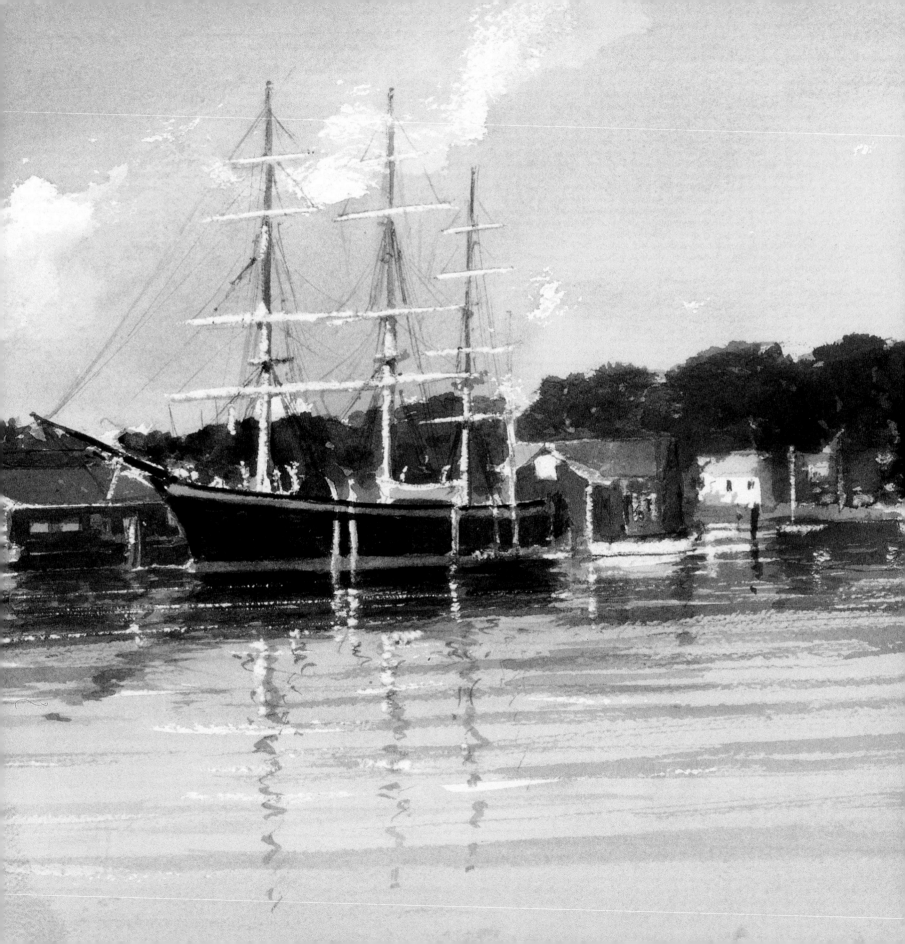

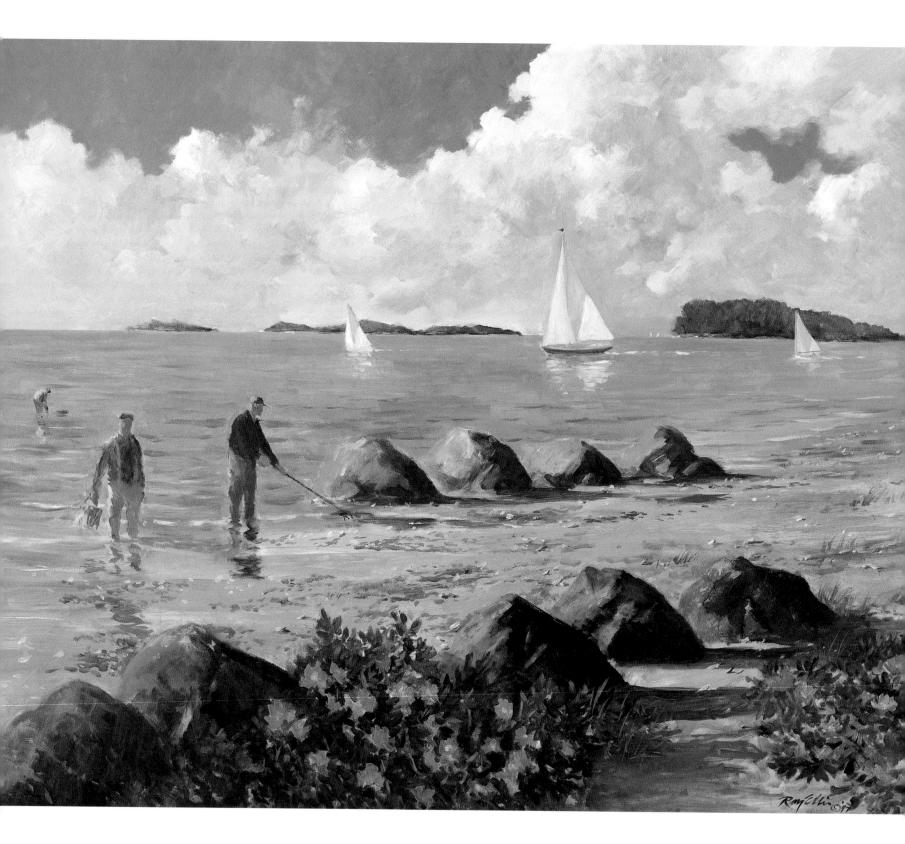

OPPOSITE:
Last year I was invited to Saugatuck Island to paint the entrance to Westport Harbor. I added people clamming and sailboats passing Sprite Island. The area inside the outer islands is Cockenoe Harbor, the location of the largest clam bed in the state.
Clamming at Saugatuck Island, *1997.*
Oil, *45 x 70 in. (114.3 x 190.5 cm).*

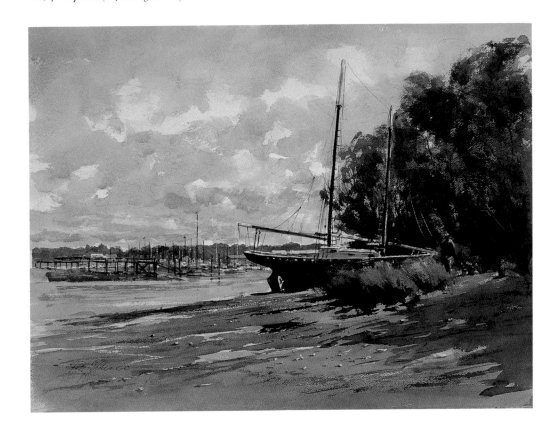

This old schooner in Darien, beached for who knows how long, was being worked on by several young men when I happened on it. Sometimes you're lucky enough to find a scene that has everything—good composition, interesting subject matter, strong values.
Beached Schooner, *1985.*
Watercolor, *18½ x 25 in. (47 x 63.5 cm).*

Ray Ellis
© 89

The Sandy
Mid-Atlantic Coast

New York to Virginia

To a denizen of New York City it is the Hamptons, but to a local, eastern Long Island is the South Fork, an island within an island forming the southeasternmost tip of what looks like a fish when viewed from space. The tail is in fact a glacial moraine deposited some ten thousand years ago. At the very tip of the tail stands Montauk Light, a granite landmark built in 1796 at the request of President George Washington.

Over the ages the winds blowing off the North Atlantic Ocean have lashed the glacial moraines of Long Island, carrying fine sands inland more than one and a half miles (2.5 km) to form beautiful sand dunes.

What makes eastern Long Island unique and accounts for its long and rich history is the chain of protected inlets and bays that has provided sanctuary to Native Americans and European settlers, to pirates, fishermen, whalers, and rum runners.

At the eastern end of the island, Sag Harbor has provided safe haven to countless sailors who found themselves fleeing from storms. From 1775 to 1871 as many as sixty-three whalers called Sag Harbor home port as they sailed the oceans of the world in search of whales. Today Sag Harbor is a yachtsman's delight, a favorite place to stop and take on supplies before

At the southern tip of New Jersey lies Cape May Point, where I've done many paintings. The dunes are sensational here, and birdwatchers abound.
Path to the Point *(detail), 1984.*
Watercolor, 15 x 20 in. (38.1 x 50.8 cm).

heading out into the open ocean for a run to Block Island or farther north toward Cape Cod and the Islands.

The East End's first settler was Lion Gardiner, a professional soldier who came to America to build a fort at the mouth of the Connecticut River near Saybrook but later purchased the island near Sag Harbor that still bears his name. Gardiner's Island is strategically located near the entrance to Long Island Sound and was once a military and economic outpost. Still privately owned, the island has been handed down from one generation to the next.

Longshore currents running parallel to the Gulf Stream sweep the southern shore of Long Island and cause its sands to be ever-moving. The warm waters of the Gulf Stream alleviate the chill of winter but also supply energy to the hurricanes that periodically attack the island's shores.

Today, millions of New Yorkers pour out of the city each summer to enjoy Long Island's sandy beaches and cooling breeze, which at times can become warm, blanketing the shoreline in fog.

The north shore of Long Island differs from the south, with its long sound creating an inland sea and its numerous little estuaries providing shelter for countless small boats at anchor. Huntington Harbor at times is host to more than two thousand boats. Nearby, atop Cove Neck at Oyster Bay, is Sagamore Hill, Theodore Roosevelt's Victorian mansion. Oysters thrive in the waters along the shores of the Sound. They do particularly well in the warm waters discharged by the power plant at Northport.

Like Nantucket Sound off Massachusetts, the protective waters of Long Island Sound are a constant battleground during the summer months when the yacht clubs dotting its coastline challenge their rivals in near-mortal combat from one end of the Sound to the other.

A short distance away from the sandy beaches and protective coves of Long Island, New York City with its ferries and tugboats is a study in contrasts. The skyline of Manhattan Island continues to change, rising higher and higher, darkening the streets long before the sun reaches the horizon. But despite its noise and congestion, immigrants from around the world continue to make New York their first home in America. Few still arrive by sea to

On many trips my little watercolor palette is my camera. I enjoy the challenge of small, spontaneous studies, many of which become the source for larger paintings either in watercolor or oil.
Cape May Victorian, *1971.*
Watercolor, 9½ x 11¾ in. (24.1 x 29.8 cm).

the welcoming raised torch of the Statue of Liberty; these days, most enter the country at nearby Kennedy International Airport.

Long before any humans reached the banks of the Hudson, the largest river in the Northeast, this body of water dumped millions of cubic yards of sediment at its mouth each year. Transported south to the coast of New Jersey, the resistant sands of the Hudson formed long linear sandbars that now stretch for 127 miles (205 km) from Sandy Hook to Cape May. At the southernmost tip of New Jersey, Cape May derives its unique charm from a hodgepodge of ornate Victorian mansions mixed with Tudor castles and Italian villas built by railroad tycoons and industrial barons after the Civil War.

In the late 1970s, Atlantic City's scenic but deteriorating boardwalk was renovated as the city was transformed into the gambling capital of the East. Casino after casino rose from the sandy soil that was once owned by Quakers.

Farther south lies one of the world's greatest estuaries—Chesapeake Bay. The Algonquin Indians called it Chesepiooc, or "great shellfish bay." Like so much of the eastern coastline, the Bay was born some ten thousand years ago when the rising sea, fed by melting glaciers, flooded a great ancient river valley and its network of more than 150 tributaries.

In the semi-enclosed waters of the Bay, freshwater mixes with seawater to create a habitat for more than 2,500 species of plants and animals. For hundreds of years man has harvested these riches—blue crab, menhaden, striped bass, and, before it disappeared, sturgeon. Shallow waters and a firm sandy-clay bottom mixed with shells make the Bay an ideal habitat for the oyster as well. Harvested at between three and five years of age, an oyster will by then have reached lengths exceeding three inches (7.6 cm).

Modern shipbuilding design continues to improve the fisherman's efficiency, but many fishermen still cling to the traditional Chesapeake Bay skipjack. With its jib-and-mainsail rigging, raked masts, and clipper bow, this boat has typified the "waterman" for the past century. Harvesting "arsters," as watermen call them, using the deadrise method is a back-breaking tradition, particularly when the winds are blowing at twenty-five miles an hour (40 km/hr).

During fall and winter, watermen handtong for market oysters, then during the summer they dredge for blue crab on the Virginia side of the

Bay. Female blue crabs mate only once, when in their soft-shell state between early May and the end of October.

The oyster population once seemed limitless, but by the early 1900s overharvesting had begun to have an effect and by the middle of the century the oyster catch was down to a fifth of what it had once been. The population continued to decline as the waters of the Bay were polluted by an overabundance of phosphorus and nitrogen, which produced algae blooms that in turn blocked out energy-sustaining sunlight and led to the depletion of oxygen. The sources of these pollutants were many, complicating their cleanup—waste treatment plants, industry outflows, and the drain-off from pastures, cropland, lawns, and urban areas. Fortunately, efforts to reduce pollution are proving successful, and the Bay's marine life is beginning to revive itself.

Chesapeake Bay is also home to an abundance of waterfowl. At one time—from 1870 to 1910—waterfowl wintering on the Bay were relentlessly hunted. According to on account from that period, ducks were killed by the thousands until they covered the water, then stuffed into barrels and transported by train to the major cities of the East. Finally, in 1918, after years of wholesale slaughter of the Bay's waterfowl, the commercial hunting of birds was outlawed, and in 1935 the "duck stamp" was devised to help raise funds to establish bird refuges in the United States. Today more than 600,000 Canadian geese visit the Bay each year, along with mallards, black ducks, gadwalls, pintails, wigeons, and goldeneyes, to name but a few.

At the eastern tip of Long Island, Montauk has a majestic location. Like other artists, I am intrigued by lighthouses, especially this prominent one.
Montauk Light, *1984.*
Watercolor, 17½ x 21 in. (44.5 x 53.3 cm).

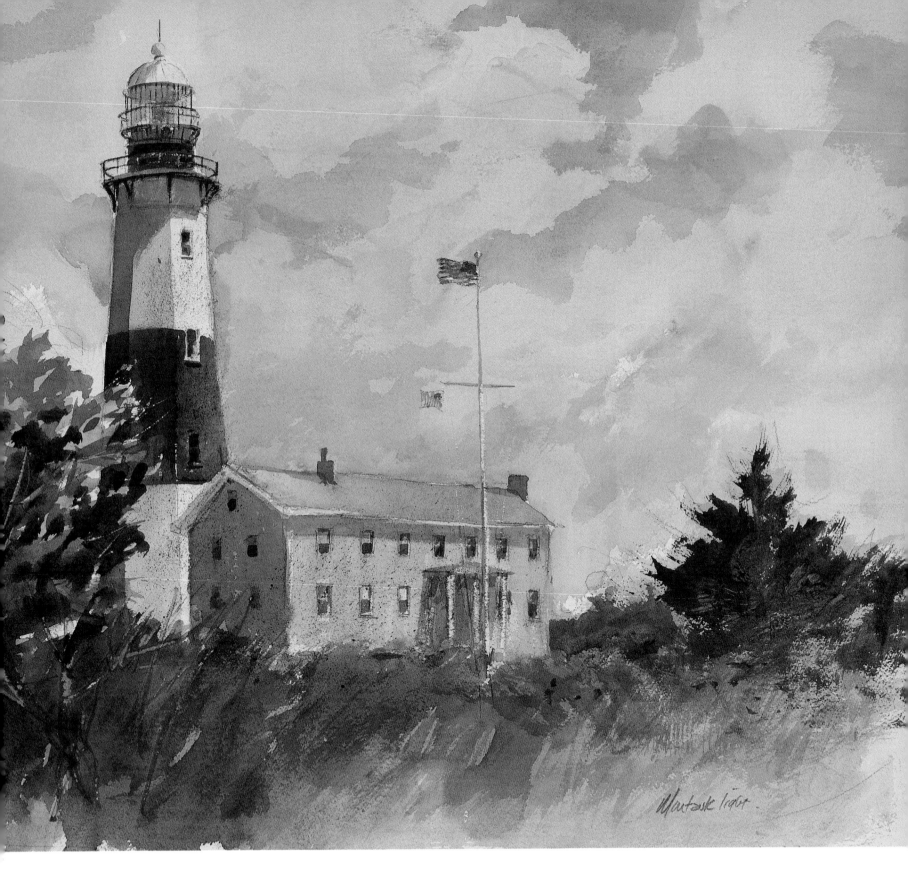

Montauk Light.

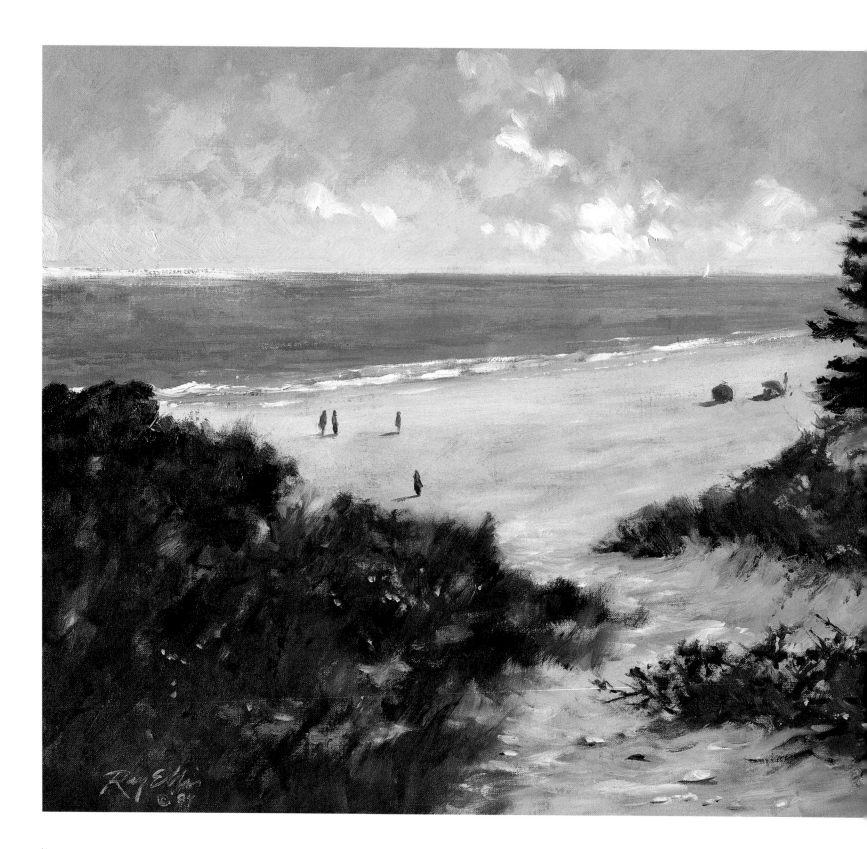

Some of the most dramatic dunes are found on the farthest reaches of Long Island. I used figures to illustrate the striking proportions of these dunes at Montauk.
Montauk Dunes, *1984. Oil, 20 x 30 in. (50.8 x 76.2 cm).*

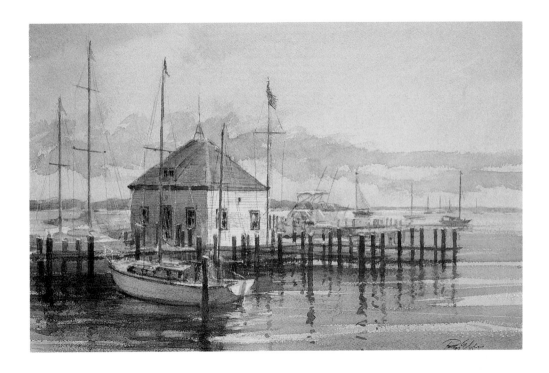

The hazy day I painted this watercolor was quite memorable. On the dock I met a seagoing dentist who invited me aboard to see how he had equipped his forty-foot cruiser with a dentist's chair and all the paraphernalia necessary to practice his profession.
Sag Harbor Yacht Club, *1984. Watercolor, 14 ½ x 22 in. (36.8 x 55.9 cm).*

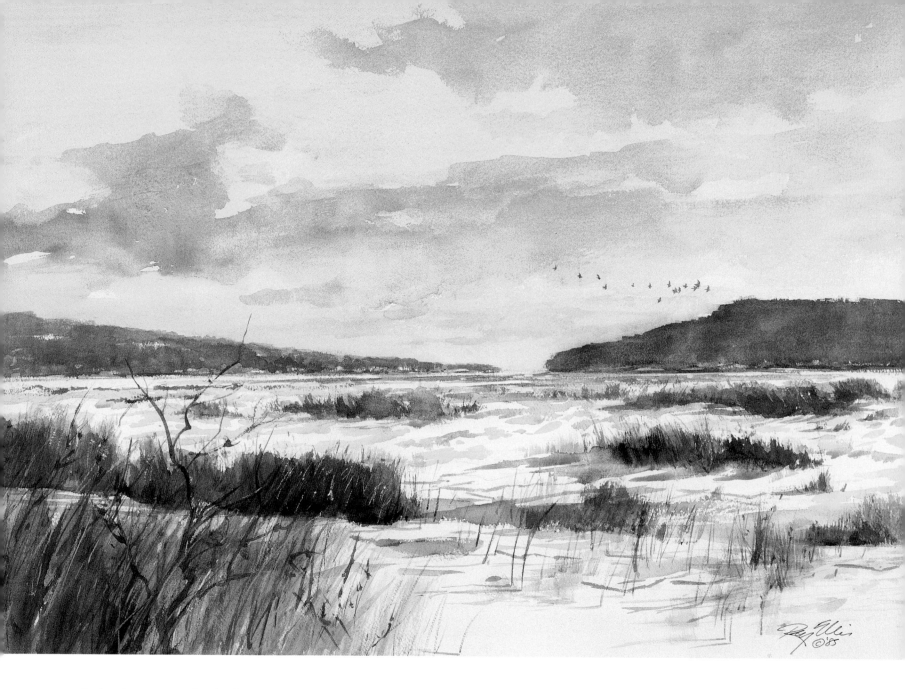

In the winter, snow and ice bank on the salt flats between Lloyd Neck and Oyster Bay on Long Island.
Many patterns in nature are formed to create a stark but beautiful landscape.
Winter . . . Lloyd Neck, *1985. Watercolor, 10 x 12 in. (25.4 x 30.5 cm).*

My wife and I happened on this scene in Sag Harbor, Long Island. As I was working on the finished painting in my studio, our tabby, Butterscotch, was asleep on the rug. I substituted him for the cat we had seen because he was so much more regal and handsome. Although he died several years ago, this painting reminds us of our great old warrior.

Napping, *1984. Watercolor, 15½ x 24 in. (39.4 x 61 cm).*

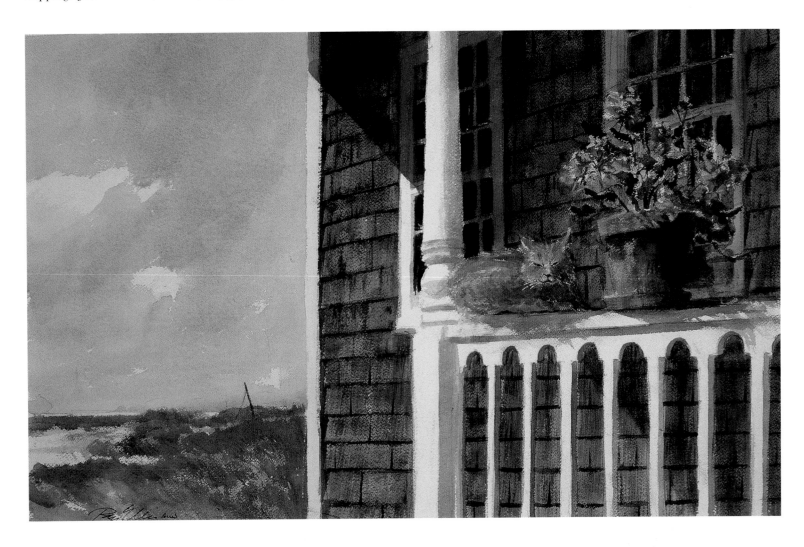

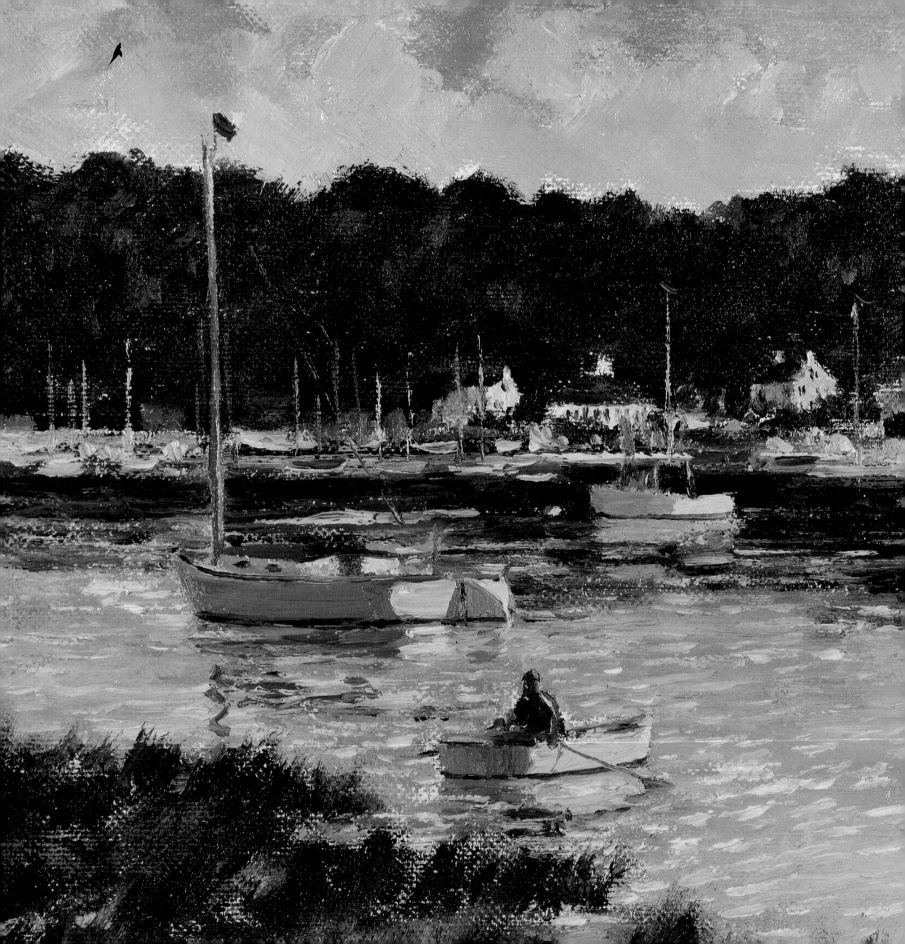

Most paintings of fog or mist have a monotone appearance
that gives them an eerie quality. Most of the buildings in
this picture are hardly defined, requiring the viewer to use
some imagination.
Mist at Eaton's Neck, 1985.
Watercolor, 10 x 12 in. (25.4 x 30.5 cm).

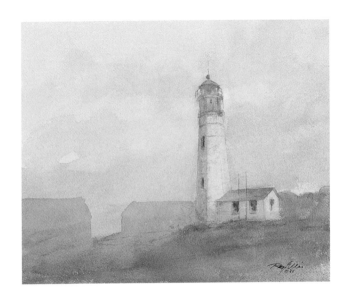

OPPOSITE:
I visited Cold Spring, Long Island, and its harbor many times
when my brother lived nearby. One fall day I sat on the banks
of the harbor and did this small oil.
Fall at Cold Spring, 1985.
Oil, 9 x 13 in. (22.9 x 33 cm).

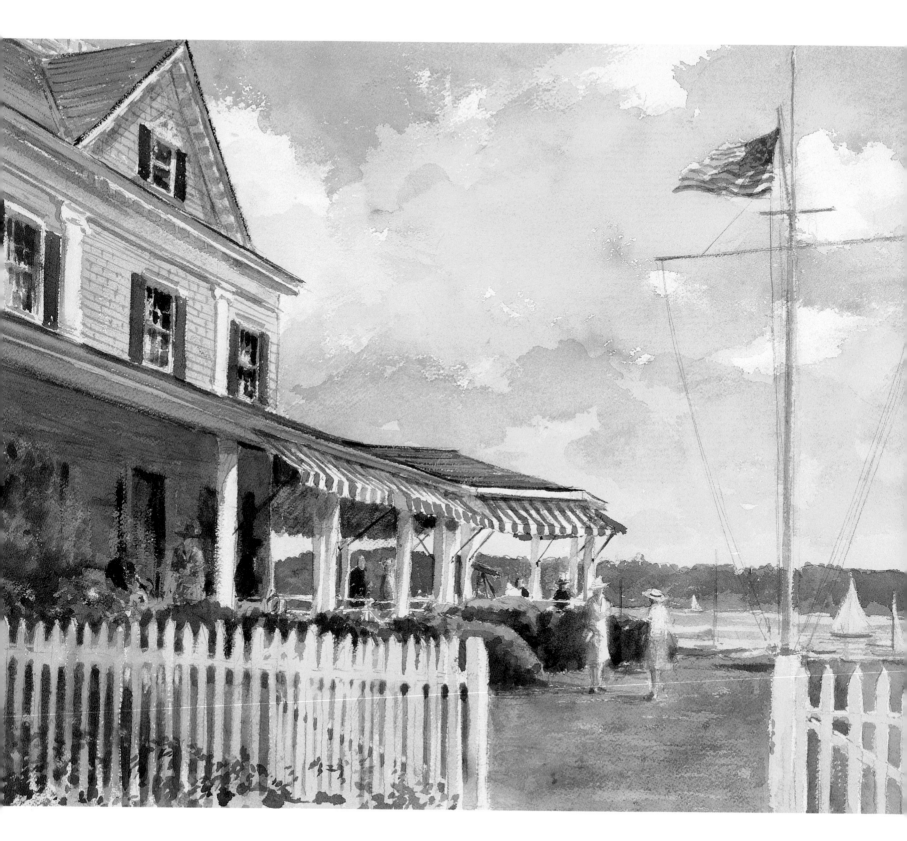

Opposite:

This is one of the picturesque, weathered yacht clubs on the north shore of Long Island. The patterns of the picket fence and the shadows of the sprawling veranda caught my eye.
Seawanhaka Yacht Club, *1985. Watercolor, 15½ x 24 in. (39.4 x 61 cm).*

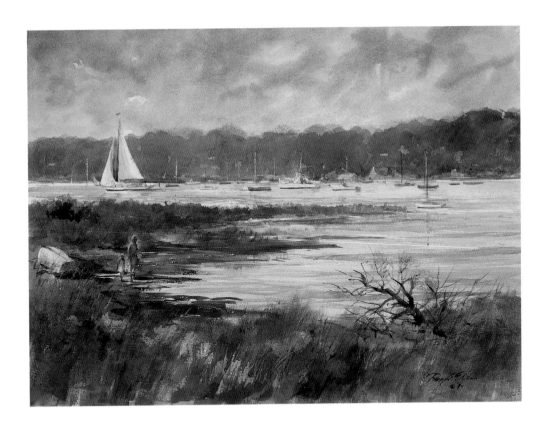

Along the shores beyond Huntington Harbor on Long Island are fine beds of mussels. I could always count on seeing someone gathering a basketful for supper.
Mussel Pickers, *1984. Watercolor, 22 x 29½ in. (55.9 x 74.9 cm).*

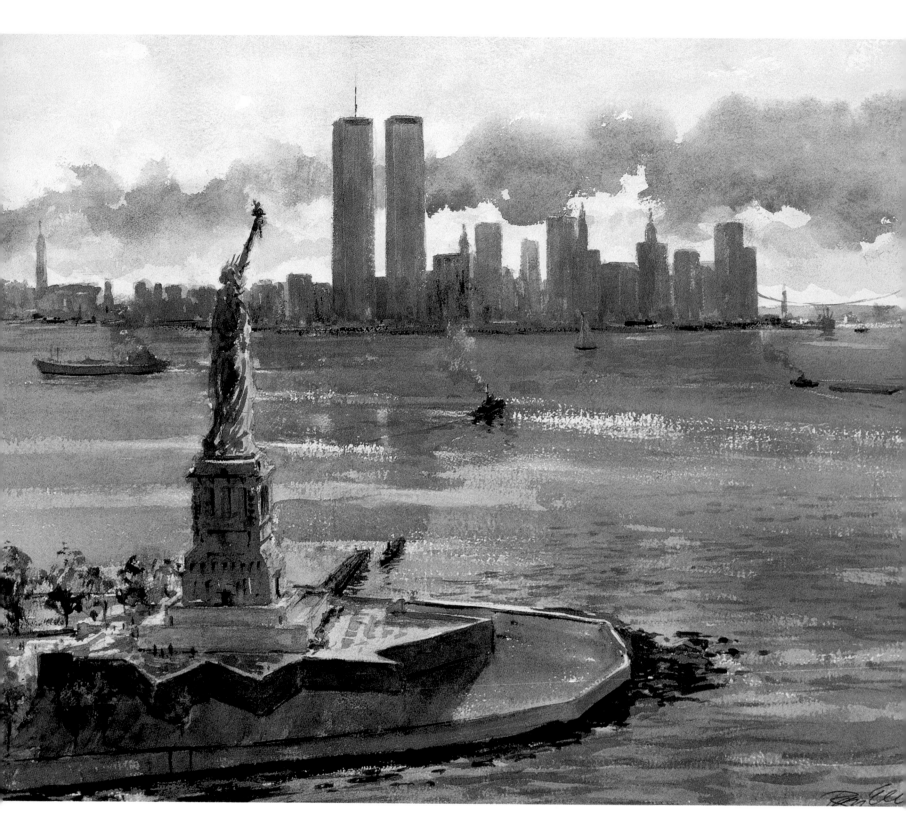

Back in the late forties I commuted from Philadelphia to New York, reaching Manhattan by ferry from Jersey City. Inspired by feelings of nostalgia, I decided to try to capture the excitement of the ferry dock where the light and shadows fascinated me.
Battery Ferry, *1985. Watercolor, 14 ½ x 24 in. (36.8 x 61 cm).*

Early one morning in 1984 I entered the Hudson River in my Bertram. The harbor was not nearly as busy as I remembered from forty years ago. Only a barge and a few pleasure craft were visible. Working from a sketch of the skyline, I added the Statue of Liberty in the foreground.
Miss Liberty, *1986. Watercolor, 19 x 29 in. (48.3 x 73.7 cm).*

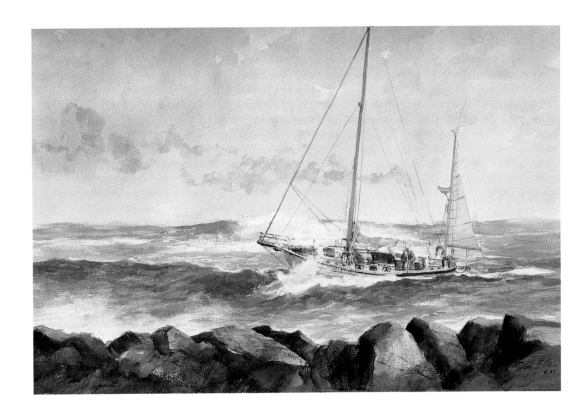

This watercolor was done from Walter Cronkite's description of the passage of his yawl Wyntje through the treacherous Absecon Inlet near Atlantic City, New Jersey, during an approaching hurricane. A press photographer recorded the event, which also helped me capture these frightening moments.

Through the Inlet, 1985. Watercolor, 26 x 39 in. (66 x 99.1 cm).

OPPOSITE:

Just after entering Townsends Inlet, New Jersey, there is a point of land with a fisherman's shack that has been there as long as I can remember. I did this painting—at low tide—in 1970.

On the Inlet, 1970. Watercolor, 21 x 29 in. (53.3 x 73.7 cm).

The veranda of the old Chalfont Hotel in Cape May, New Jersey, was a wonderful subject to paint, especially at twilight. The rocking chairs were empty because all the guests were at supper.

Suppertime, 1984. Watercolor, 25 x 33½ in. (63.5 x 85.1 cm).

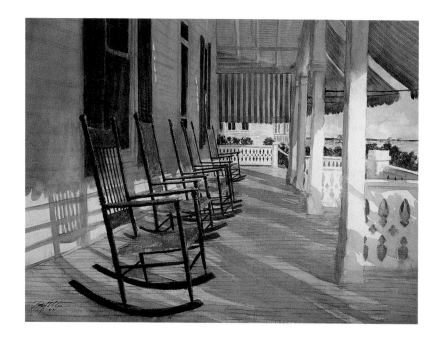

My family spent many summers at our home on the beach at Avalon, New Jersey. I painted this scene of my wife and four young children often.

First Dip, 1997.
Oil, 30 x 40 in. (76.2 x 101.6 cm).

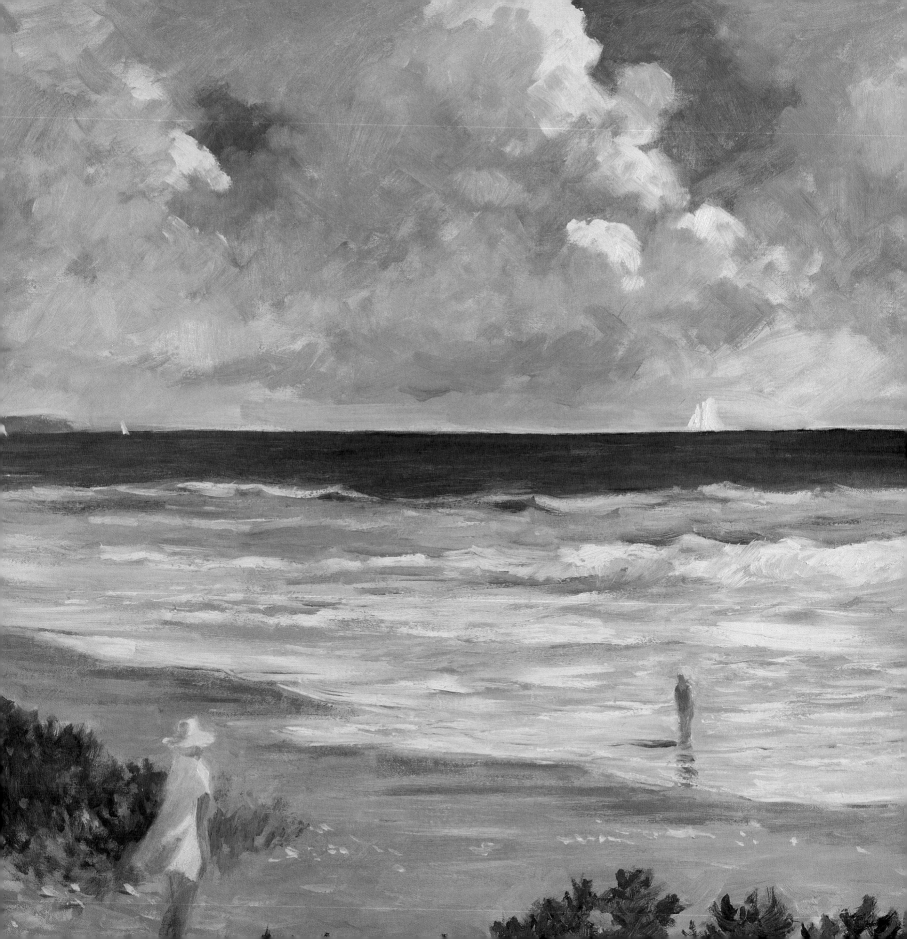

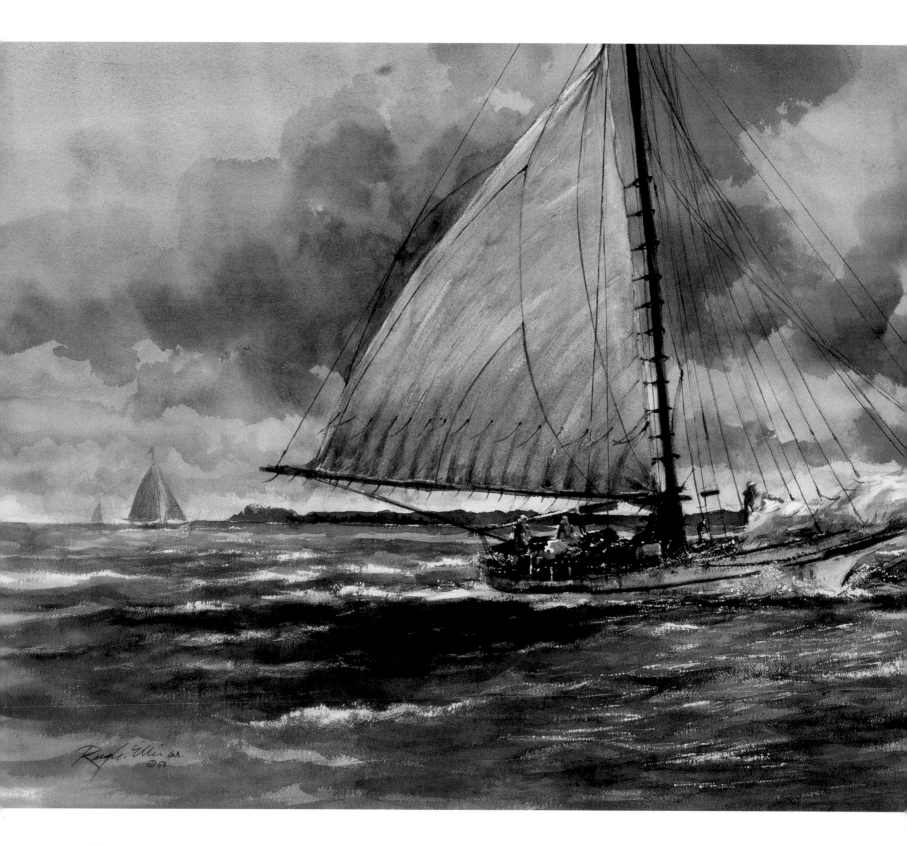

When I was cruising around the Chesapeake right after the Second World War there were many of these sleek-looking craft in the oyster fleet. They have always been among my favorite boats. Here the sailors are dropping the jib in a squall.

Skipjack Through a Squall, *1983. Watercolor, 24 ¼ x 38 in. (61.5 x 96.5 cm).*

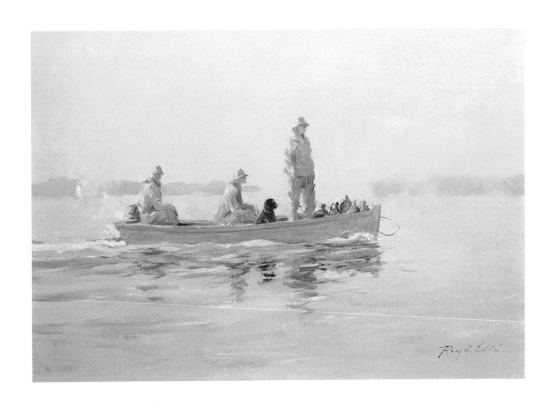

During a duck-hunting trip on Maryland's eastern shore, this early morning scene really captured my interest. The hunters, the black Lab, and even the decoys—or so it seemed—waited in anticipation.

To the Blind, *1979. Oil, 20 x 30 in. (50.8 x 76.2 cm).*

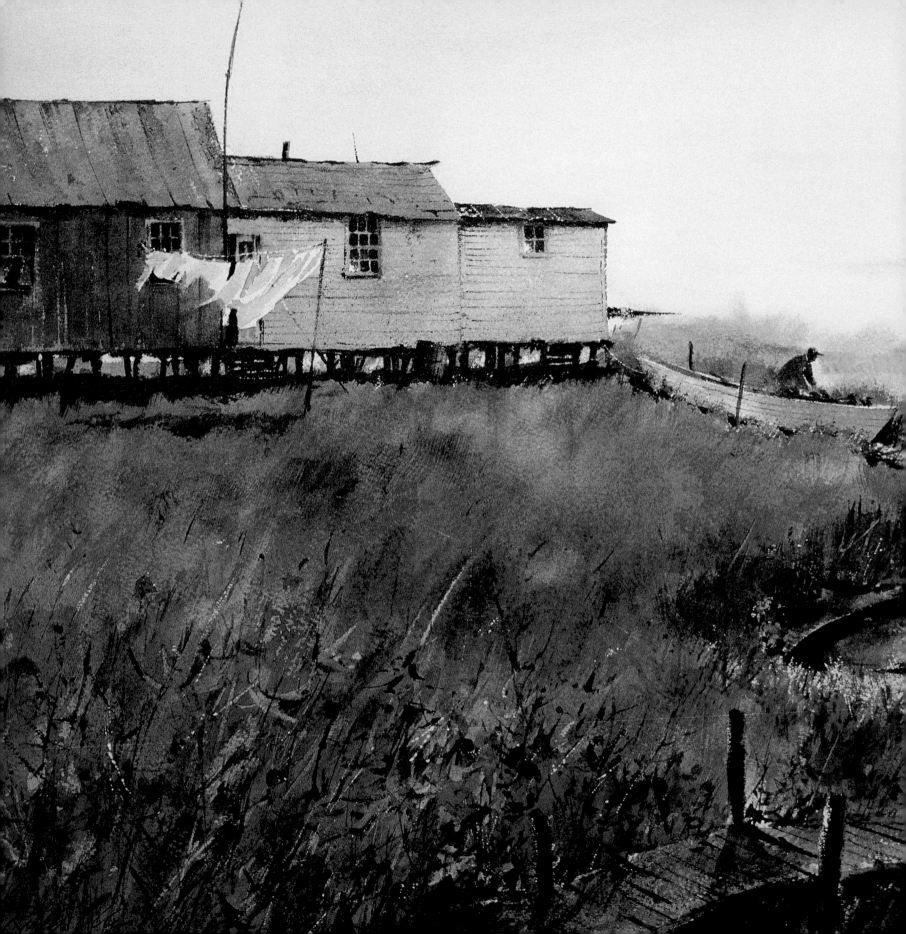

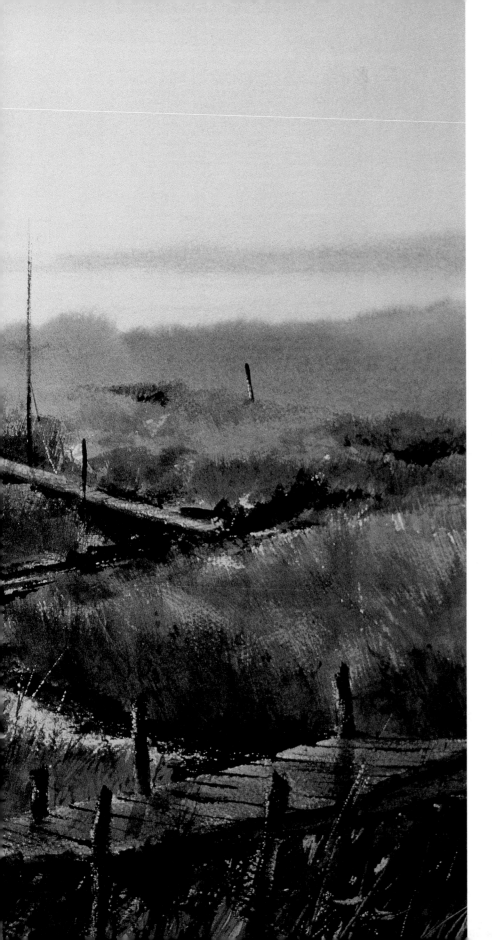

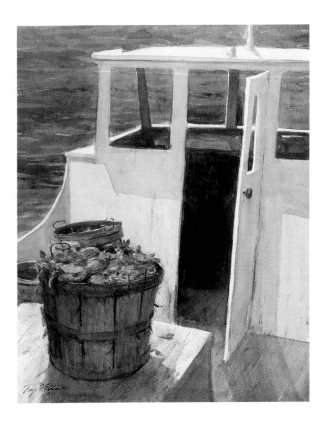

Crisfield, Maryland, has been called the blue crab capital of
the world, and perhaps it is. The contrasting values and
abstract shapes in this composition—blue crabs in a basket
on the deck of a crab boat—fascinated me.
Bushel of Blues, 1982.
Watercolor, 24 ½ x 20 in. (62.2 x 50.8 cm).

This scene could probably be encountered anywhere from
Cape May to Florida. In fact, it is on the eastern shore of
Maryland. I made the painting on a sketching trip with my
old artist friend Ranulph Bye back in the early 1970s.
Benny's Landing, 1973.
Watercolor, 18 x 29 in. (45.7 x 73.7 cm).

Many shrimpers put their boats on a mud bank in the marsh during the off season. When the tide is out they work on the bottom of the hull and do other repairs. I thought the long white hull against the dark foliage and faded marsh grass was a great subject.

Off Season, 1976. Watercolor, 18 x 29 in. (45.7 x 73.7 cm).

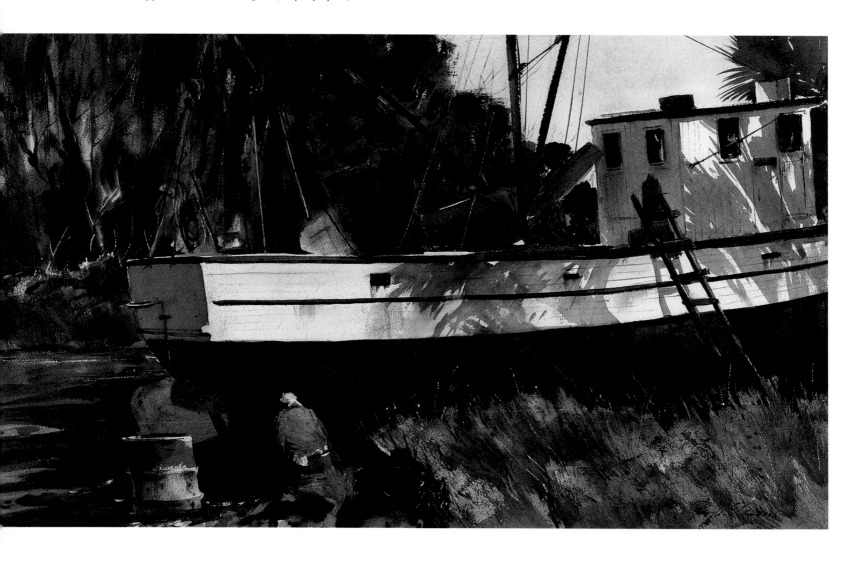

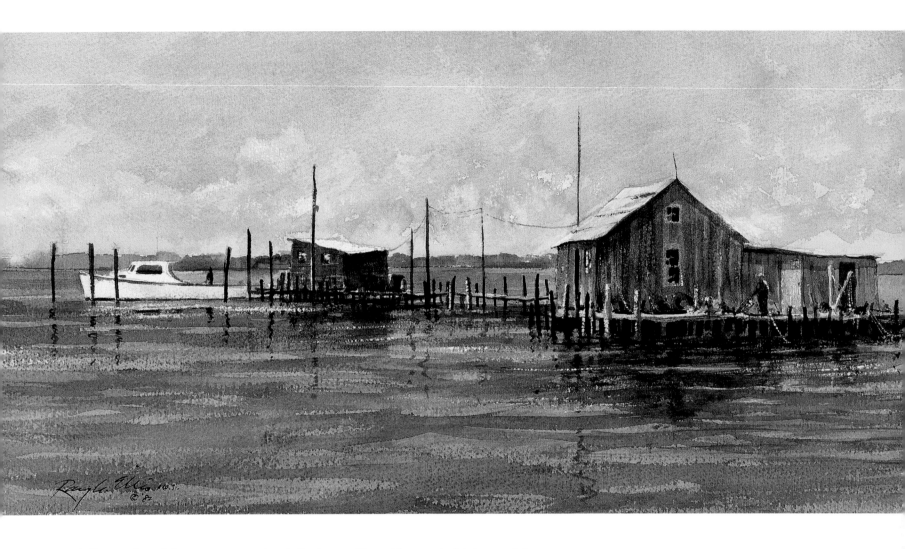

A Chesapeake crab boat possesses a unique hull—long and low with a wonderful sheer, and the docks that the boats tie up to are dotted with different-sized shacks. It was this long, narrow composition that attracted me.

Crab Docks, *1982. Watercolor, 12 x 21½ in. (30.5 x 54.6 cm).*

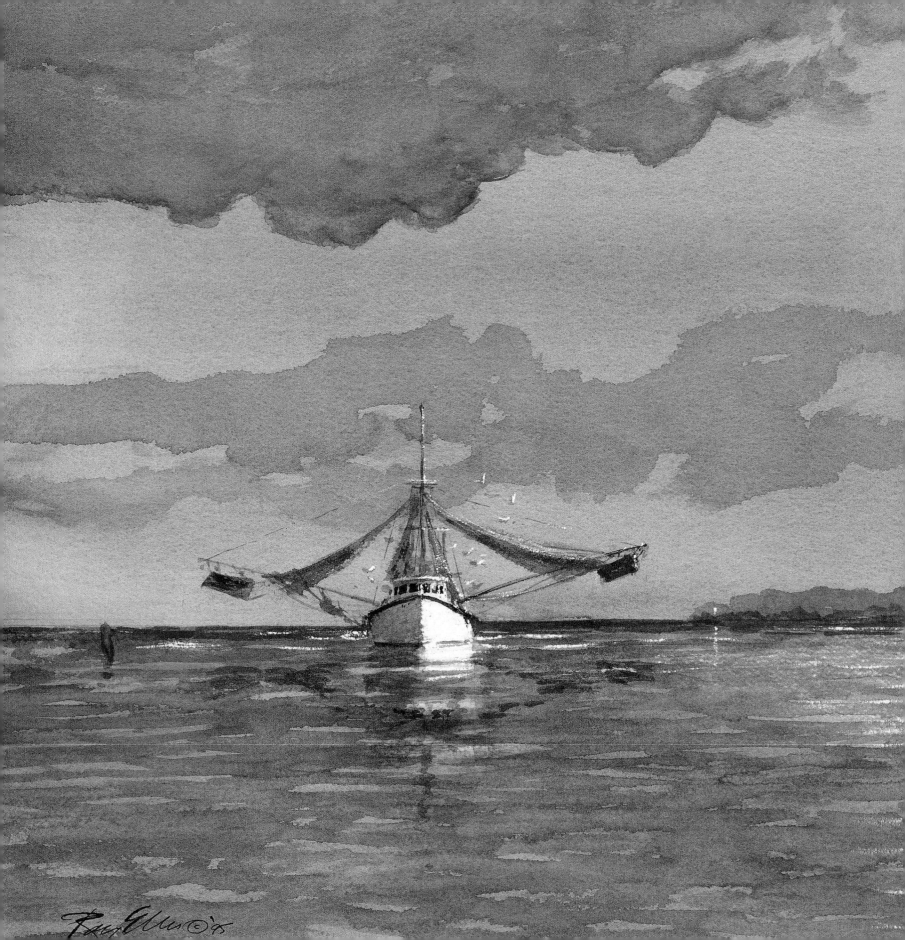

Shrimp boats leave early in the morning and often return when the moon rises. Here a full moon lights up the hull of a lone shrimper as she heads for port.

Moonlight Return, *1996. Watercolor, 15¼ x 20½ in. (38.7 x 52.1 cm).*

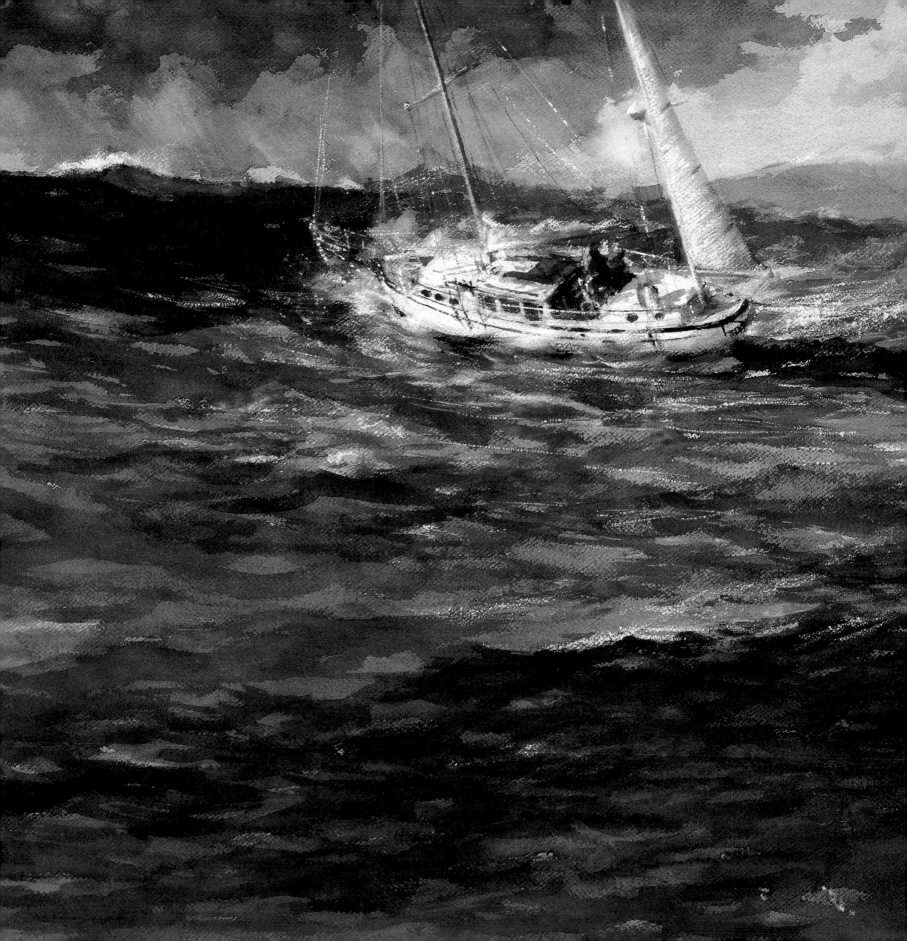

Barrier Islands and Pirates

North Carolina to Georgia

Cape Hatteras and the Outer Banks, in North Carolina, are names early mariners whispered under their breaths, names that conjured up images of shipwrecks, pirates, and lost colonies.

The first European to navigate these treacherous shifting shoals was Giovanni da Verrazano, an Italian explorer sailing in 1524 under the flag of France. But it was the British who, thirty-three years later, established the first colony on Roanoke Island. As the colony ran low on supplies, the settlers' leader, John White, was forced back to England, leaving 116 colonists behind. When White returned three years later the settlement was in ruins and no trace was ever found of its inhabitants.

It was here too on Roanoke Island that the infamous pirate Blackbeard met his end from wounds sustained in a bloody fight. His head was carried away on the bowsprit of his assassin's ship.

Although surf fishermen love the waters off the Outer Banks for their striped bass, bluefish, and flounder, sailors don't. More than two thousand ships, including the famous Civil War ironclad the *Monitor*, have vanished off Cape Hatteras, which is known as the "graveyard of the Atlantic."

During the times I sailed with Walter Cronkite while doing our books of the coasts, we encountered a few serious storms. He didn't always sail in them, but when he did, it made for exciting paintings.
Passing Storm, 1982.
Watercolor, 21 x 28½ in. (53.3 x 72.4 cm).

Behind the Outer Banks lie Albermarle and Pamlico Sounds. When the wind is blowing in the right direction these waters can build up a mean sea, challenging the best of sailors and forcing them to find a protective lee. At the southern end of Pamlico Sound is Cape Lookout. An unmanned lighthouse rests on a narrow ribbon of sand. Wild horses, family cemeteries, and abandoned buildings speak of other times.

The present centers for human activity in this area are the twin cities of Beaufort and Morehead City. Beaufort is sometimes referred to as a "colonial jewel" for its pre-Revolutionary houses. Morehead City is a mecca for fishing and scalloping.

Some two hundred miles down the coast in South Carolina, is Charleston, where a walk through its streets is a journey into the past. Had it not been for the Civil War, some people believe, Charleston would not be the charming historic city it is today. In the wake of the war, Charlestonians could not afford to build new homes; instead they remodeled, and the result of that renovation is a beautiful collection of Georgian houses as well as many dating from even earlier periods.

Along the coast of South Carolina lies the Intracoastal Waterway, a maze of islands, inlets, rivers, and bays—more water than land. In places the area resembles unspoiled wilderness. Mud flats exposed at low tide teem with waterfowl. Reeds wave in the wind above salt marshes. Winding rivers create lonely stretches along which the explosive wings of a startled cormorant at sunset can send a shiver up one's spine. Spanish moss hangs from tall oak trees that resemble haunting giants. In bygone years, this was a place of pirates, blockade runners, and rum runners. Today those earlier fugitives have been replaced by participants in the drug trade. The few permanent human inhabitants of this watery world earn a living by harvesting reeds, shrimp, and oysters, and as guides to duck hunters.

Nestled in this lush greenery is the beautiful city of Beaufort, or "Bewfort," as its residents call it. The town is known for its handsome mansions with wide verandas and for the sweet smell of flowers that permeates the air.

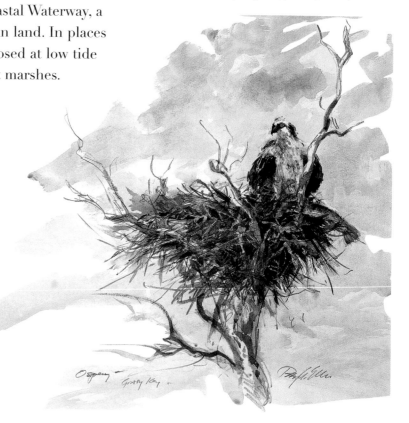

During the time I painted in and around the Cape May, New Jersey, area, I did many studies of osprey and their nests. These wonderful "fishermen" and their rugged nests have always fascinated me.
Osprey, *1982.*
Watercolor, 17 x 19 in. (43.2 x 48.3 cm).

Closer to the open sea to the south is Port Royal, a French settlement established in 1562. Still farther south is Hilton Head, a posh resort area with well-manicured golf courses and the finest marina along the Inland Waterway. Hilton Head is an oasis of human activity in the seemingly endless expanses of the Low Country. A short distance away from Hilton Head lie marshlands that seem to stretch forever into the horizon with not a hill in sight. Streams that meander in long sinuous curves appear to have lost their way on their leisurely journey to the sea. This was the landscape that inspired Johnny Mercer's "Moon River."

Solitary fishermen cast their nets into a river's amber water. They catch their evening meal of shrimp, which they cook on open bonfires as smoke spirals upward through the canopy of trees on small forested islands within the marshes. It is easy to believe that you are alone in this Garden of Eden— until the blare of a ship's horn shatters that notion. You have heard the sound of a large cargo vessel gliding upstream toward the magical city of Savannah, Georgia.

Spared the torches of General Sherman's drive to the sea during the Civil War, which cut the Confederacy in two and ended its attempt to separate from the Union, Savannah's historic district is the largest of its kind in America. There are more than one thousand preserved structures here.

In Savannah you can stroll down Bull Street and see attractive brick-walled gardens, symmetrical squares, antebellum mansions, and churches. You may see a profusion of azaleas, and you may inhale the sweet scent of jasmine.

Returning to the coast, a voyager passes fields carpeted in daffodils and cotton. At the shore's edge are white sandy beaches. There is a network of islands, including Blackbeard Island—where legend has the famous pirate burying his stolen treasure—and Jekyll Island, where Rockefeller, J. P. Morgan, and the Vanderbilts poured their treasure into magnificent "cottages" that most of us would call mansions.

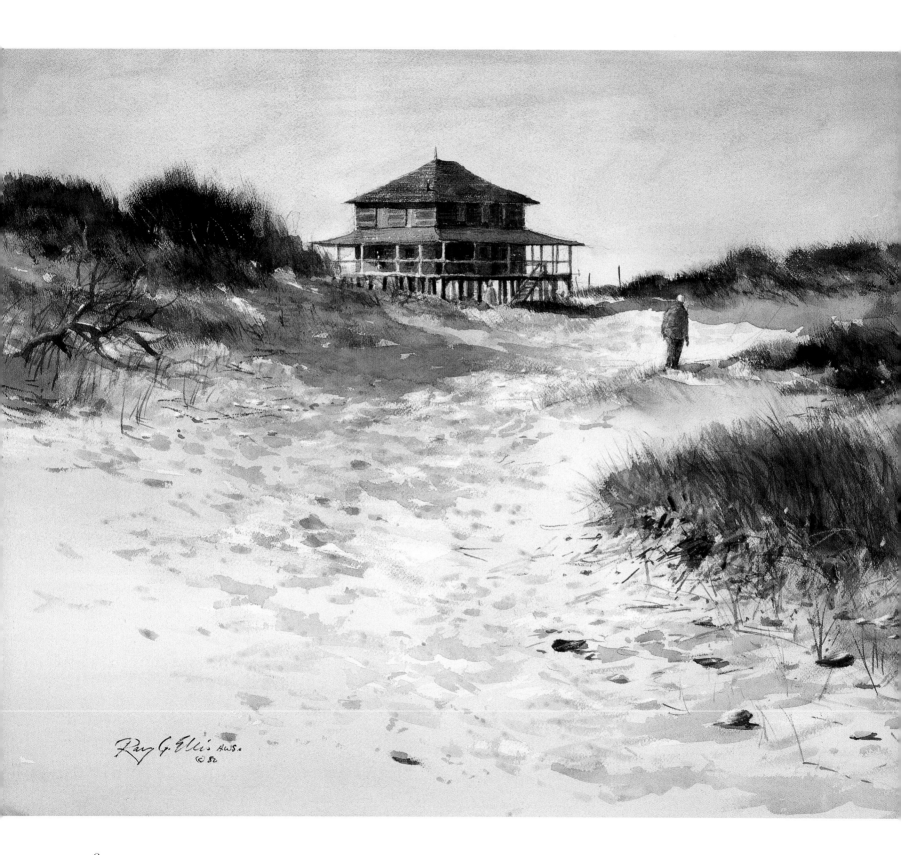

Ray G. Ellis AWS.
© 82

Closing up the summer place always creates a feeling of nostalgia. Beach people up and down the coasts can relate to this painting— the actual house was located at Nag's Head on the Outer Banks.
End of the Season, *1982.*
Watercolor, 22½ x 37 in. (57.2 x 94 cm).

This morning scene on the beach at Nag's Head in North Carolina, with fishermen in their waders and with mist and sea spray ghosting their figures, called for an impressionistic treatment.
Surf Fishermen, *1982.*
Oil, 8 x 10 in. (20.3 x 25.4 cm).

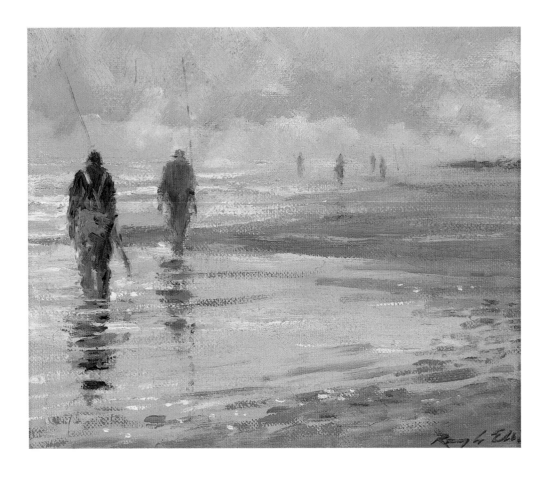

This is typical of the type of general store one might find in many areas along the intracoastal waterway. They handle bait, fishing equipment, dry goods, ice, . . . you name it, and the American flag is always flying out front.

Cecil Payne's Bait Shop, *1982. Watercolor, 16 x 29 in. (40.6 x 73.7 cm).*

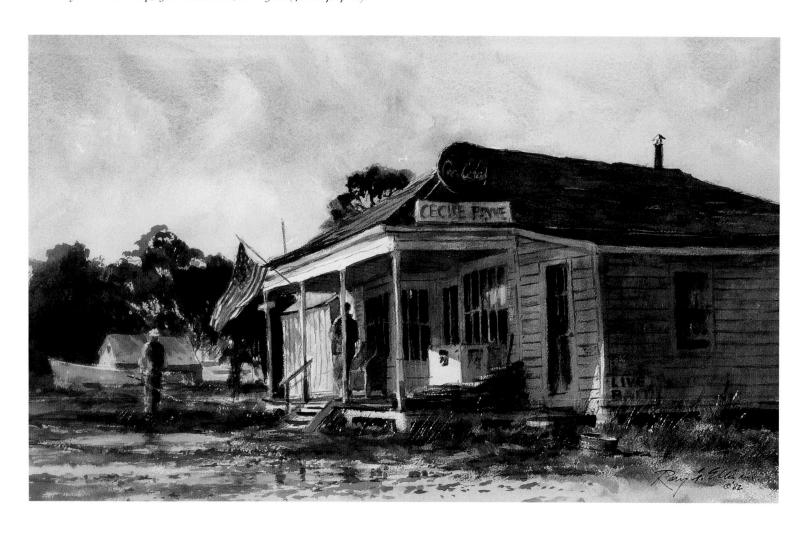

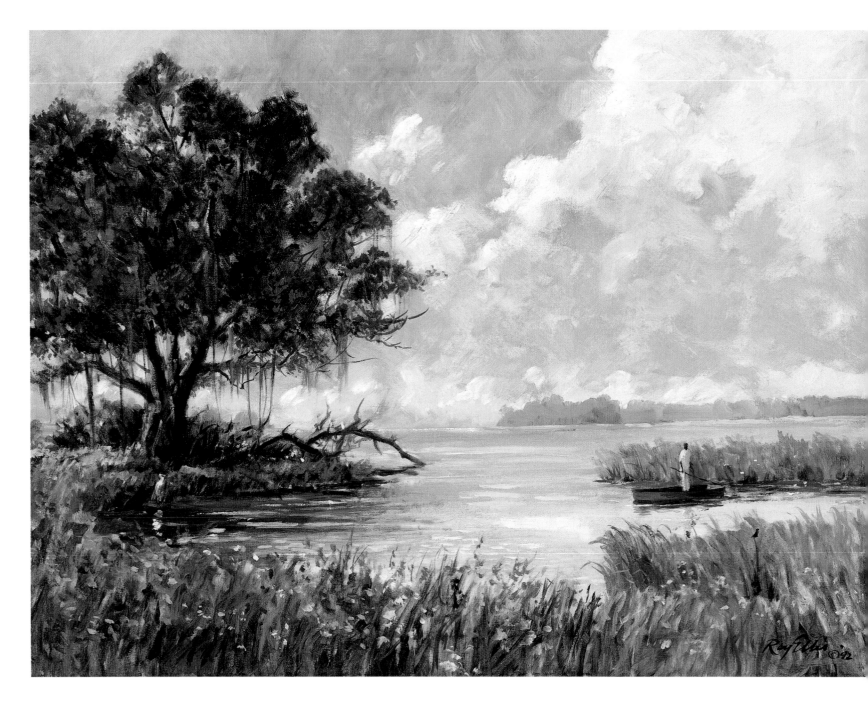

Not everyone gets off the beaten track to observe the sight of a quiet morning on the interiors of the marsh. Off the hummocks that rise above the marsh, one can often see an isolated oysterman or shrimper in his bateau.

Low Country Morning, *1992. Oil, 23 x 31 in. (58.4 x 78.7 cm).*

Pawley's Island has been a family retreat for many years. The place is so laid back that it is known for its hammocks. A favorite pastime for residents is hunting for shells at low tide.
Gathering Shells, *1996. Watercolor, 11¼ x 19½ in. (28.6 x 49.5 cm).*

Bleached oyster shells that have been shucked and discarded on the banks of the many tributaries along the waterways have created huge mounds over the years.
Shellbank, *1996. Watercolor, 12¾ x 38¾ in. (32.4 x 98.4 cm).*

Live oaks, draped with Spanish moss,
surround this remote spot on the Waccamaw
River near Myrtle Beach, South Carolina.
Fishing the Waccamaw, *1996.*
Watercolor, 12 x 19¼ in. (30.5 x 48.9 cm).

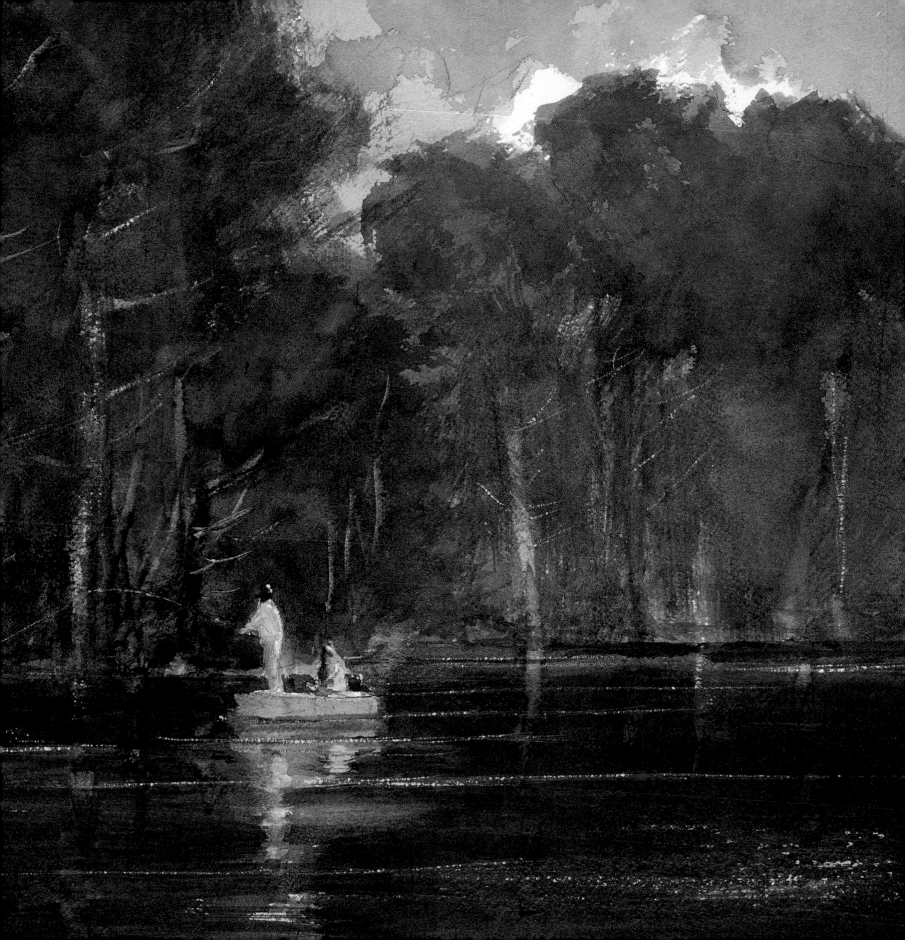

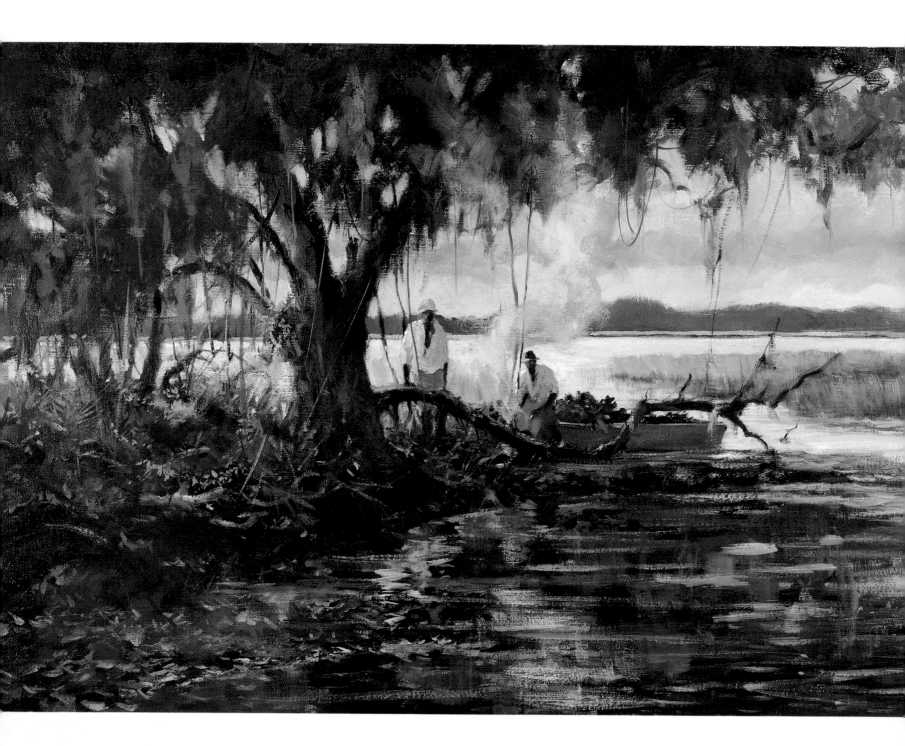

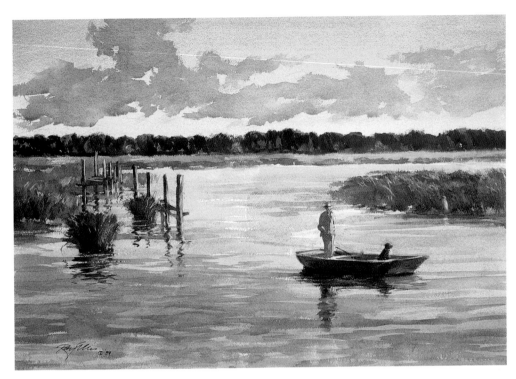

There are thousands of miles of waterways winding through the marshes and tidal creeks on the southeast coast. I never tire of painting these secluded areas as well as their abundant wildlife.
Drifting Along the Marsh, *1989. Watercolor, 18 x 26 in. (45.7 x 66 cm).*

In my years of exploring the waterways of South Carolina and Georgia, scenes like this were among my favorites. I would often see secluded spots on the marshes where oystermen had hauled up their filled bateaux to take a respite and sample their catch.
Roastin' Oysters, *1980. Oil, 24 x 36 in. (61 x 91.4 cm).*

On the marshes along the coast, these birds
can be seen perched on bending reeds of
marsh grass. The red markings on the wings
are visible at quite a distance.
Redwing Blackbird, *1996.*
Oil, *12 x 18 in. (30.5 x 45.7 cm).*

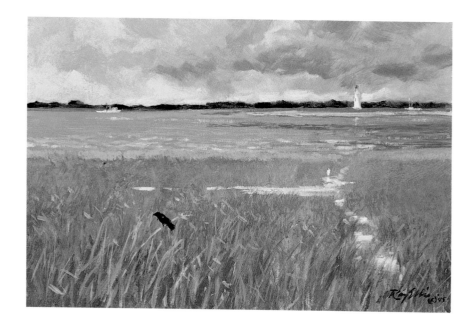

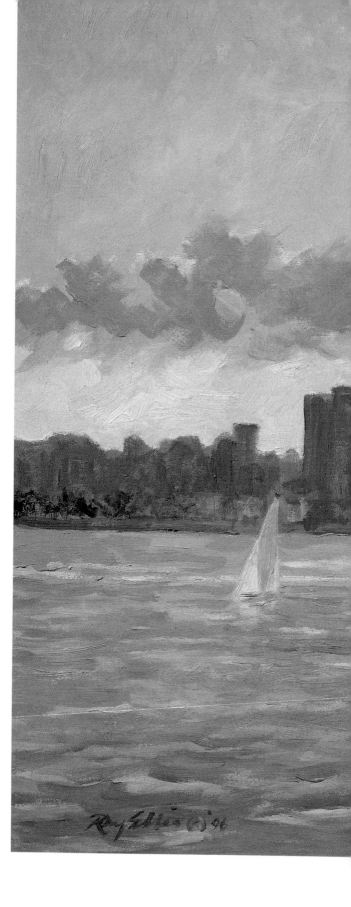

This Aegis-class destroyer was commissioned
at the Charleston Naval Station in 1995. I was
then asked to paint her in Charleston Harbor.
While she is a handsome ship, she looks totally
different from sailing vessels commonplace to
the harbor 130 years ago.
USS Paul Hamilton, *1996.*
Oil, *24 x 36 in. (61 x 91.4 cm).*

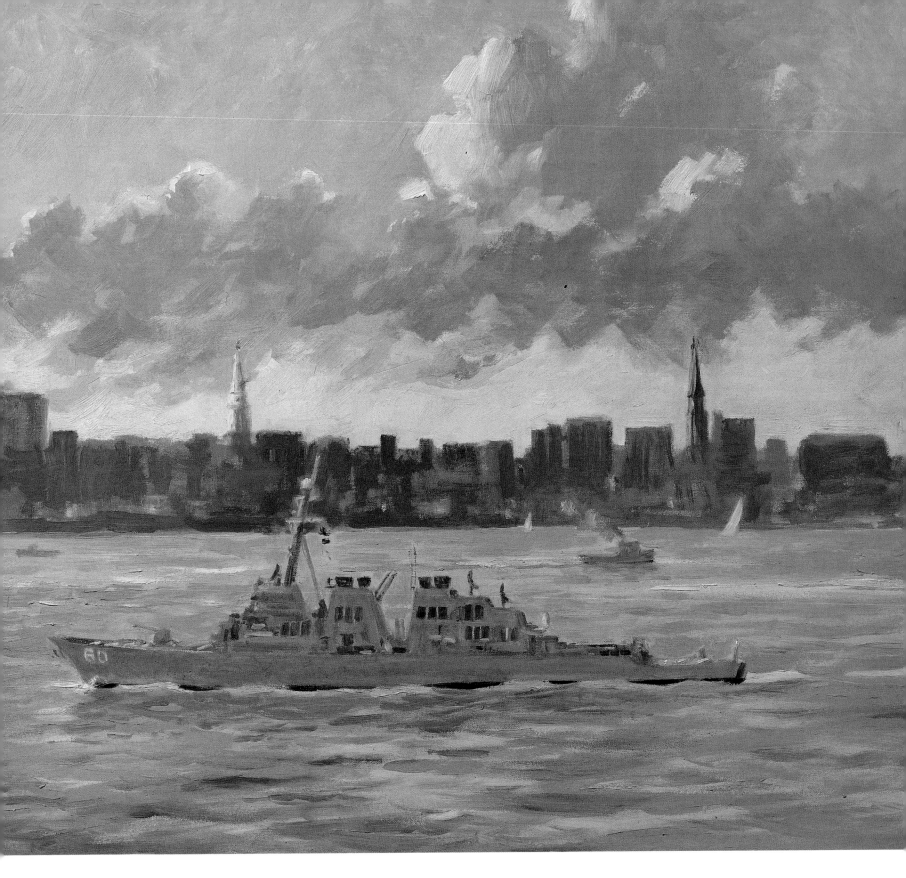

When small boaters see that a heavy squall is approaching, they usually head for shelter. Squalls can be strong enough to knock a boat over but despite the danger there is an excitement and beauty in storms. The gray-green spray, the bending palms—I had to paint this one.
Squall, 1996. Oil, 20 x 30 in. (50.8 x 76.2 cm).

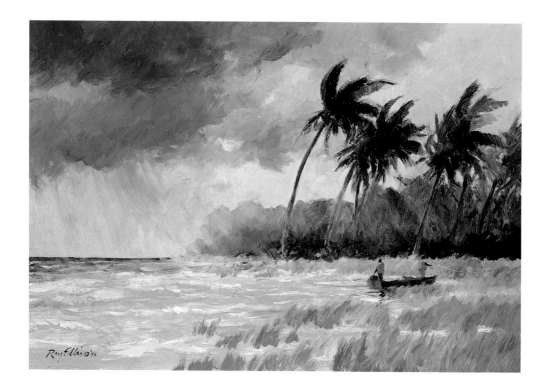

Basket weaving is a trade that goes back centuries in the Low Country. Although women have traditionally done this craft, it is generally the men who venture out into the marshes in their bateaux to gather the reed-like grass used to make the baskets.
Ferrying Hay, 1996.
Oil, 24 x 36 in. (61 x 91.4 cm).

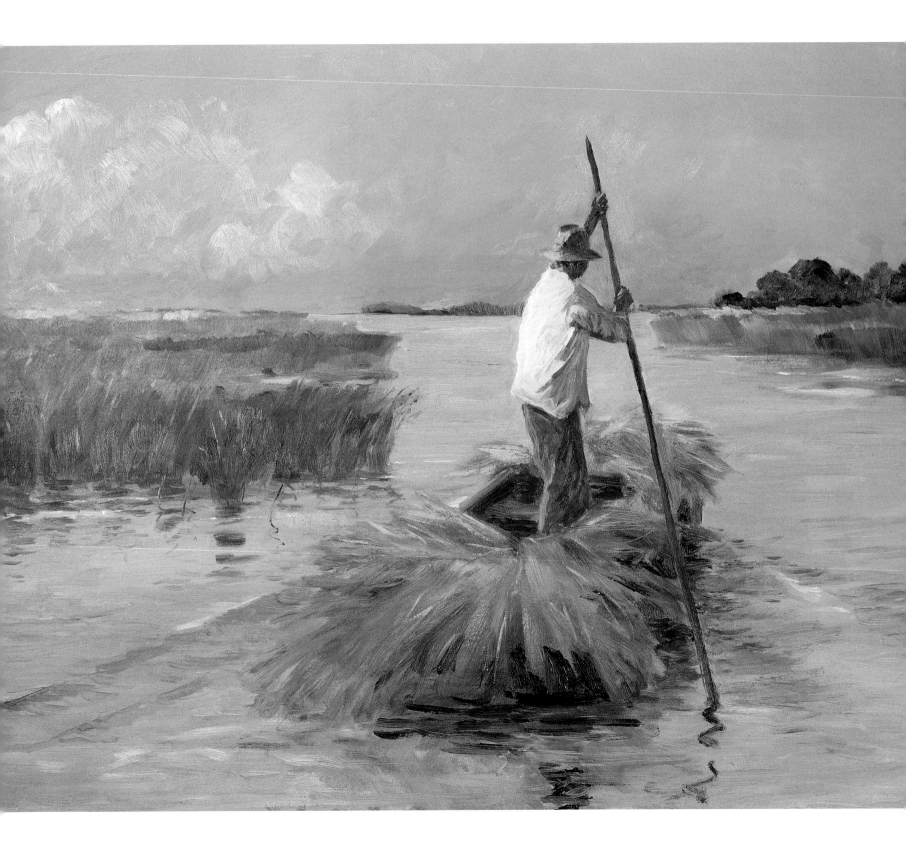

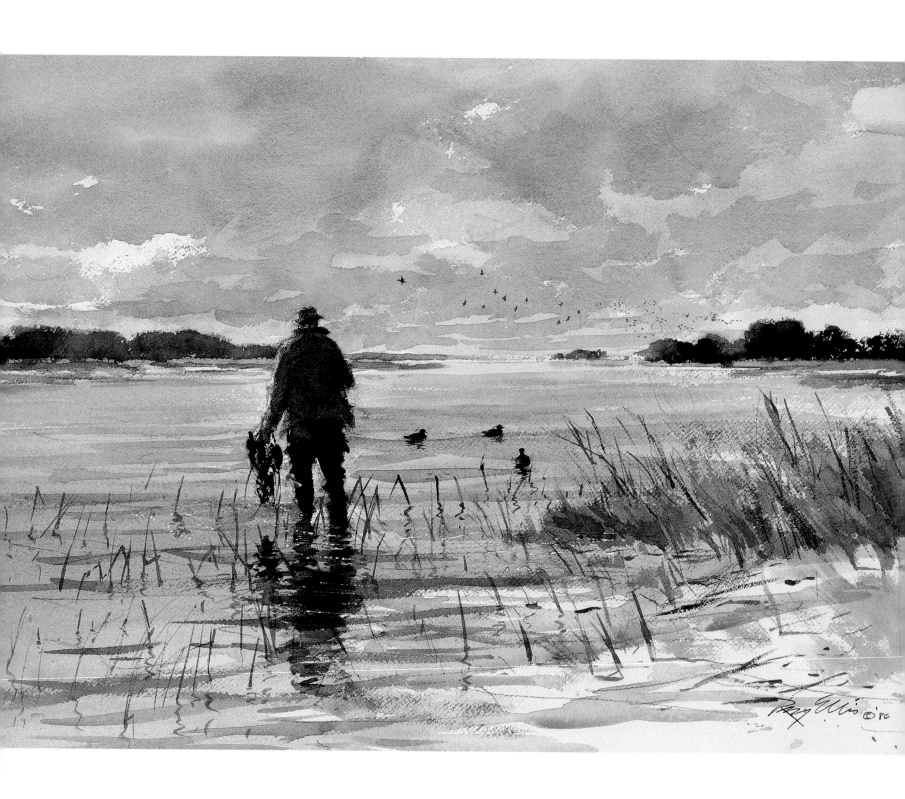

BARRIER ISLANDS AND PIRATES

Yes, it does get cold in Georgia. I love to paint such winter scenes as this one with a hunter setting
decoys early on a raw morning.
Winter Morning (Duck Hunter), *1986. Watercolor, 16 x 22 in. (40.6 x 55.9 cm)*

One always has to be on the alert for oncoming barges while traveling the Intracoastal Waterway.
Some of the larger vessels don't leave much room to pass. I tried to depict that feeling in this painting.
Barge Around the Bend, *1982. Watercolor, 20½ x 36 in. (52.1 x 91.4 cm).*

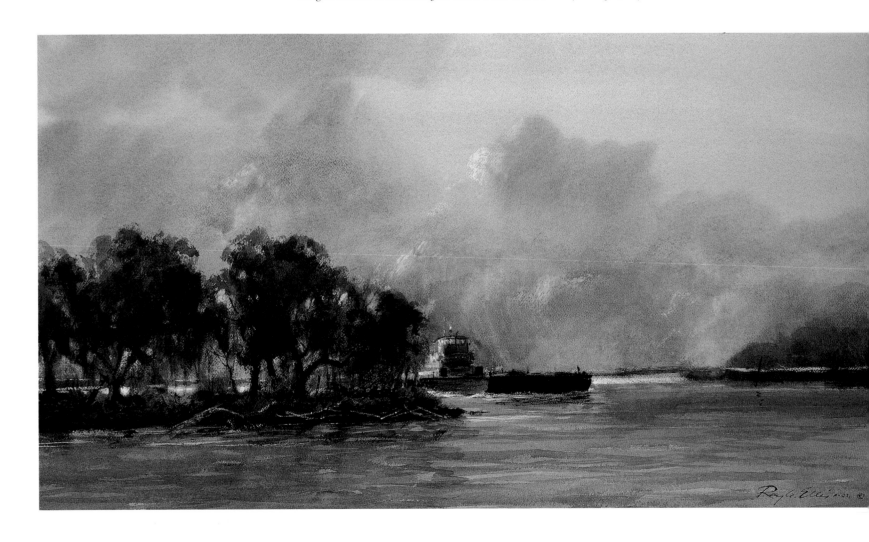

I suppose the main reason I painted this oil was the rich contrast between the dark green foliage and the bleached white oyster shells on the mud flats. I think adding the reflections of the figures and the upward-coiling smoke make this painting an especially good subject.
Casting for Shrimp, *1992. Oil, 24 x 36 in. (61 x 91.4 cm).*

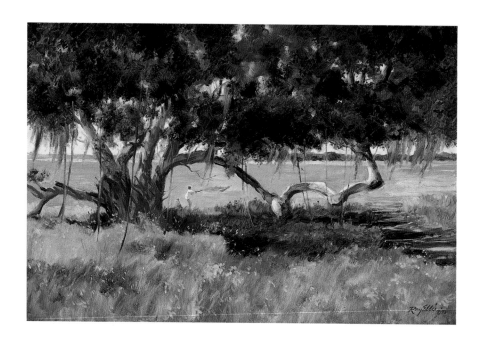

The live oak is my favorite Southern tree. These majestic giants, with Spanish moss usually dripping from their twisted, long branches, are seen everywhere from the banks of rivers to urban parks to rural farmlands. This was my idea of the quintessential live oak.
The Live Oak, *1993. Oil, 24 x 36 in. (61 x 91.4 cm).*

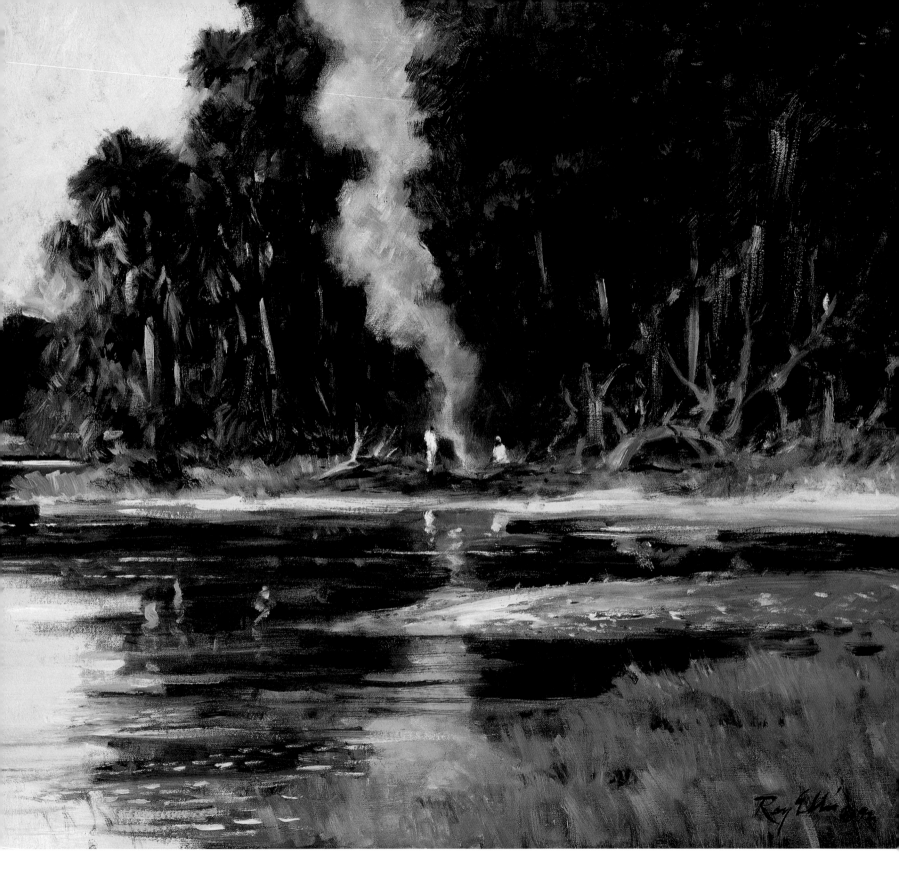

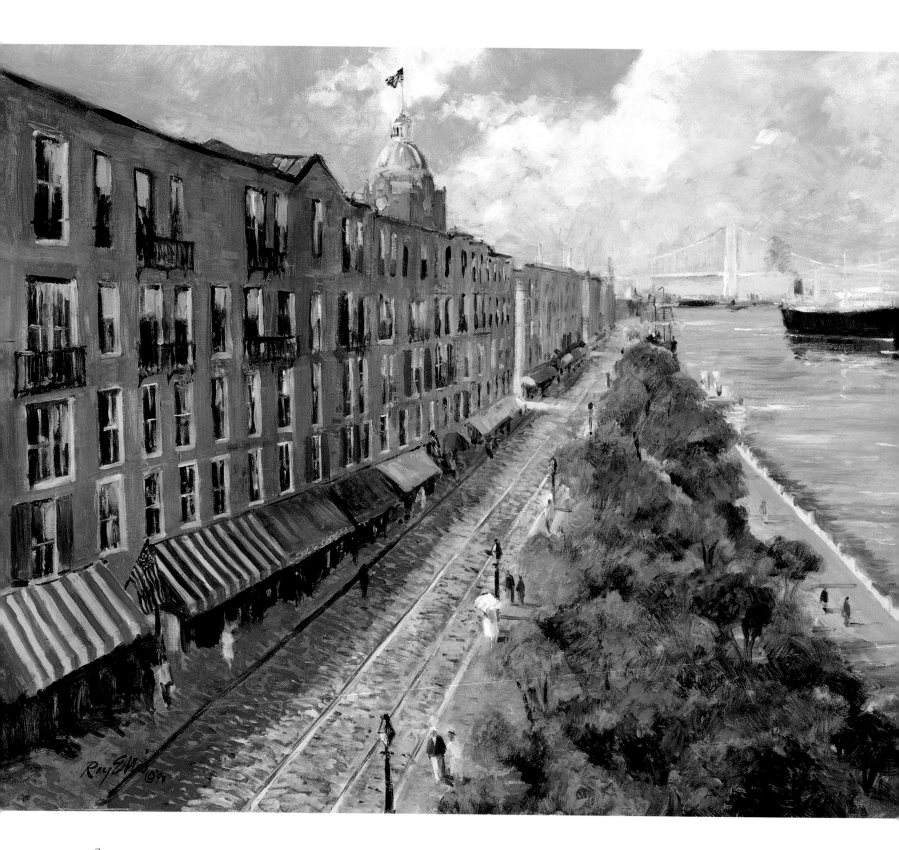

Savannah is one of the busiest ports on the east coast even though it is about twelve miles (19.3 km) upriver from the sea. At twilight the lanterns on River Street come on, and the last rays of sun filter between the old buildings. Freighters such as this one make their way up the narrow channel. Savannah Riverfront, 1993. Oil, 24 x 36 in. (61 x 91.4 cm).

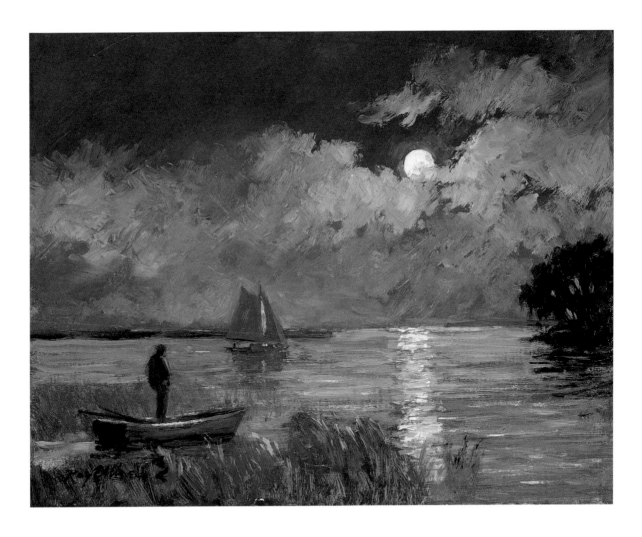

Johnny Mercer's famous song inspired my series of paintings depicting the moonlight on the now legendary Moon River.
Moon River Series VII, 1994. Oil, 11 x 14 in. (27.9 x 35.6 cm).

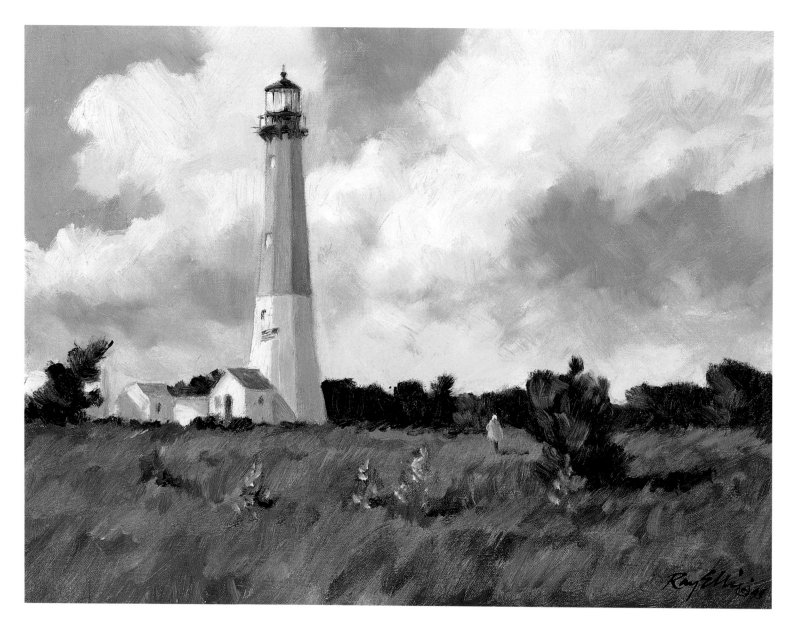

*While living in Savannah, we would often go out to nearby Tybee Island at twilight and walk along
the beach to the lighthouse. Tybee Light is one of the oldest and certainly one of the most picturesque
lighthouses in the South.*

Twilight at Tybee, 1995. Oil, 12 x 16 in. (30.5 x 40.6 cm).

Shrimp boats generally work quite close to shore in calm waters, but they do occasionally get caught in some pretty nasty weather. I have passed them moving through rough seas with their decks awash. People often ask how I can keep my easel steady while I put brush to canvas. Obviously much of the work is done in my studio from memory, sketches, and a vivid imagination.

Shrimper Offshore, 1982. Watercolor, 19¾ x 27¾ in. (50.2 x 70.5 cm).

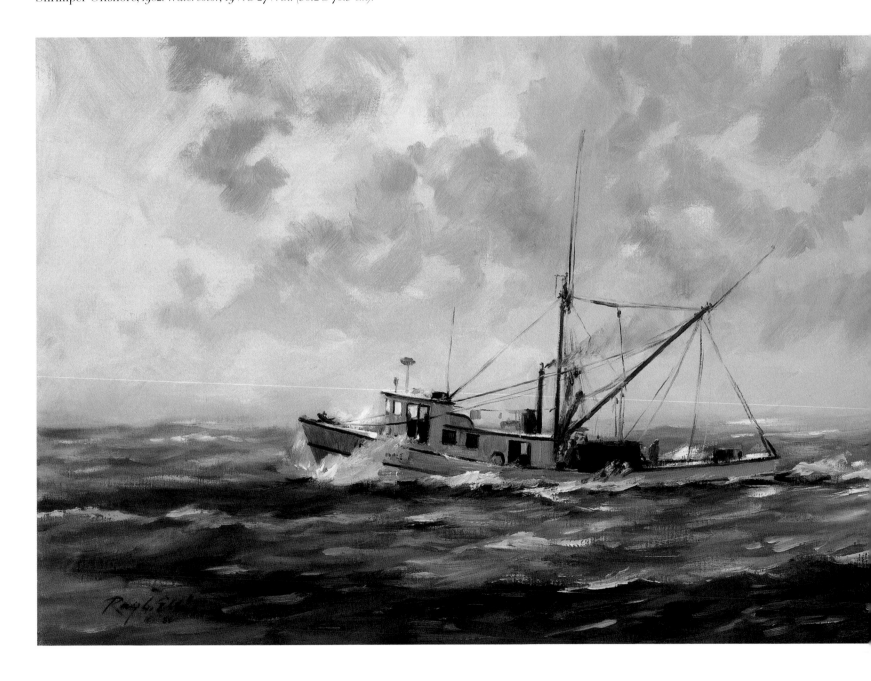

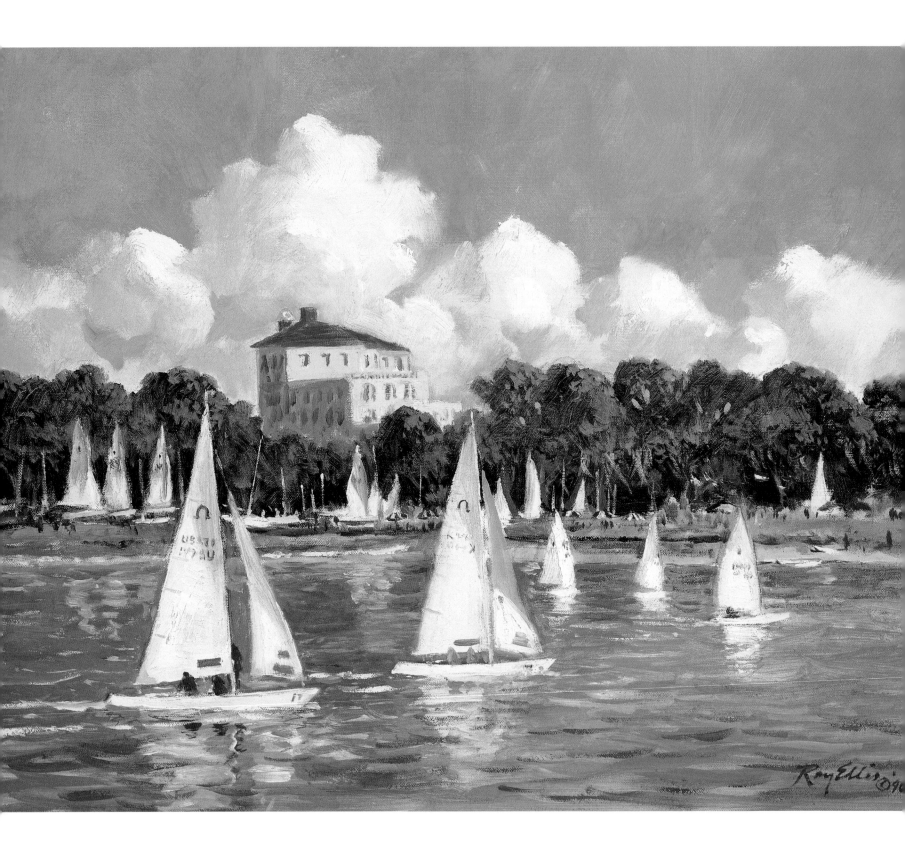

I painted this oil to commemorate the 1996 Sailing Olympics in Savannah. All classes are represented on the Wilmington River, with the old Sheraton Hotel in the background.
Savannah Yachting Venue, *1996. Oil, 24 x 36 in. (61 x 91.4 cm).*

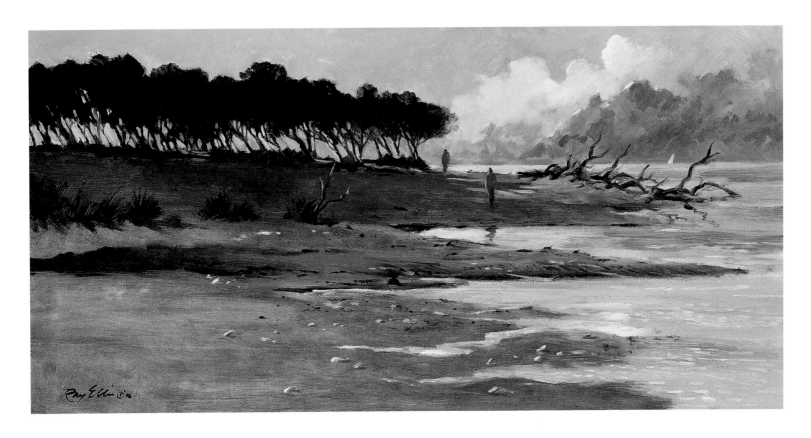

Blackbeard Island is almost exactly the way it was when the infamous pirate Blackbeard sailed these waters. We have often enjoyed anchoring off the beach and coming ashore for an oyster roast in late afternoon. Legend has it that Blackbeard buried some treasure there, but so far we haven't found it!
Twilight at Blackbeard, *1996. Oil, 18 x 36 in. (45.7 x 91.4 cm).*

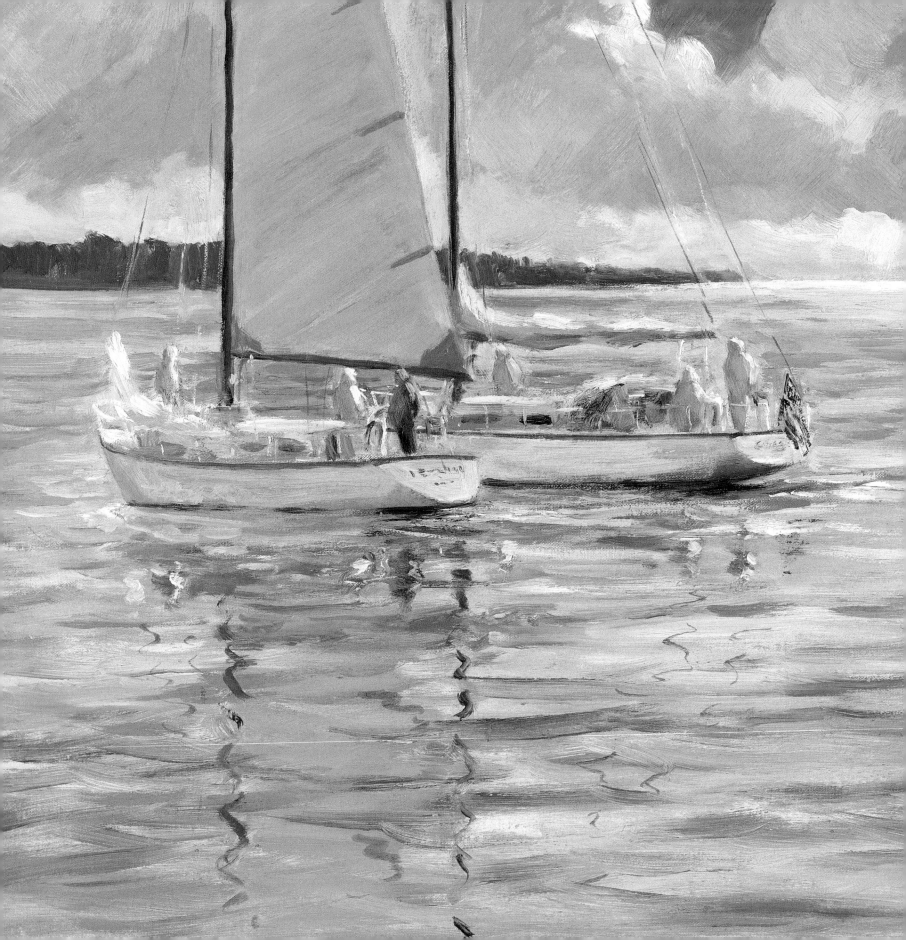

Coral Sands and the Intracoastal Waterway

Florida

F lorida is unique among American states, having risen up from the sea and attached itself to the crystalline core of our country while it continues to grow. As you walk its beaches heading south toward the Keys, its sands begin to change in texture and composition, providing clues to its origins.

The sand of most American beaches is composed primarily of quartz, the most common mineral contained in such crystalline rock as granite and the most resistant to the powers of weathering and erosion. It is the winner of a natural marathon that has taken years and years to complete. Water traveling downward toward the sea erodes the rocks over which it passes and breaks them down into their basic components. Only the most resistant minerals—quartz, for example—survive this journey.

Florida, however, is not made of crystalline rock that hardened from molten magma. Instead it consists of countless tiny cemented skeletons of coral animals—skeletons of successive generations of animals molded together. This process, over millions of years, has formed the tremendously thick limestone layers that underlie the Florida Peninsula. Florida's coral sands are the result, and a beachcomber can feel the difference. They crunch

Very often, moorings or berths are hard to come by. Many boaters will rendezvous and "raft up" for the night for convenience and comradery.
Summer Squall *(detail), 1995.*
Oil, 24 x 36 in. (61 x 91.4 cm).

underfoot; their particles are sharper and less rounded than sands that traveled a much longer distance to reach the beach of river-borne quartz.

Although Florida has rivers like the St. Johns and the Suwannee, which inspired Stephen Foster to write the state song, "Suwannee River," it's almost flat, rising no more than 350 feet (107 m) above sea level, and is pockmarked with thousands of sinkholes that defy rivers to cross them. As a result, its sands are more locally derived and commonly are coarse in texture.

But Florida is not one gigantic beach running from end to end. In fact, most of its coastline—the second longest in America after Alaska's—is made up of mangrove swamps, marshes, and shallow muddy bays inhabited by shrimp. Some say that the shrimp industry in America began in the early nineteenth century near Amelia Island north of Jacksonville.

Since Florida only recently rose up out of the sea, its oldest documented Native American village dates back only some five thousand years, long after the rest of the continent was populated.

Perhaps no episode of American history is more familiar than Ponce de Leon's search for the fountain of youth. The Spanish explorer arrived in Florida in 1513. After slaughtering the inhabitants of a French Huguenot outpost at the mouth of the St. Johns River, the Spanish built their massive Castillo de San Marcos fortress and established St. Augustine, the oldest European settlement in America.

Today, Florida has relegated the incidents of its inglorious history to the past, and its coastal people have returned to their origins, the sea. You can fish for marlin in the Gulf Stream or work on that perfect tan on Vero Beach. Each year students swarm to Fort Lauderdale and Daytona for spring break, and Palm Beach is a comfortable home to winter residents of all ages. The Intracoastal Waterway dotted with comfortable marinas is a yachter's paradise, offering pleasure and safe cruising.

Many lovers of the sea find seclusion and adventure in what the Spanish call the Cayos, or "little islands." These thirty-two coral islands that make up the Florida Keys are connected by a 100-mile-long (160 km) highway. The Keys protect Biscayne Bay from the open ocean, forming a shallow sea into which empty the waters of the Everglades along whose edge lives the endangered crocodile.

Key Largo is a mecca for divers, and John Pennekamp Coral Reef State Park is the only coral reef in America. Scuba divers and snorkelers

will find the underwater world in the Keys teeming with fish whose colors span the rainbow. Here too one finds the gentle "sea cow," or manatee, a strict vegetarian.

The southernmost tip of continental America lies at Key West, which still possesses the charm that attracted Ernest Hemingway half a century ago. The narrow streets are lined with classic Conch houses. There are no massive hotels or mansions here.

Key West's relaxed environment reflects its unusual origins, when "wreckers" became its first citizens. They were dependent upon the misfortunes of ships trying to navigate its coral-studded waters, dating back to when the Spanish lost priceless shipments of Inca gold bound for the king of Spain.

Fort Jefferson is an outpost, initially built to protect America's southern flank. It was converted to a prison after the Civil War. The fort's most famous inmate was Dr. Samuel Mudd. Having fatally shot President Lincoln, John Wilkes Booth fell to the stage floor of the Ford Theater and in so doing injured his ankle. He sought aid from an unsuspecting Dr. Mudd, who was subsequently—and unjustly—tried, found guilty of conspiracy, and shipped off to Fort Jefferson to rot in his cell. But when the prison was struck by an epidemic, Dr. Mudd saved many of its prisoners and prison staff, thus earning himself an early pardon. Today the prison is a tourist attraction.

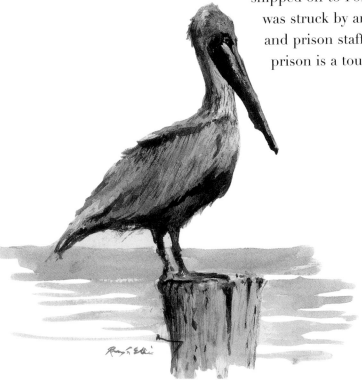

The pelican is my favorite bird to watch in flight. They remind me of a squadron of old Navy PBY's skimming over the water.
Brown Pelican, *1982.*
Watercolor, 8½ x 9 in. (21.6 x 22.9 cm).

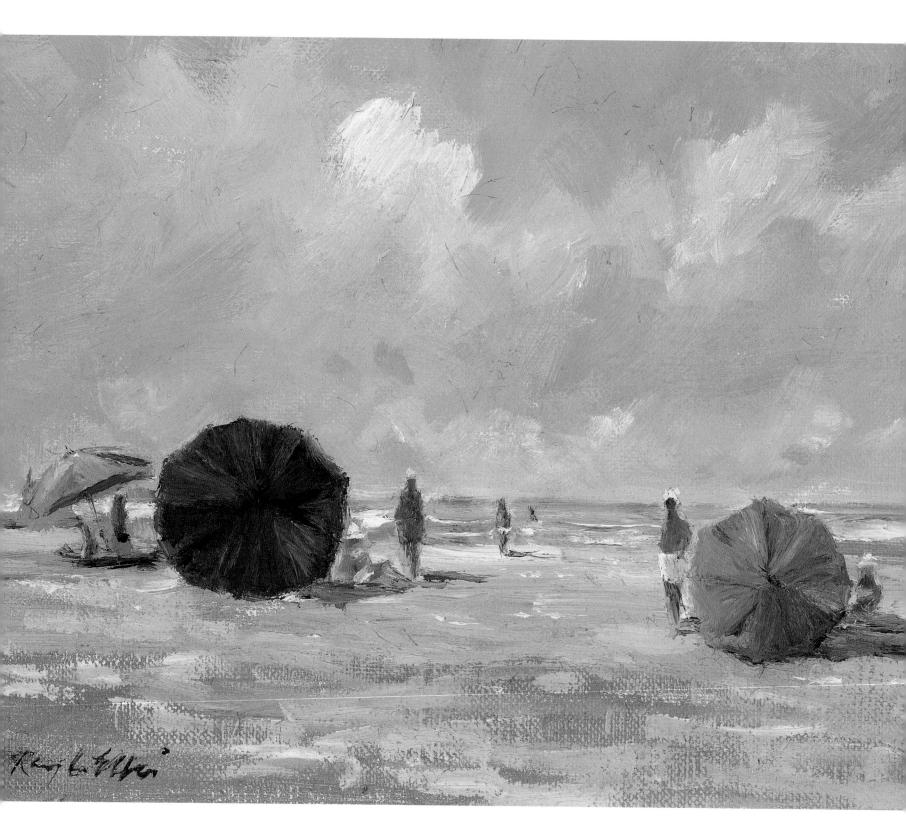

CORAL SANDS AND THE INTRACOASTAL WATERWAY

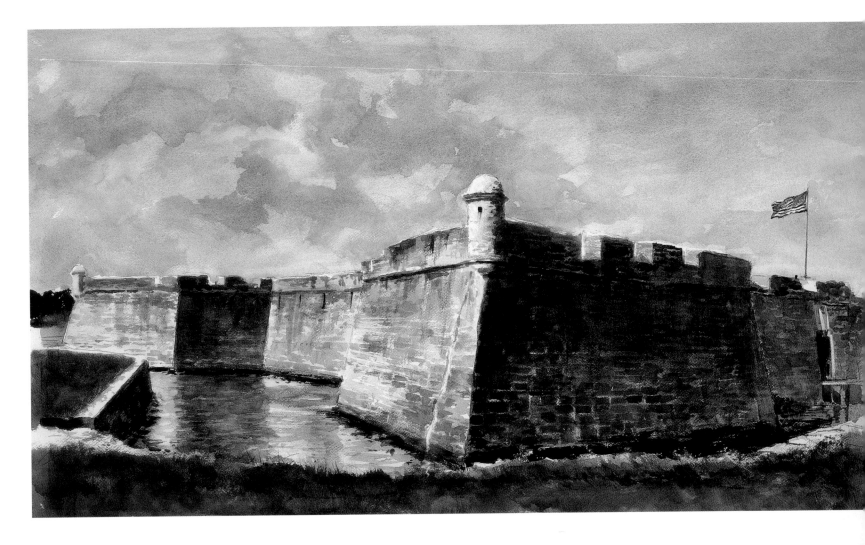

One of the most unusual landmarks on any of the American coasts is this old Spanish fort at St. Augustine. I was tempted to put in some figures but decided that unless they were in period costume they would seem out of place.
The Moat, *1982. Watercolor, 17 x 30½ in. (43.2 x 77.5 cm).*

There are many wide stretches of sandy beach in Florida. Beaches dominated by colorful umbrellas make especially interesting painting subjects.
At the Beach, *1981. Oil, 8 x 10 in. (20.3 x 25.4 cm).*

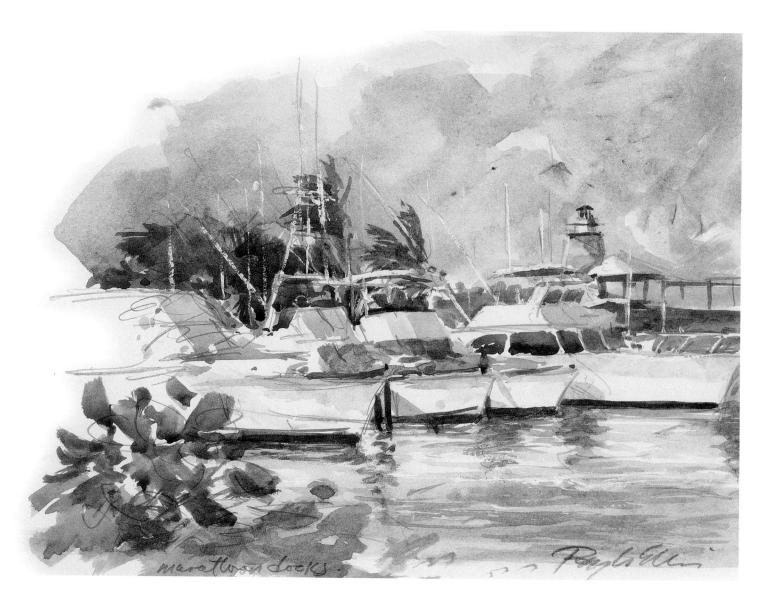

*This quick watercolor sketch done in Marathon, Florida, is typical of the many small, spontaneous
paintings I have done while traveling. Pictured here is part of a sport-fishing fleet beside a small
lighthouse at the end of a marina. I often develop such sketches as this one into more finished paintings.*
Marathon Fisherman, *1982. Watercolor, 7 1/2 x 10 in. (19.1 x 25.4 cm).*

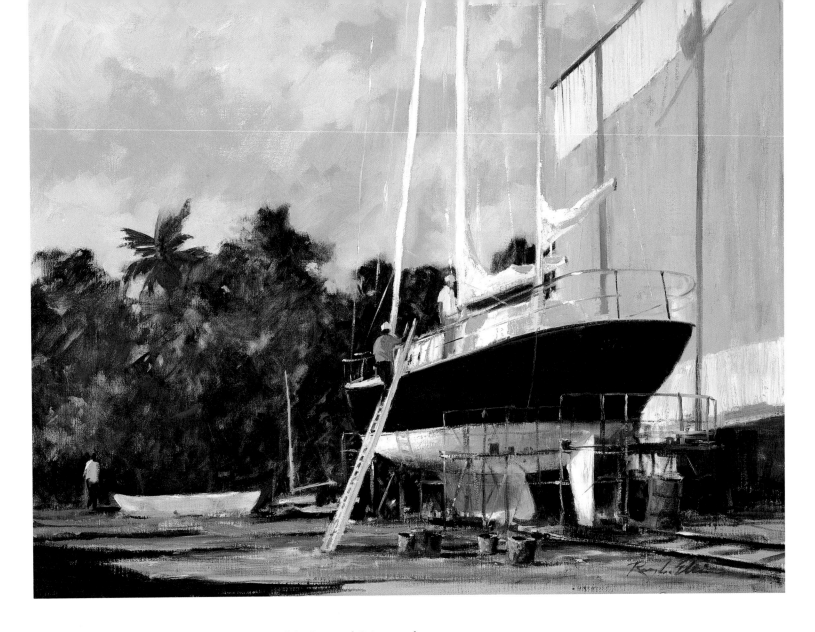

Most yachtsmen who sail the southeast coast know of this boatyard. It is a very busy place, and I loved wandering around amidst all the activity. This blue yawl was being worked on beside one of the giant boat sheds. Cans of paint, oil drums, ladders, scaffolding, and a backdrop of palms and oaks combined to make a fascinating composition.

Spencer's Boatyard, 1982. Oil, 22 x 28 in. (55.9 x 71.1 cm).

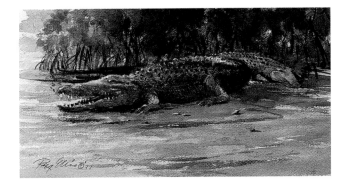

I have always admired John Singer Sargent's watercolor of alligators on a muddy beach. I wanted to try my hand at it, but in this case my subjects were Florida crocodiles in a much different setting.

American Crocodile, 1997. Watercolor, 6 x 12 in. (15.2 x 30.5 cm).

This old sentinel is surrounded by live oaks and palms, which accentuate its
weather-beaten and faded structure.
Key West Light, *1982. Watercolor, 19 x 25¼ in. (48.3 x 64.1 cm).*

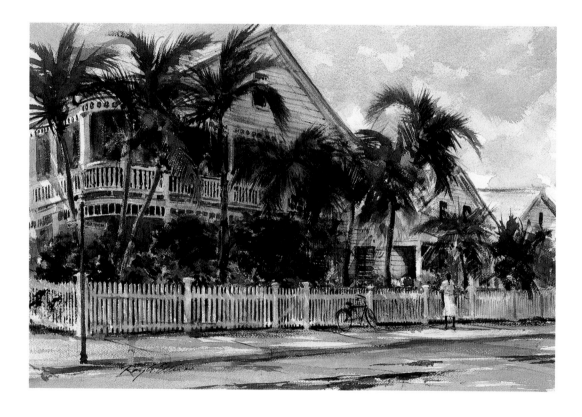

To me this painting typifies this quaint and unique town—old shuttered frame houses brushed by tall
palms swaying in light breezes and bicycles leaning against white picket fences.
Key West Corner, *1982. Watercolor, 16 x 24 in. (40.6 x 61 cm).*

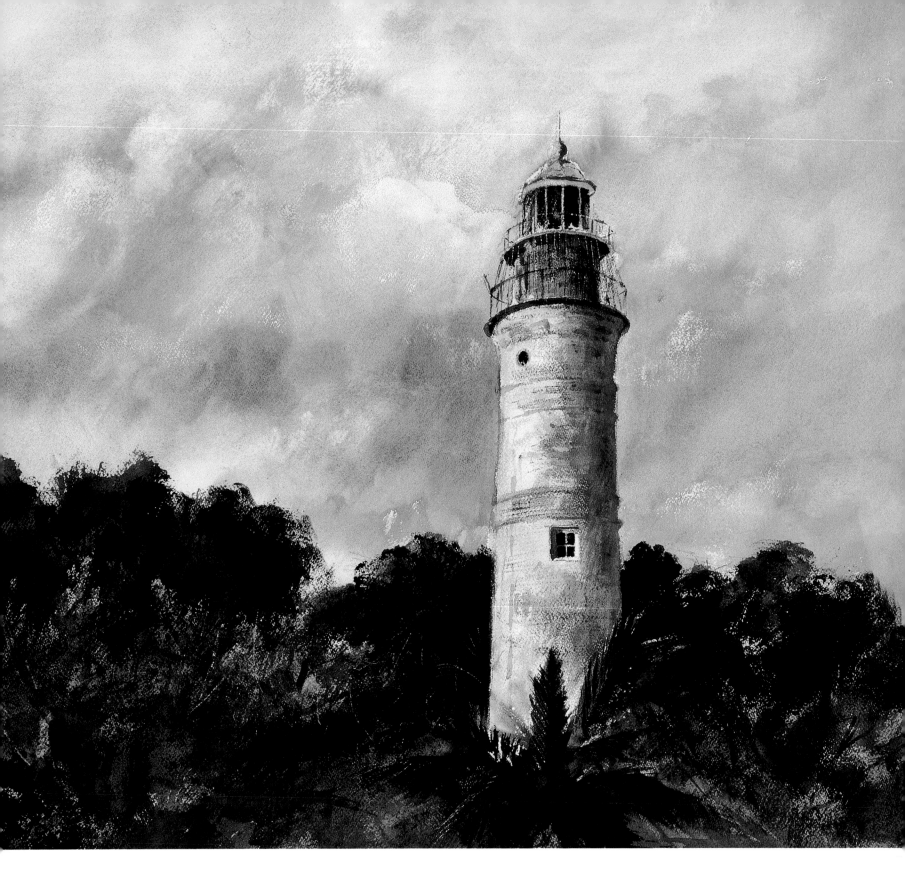

OPPOSITE:

*Between Key West and the Dry Tortugas
I came upon this wonderful old ketch being
used by sponge divers. The simplicity of
composition with the ketch's dark green hull
and the dark green dory-like boat being
towed behind caught my attention.*
Tortuga Divers, *1982.*
Oil, 24 x 36 in. (61 x 91.4 cm).

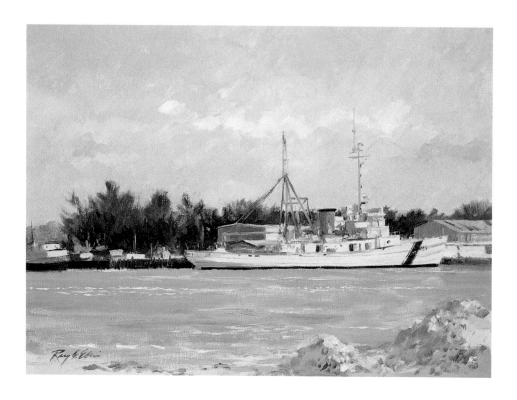

ABOVE:

*The United States Coast Guard has had a presence here for many years. During the Second
World War the base teemed with antisubmarine vessels. More recently it has teemed with ships
fighting the drug war. Because of my four years of service in the Coast Guard I am partial to
the impressive white hulls of these cutters.*
Cutter at Key West, *1982. Oil, 22 x 30 in. (55.9 x 76.2 cm).*

OVERLEAF:

*The color of spring flowers above these gray cliffs is a sight I will never forget. The orange-red
of the poppies and the blue of the lupine were spectacular—I couldn't resist doing a painting.*
Poppies and Lupine, *1988. Oil, 18½ x 23 in. (47 x 58.4 cm).*

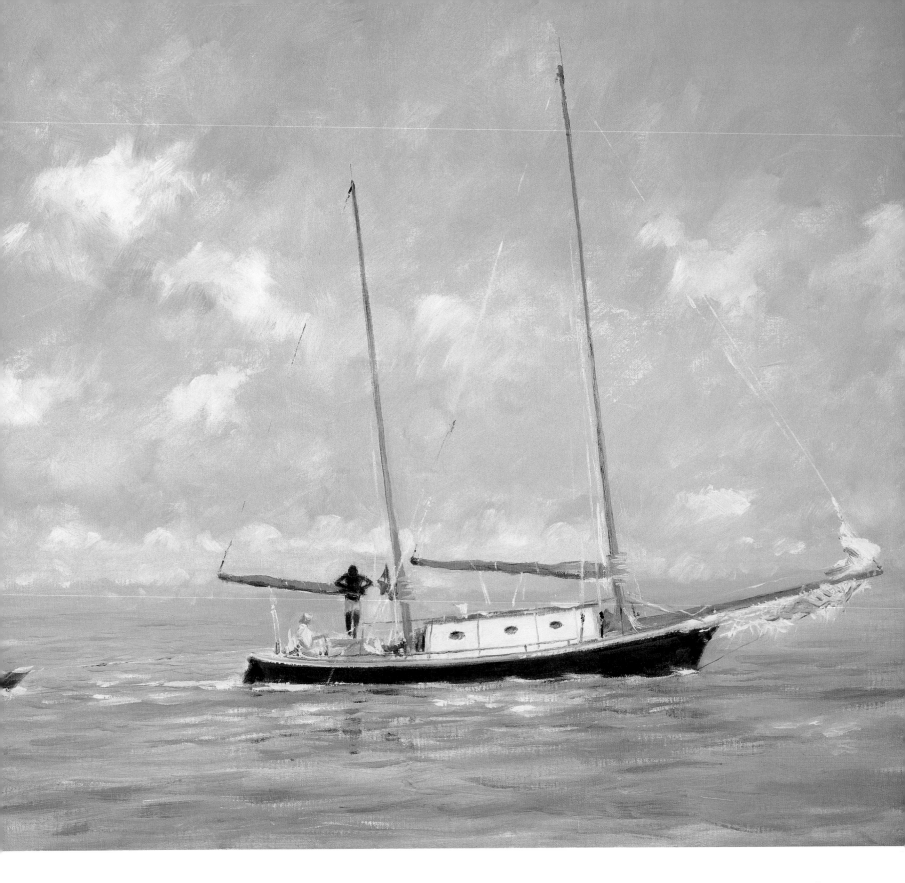

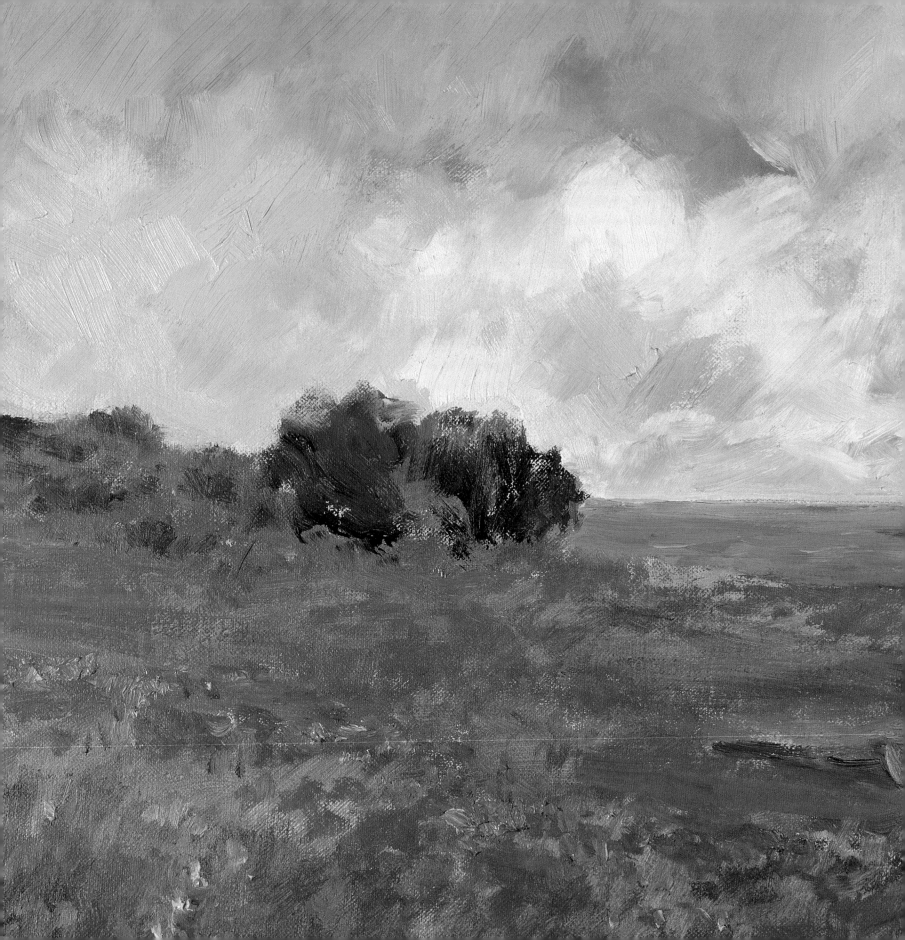

The West Coast

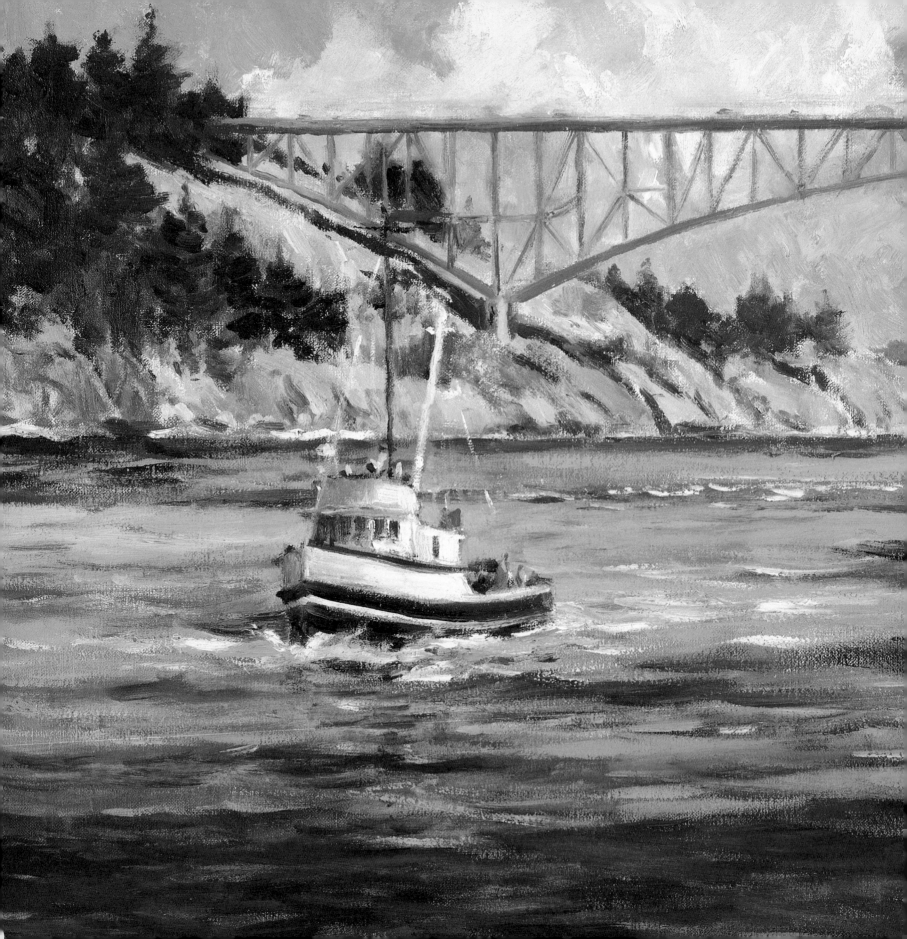

Puget Sound to the
Strait of Juan de Fuca

Washington's Inland Waters

The mountains that rise from the sea, draped in mist and washed by rain, are covered by a green carpet of vegetation. The waters here run deep and cold. They are home to the largest octopus in the world and to giant, ghostly sea anemones.

On the horizon stands the snow-covered peak of Mount Baker in the Cascades, over which the sun dawns. Though asleep now, this active volcano may some day erupt as violently as its sister to the south, Mount St. Helens. The ground frequently trembles as the ocean floor beneath the continent causes it to rise, feeding the volcanic chain of the Cascades with molten rock laden with explosive volatiles. While it's a bomb that may explode, it fortunately has a long fuse that shows no sign of being lit.

Offshore, the subarctic current, rich in nutrients, collides with the coast. Combined with the rocky substrate, local upwelling results in far more species of marine life than are found in the East, including the king of all sea predators, the killer whale. Roving the intrawaterways of Puget Sound and the inlets of the San Juan islands, the whales resemble wolf packs that encircle their prey, commonly pursuing sea lions drawn to the area to feed on salmon or a wide variety of other marine life. Once the sea lions are

The current comes through this pass with extraordinary speed, into and out of Skagit Bay. Here a rugged fishing boat passes through at the northern end of Whidbey Island.
Deception Pass *(detail), 1989.*
Oil, 20 x 24 in. (50.8 x 61 cm).

surrounded and held in check by the pod, a single killer whale penetrates the circle, attacking its chosen victim.

It is hard to imagine that such skilled predators would allow themselves to be captured by humans without a great struggle and would then easily adapt to captivity. Forced to swim in a tiny circle within its holding pen, it is tragic to watch as the great dorsal fin of the male, which can exceed six feet (1.82 m) in height, slowly bends over into a grotesque curl.

North and east of the San Juan Islands, the ocean cuts into the mainland, forming bays with names like Birch, Bellingham, and Samish. Some areas of the bays are shallow, and the mud flats exposed at low tide are excellent for clamming.

The protective waters of Bellingham Bay were landfall for settlers in the nineteenth century. At that time the economy here was bustling; it collapsed, however, when the Great Northern Railroad chose Seattle instead of Bellingham as its western terminus. Today the area is popular as a stopping point for sailors on Puget Sound, for dinner cruises to the San Juans, or for whale watching.

Care must be taken by sailors approaching Deception Pass. One should not be distracted by the high bridge that spans steep-sided cliffs connecting Fidalgo and Whidbey Islands. When the tide is running, the water here can be swift and turbulent.

Wise conservation measures have preserved virgin stands of grand fir on the islands. Eagles nest atop ancient Douglas firs up to nine feet (2.74 m) in diameter, and the nearby waters contain an abundance of fish on which the eagles feed.

Here too stands Fort Casey, built during the Spanish-American War to protect Puget Sound from naval attack by creating the "Devil's Triangle," a deadly zone of interlocking firepower with Fort Worden and Fort Flagler.

Owing to its unique climate and low rainfall relative to the water-drenched Olympic Peninsula to the south, Whidbey Island was once home to the largest Native American population in the Northwest. This coastal paradise was eventually discovered, however, by Europeans, one of whom—Ebey—claimed the lands as his own. So outraged were the original inhabitants by subsequent and various swindles resulting in the loss of their land that they rose up in war, which cost Colonel Ebey his head.

This small lighthouse was quite different from the ones I was used to seeing on the east coast, but the angular white base sitting on the smooth rock is typical of lighthouses in the San Juans.
Heceta Head Lighthouse, 1989.
Watercolor, 8½ x 9½ in. (21.6 x 24.1 cm).

Seattle is the capital of the Northwest. It is a boomtown supported by the lumber industry, by Boeing, and, most recently, by Microsoft. It is famous for its bustling Pike Place Fishmarket where, incidentally, an unsuspecting tourist could be hit by a flying salmon.

A lunch of fish chowder and smoked salmon can be eaten on the run, but time should be reserved for dinner in one of the many dockside restaurants. Steamed Dungeness crab with drawn butter, a specialty here, can take more than a hour to eat and is especially good with a chilled bottle of St. Michel Chardonnay. At Pier 51 you can catch a ferry to Bainbridge Island or take a longer ride to Bremerton on the west side of Puget Sound where a boatsman could easily become lost in the maze of inlets and islands.

When navigating the pristine waters of Hood Canal, don't be surprised if you see the sleek black silhouette of a nuclear submarine coming home to its base in Bangor after a long patrol in the depths of the Pacific.

To the north of Seattle is Ballard and its famed locks. Said to have been lost in a card game to Captain Ballard by a local resident, it is a favorite place to relax and watch a long line of boats waiting their turn in the locks that will carry them to the freshwaters of Salmon Bay and farther inland to Lake Washington.

Years ago, the people of Port Townsend, at the entrance to Puget Sound, expected the capital of the Northwest to be their town. In the 1880s Port Townsend was a boomtown with a population of twenty thousand. It boasted Victorian mansions and a harbor crowded with four-masted sailing ships. But that prosperity came to a crashing end when the transcontinental railroad line stopped in Seattle. Today Port Townsend has the distinction of being the "Wooden Boat Capital of the World," with a three-day summer festival that attracts thousands by car, ferry, and sailboat.

Leaving the sound at Port Townsend, a sailor enters the Strait of Juan de Fuca as he heads west toward open sea and Cape Flattery, the westernmost tip of continental America. The strait, which runs along the United States–Canadian border, separates Vancouver Island to the north from the Olympic Peninsula to the south. Railroad tracks run parallel to the strait, with a station in Port Angeles, which is the gateway and entrance to the magnificent forests and snowcapped peaks of the Olympic National Park.

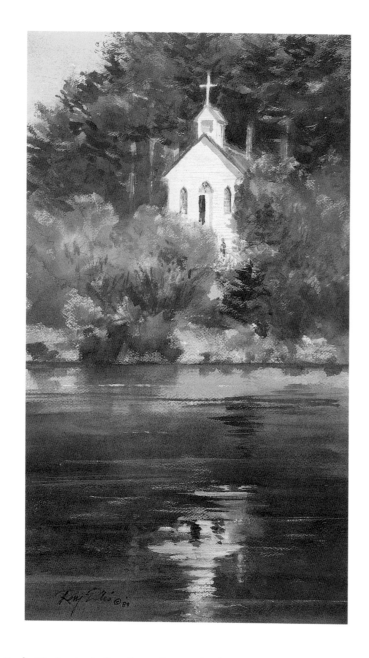

Entering Roche Harbor in the San Juans, I was taken by a small, modest white church high on the bank and by its reflection in the water below.
Church Reflections, *1989. Watercolor, 21 x 12 in. (53.3 x 30.5 cm).*

There are not too many places along the coast of the United States where one can anchor a boat and see a snowcapped mountain. We watched the sun rise slowly over this majestic range.
Daybreak Over Mt. Baker, *1989. Oil, 12 x 16 in. (30.5 x 40.6 cm).*

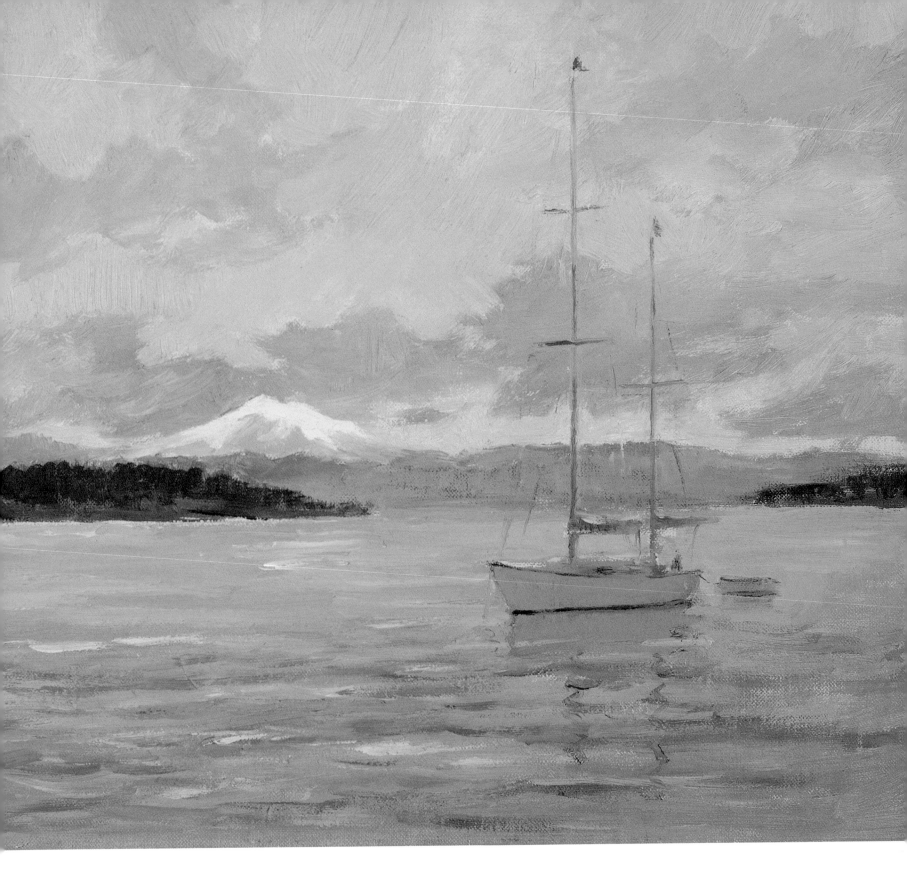

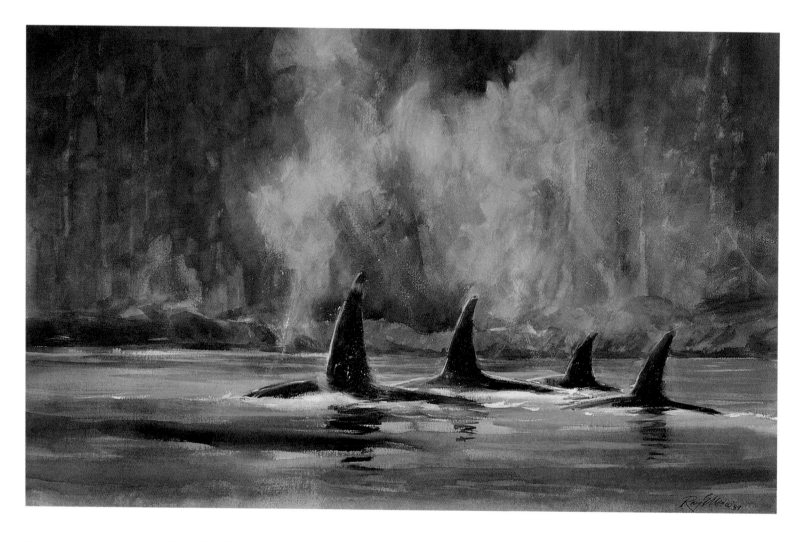

It was an exciting moment, after waiting for days, to see these magnificent creatures surface and blow.
Their shiny, dark, wet skin reminded me of the surface on a new Steinway piano.
Orca Whales, *1989. Watercolor, 24¾ x 29 in. (62.9 x 73.7 cm).*

After anchoring our boat for the night, we hiked to the western side of Sucia Island, Washington. There
in a quiet cove were two sloops against a magnificent pastel sunset. We watched as the sun fell below
the horizon.
Sucia Sunset, *1989. Watercolor, 15¾ x 23 in. (40 x 58.4 cm).*

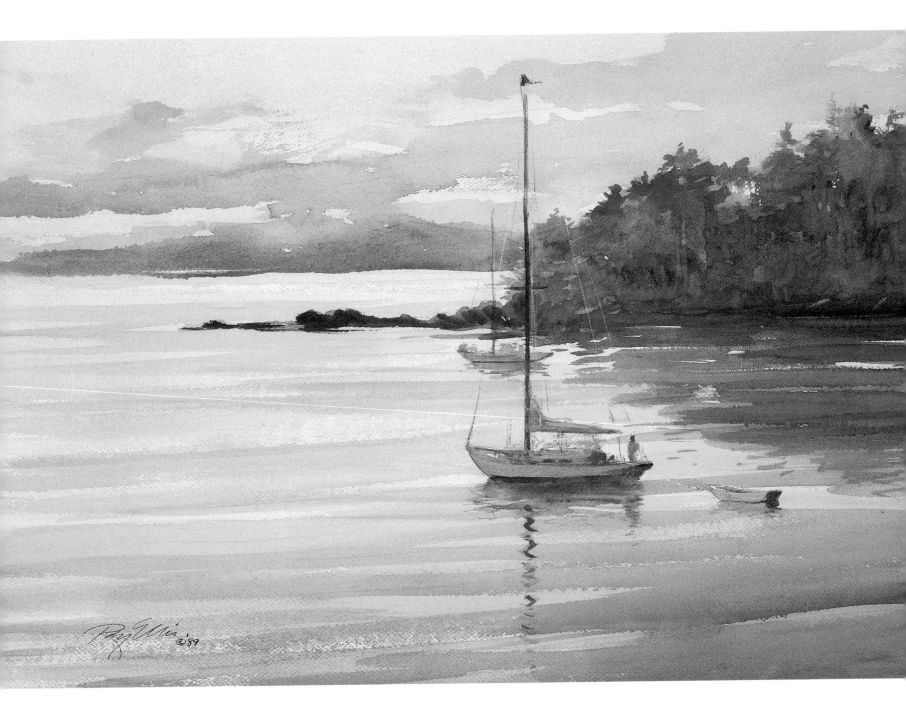

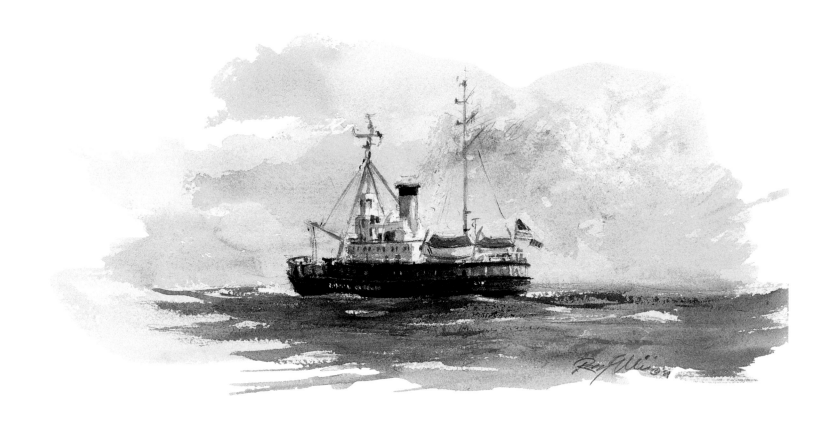

*Having spent four years as a Coast Guardsman during World War II, it is not surprising that
I wanted to include a Coast Guard vessel in this book. When I did this sketch in 1989 the* Fir *was
stationed in Washington.*

Coast Guard Cutter Fir, *1989. Watercolor, 7¾ x 14 in. (19.7 x 35.6 cm).*

*Waking up to such scenes as this was a common occurrence during our travels through the islands.
Here at Orcas the sun hit the cliffs, which were dotted with pine trees. I loved the reflections in the
smooth water.*

Cliffs in the Morning, *1989. Oil, 20 x 30 in. (50.8 x 76.2 cm).*

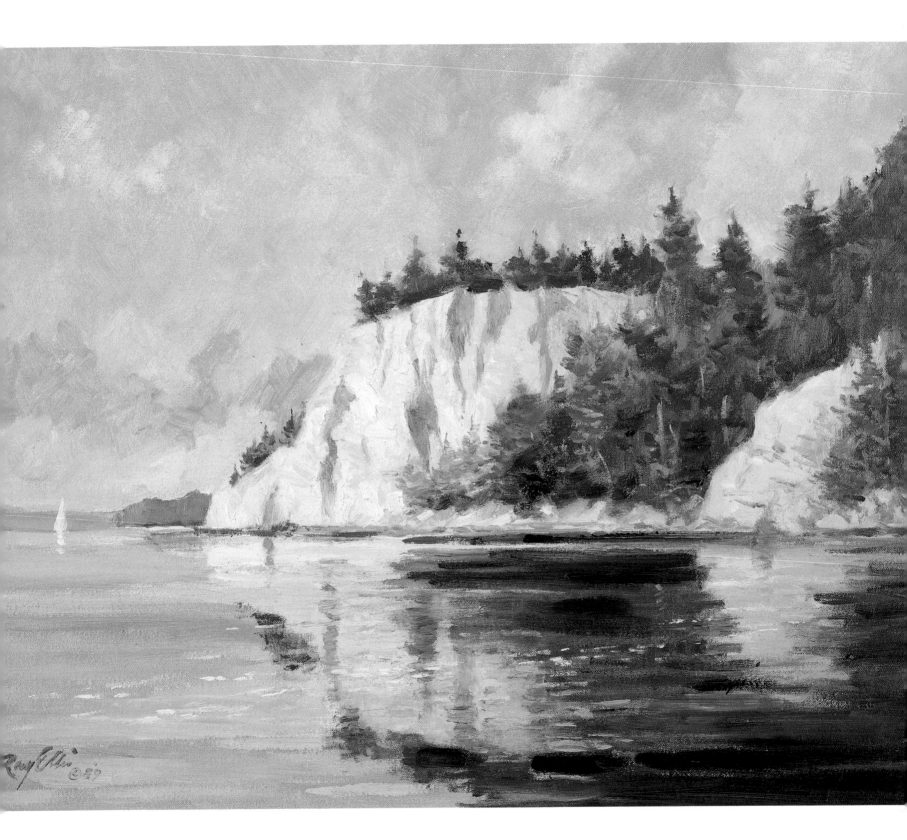

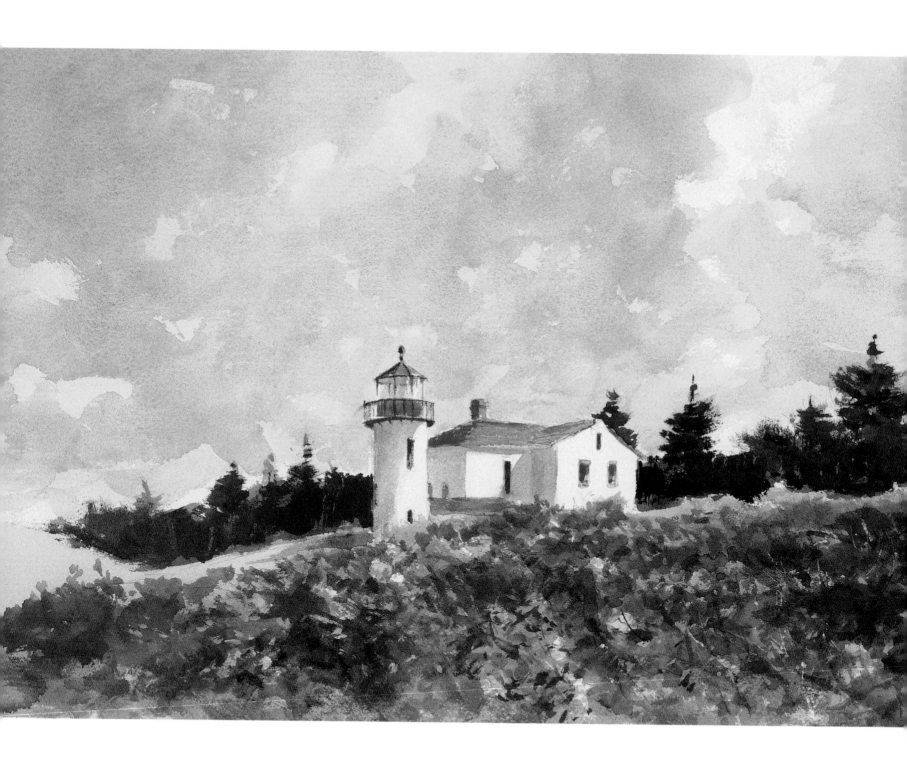

This colorful light on Whidbey Island overlooks the high dunes near the dock where the ferry from Port Townsend comes in.
Fort Casey Lighthouse, *1989.*
Watercolor, 12½ x 24¼ in. (31.8 x 61.5 cm).

The tidal flats in Washington can be immense. When the tide is out, clammers dot the shoreline with their rakes and wire baskets to harvest these delicious mollusks. I was attracted to the reflections on the beach, with its many shades of tan, gray, and blue.
Clamming, *1989.*
Watercolor, 14 x 24¾ in. (35.6 x 62.9 cm)

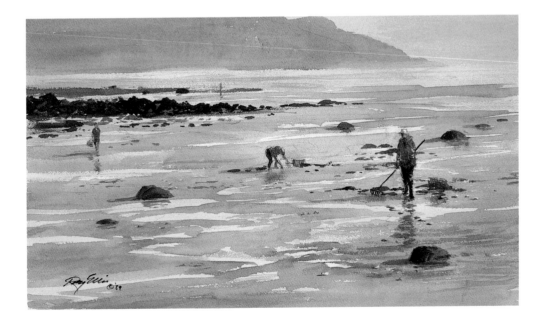

*Most things haven't changed a whole lot on
Whidbey Island. Except for the naval air
station most structures have been there for
a long time. Captain Ebey's farm is a legend
among islanders. I was struck by the old
weathered house and barn overlooking
Puget Sound.*
Captain Ebey's Farm, *1989.*
Watercolor, 19 x 39 in. (48.3 x 99.1 cm).

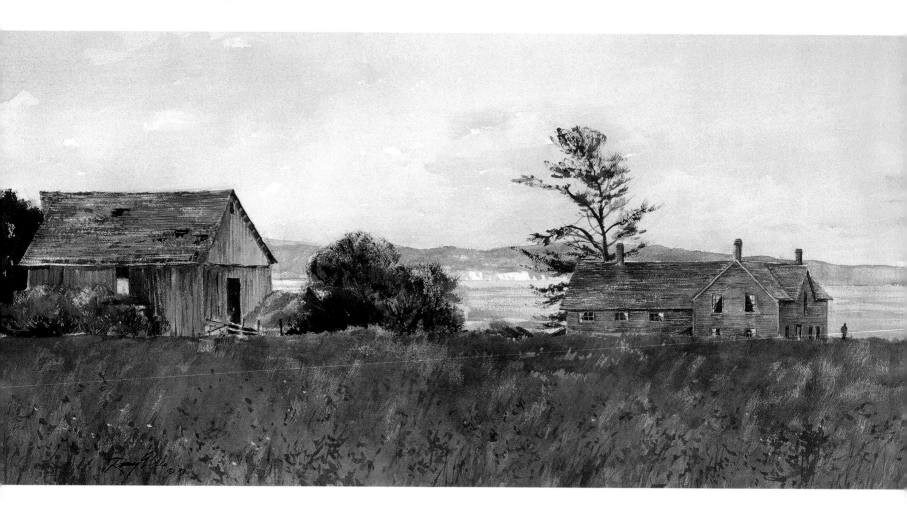

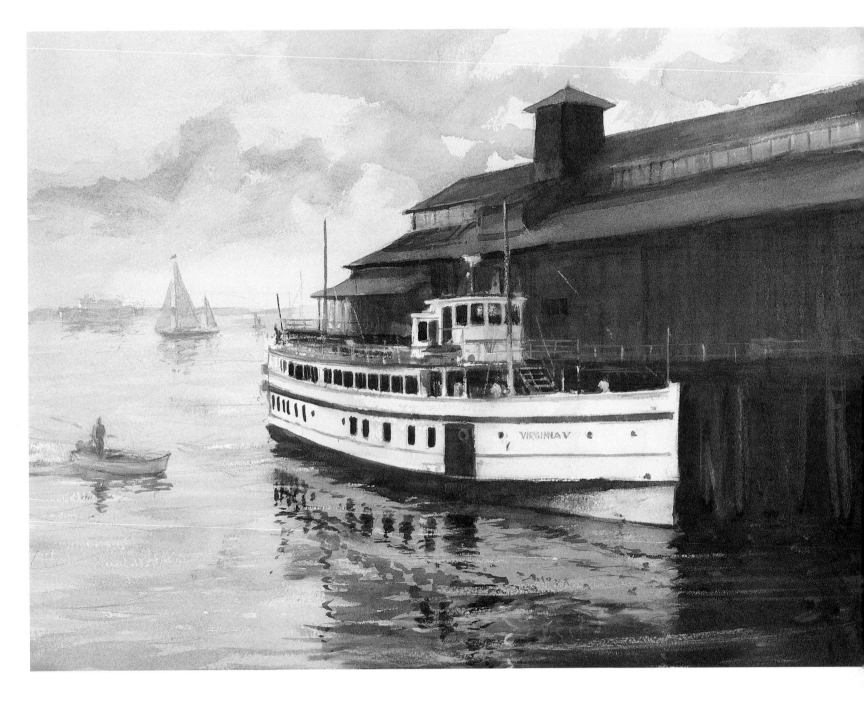

The old Virginia V *is a favorite boat for a day cruise on Puget Sound. At her dock in Seattle harbor,*
against a faded red building, she made a great subject.
Day Tripper, *1988. Watercolor, 16 x 20½ in. (40.6 x 52.1 cm).*

Sailboats with spinnakers set race by the
lighthouse at Old Fort Townsend.
Spinnakers Off Port Townsend, *1989.*
Watercolor, 17½ x 25 in. (44.5 x 63.5 cm).

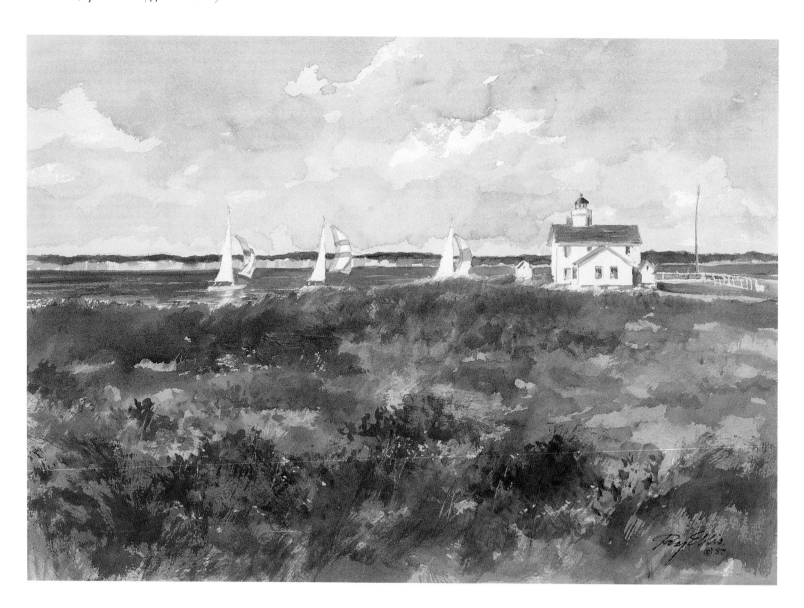

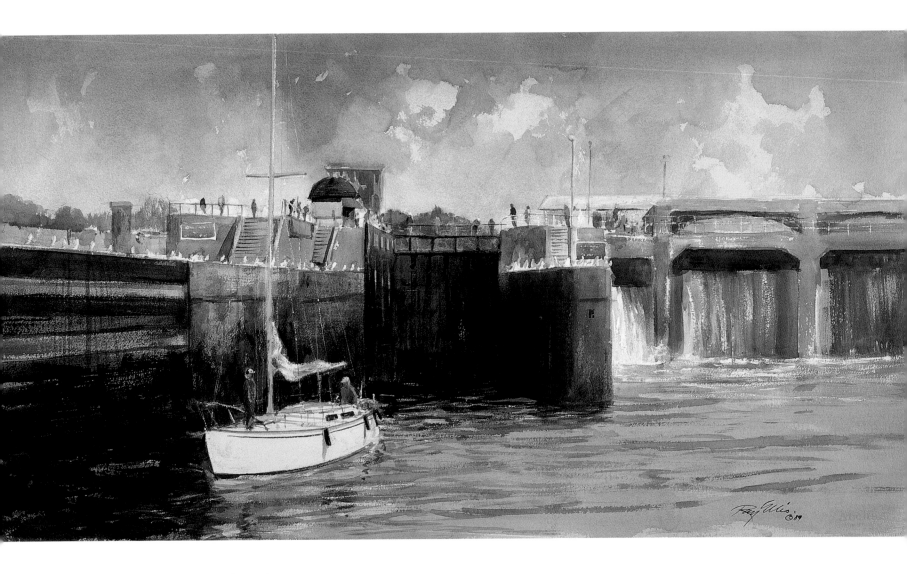

*Cruising down from Puget Sound, one always
finds an abundance of activity as spectators
congregate to observe the workings of the
various locks along the way.*
The Lock, *1989.*
Watercolor, 21 x 39 in. (53.3 x 99.1 cm).

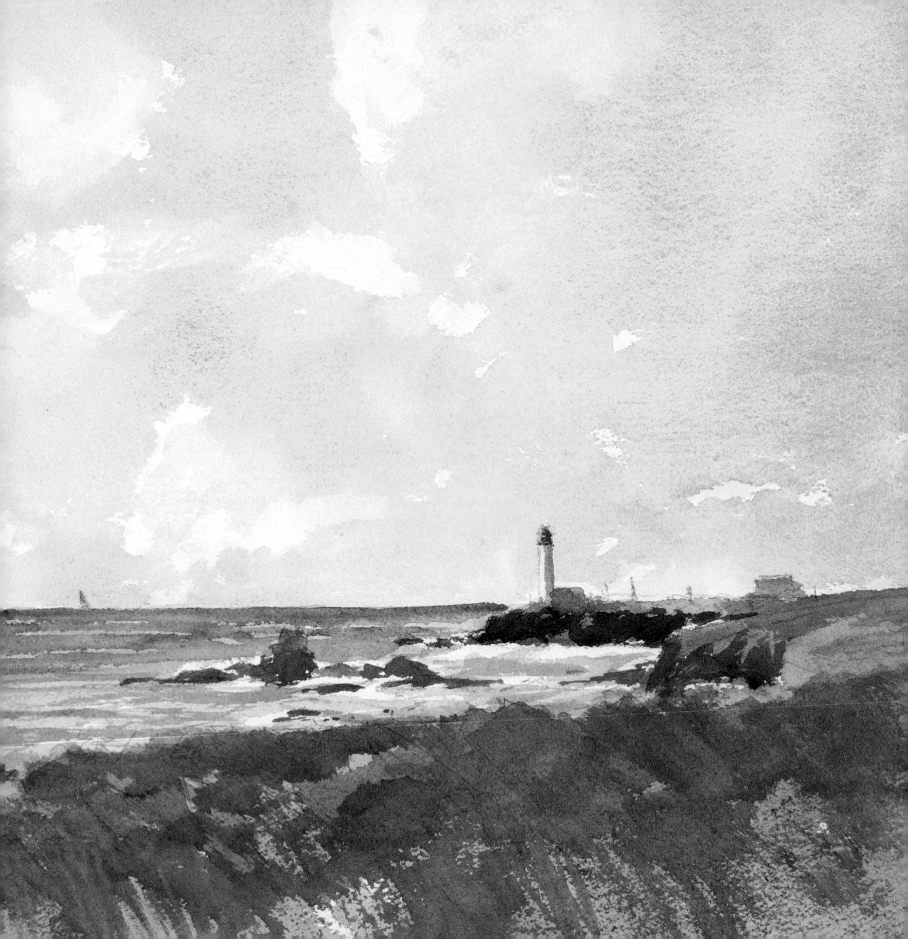

Cape Flattery to Point Arena

Washington to Northern California

The winters here are relatively mild, but the wind and surf are unforgiving. It is as if war has been declared and the ocean will not relent until it has washed the land into the sea. Wave follows wave, averaging twenty feet (6 m) in height as each crashes into the rocks. Even in summer, distant storms can cause the temporary truce to be interrupted at any time.

But the land built a fortress to resist the assault. Millions of years ago a rift opened in the crust, out of which flowed an ocean of molten rock that followed the Columbia River to the sea, forming the coastal mountains.

Today's coastal topography is the result of the ongoing battle between land and sea, with rugged seacliffs and headlands cut into coastal mountains, sea stacks, tidal pools carved out of the lava flows, and a narrow or nonexistent coastal plain with small bays and short estuaries.

Adding to this scene is the unique climate of the Northwest. In the summer, the Aleutian Low that helped generate gale-force winds during the winter shifts north, letting the North Pacific High dominate, producing a steady wind. As the warm, moist air caused by the high flows east toward land and sinks, it comes into contact with the cold ocean surface. The result is dense fog. In fact, the mouth of the Columbia River is the foggiest

This point, about eighty miles (130 km) north of San Francisco, is well-known to mariners. A lighthouse stands isolated on the rocky promontory.
Point Arena *(detail), 1988.*
Watercolor, 14 x 17½ in. (35.6 x 44.5 cm).

place in America, with 106 days of fog a year. Lewis and Clark called it Cape Disappointment.

During the spring, volcanic sand flushed down the Columbia River forms long, hard-packed sandy spits, behind which are found shallow bays full of clams and oysters.

Spanning the river to Astoria in Oregon is the world's largest truss bridge, built in the late 1960s. Astoria, the oldest city on the West Coast, supports a large fishing industry for salmon, sea-run cutthroat, sturgeon, and other species plentiful in this area. Care must be taken, however, when navigating the dangerous offshore sandbars, the area having earned the name "graveyard of the Pacific."

Before humans arrived, giants dominated California's north coast. Redwoods, the tallest living things on earth, once stretched for 450 miles (725 km) along the coast and extended thirty miles (48 km) inland. Nowhere else on earth does this tree live. It thrives in the unique weather of the area that sends thick moist layers of fog up the steep valleys.

The coast is dotted with logged-out lumber towns and with enormous stumps, mute testimony of where giants once stood. Still, despite man's presence, great groves of redwoods even now form darkened forests protected from the lumberman's chainsaw.

Along the coast, small inlets and bays are crowded with fleets of fishermen who leave in the morning and return at sunset. With any luck their holds will be full of salmon.

While Americans and the British were preoccupied with the War of 1812, the tsar of Russia sent forces to northern California. His soldiers built Fort Ross and declared shipping in the area to be under their control. They also set about decimating the local sea otter population for its fur. Either the Monroe Doctrine, which declared that European powers were not permitted to colonize America, or the fact that the Russians had reduced the otter population to fewer than a hundred animals, caused the tsar to order their retreat, leaving only their name on the local Russian River.

A century and a half later, during the heyday of 1960s counterculture, a new and very different cash crop was added to the local economy. Despite efforts to eliminate marijuana, an underground market continues to thrive— never mind that most residents would probably prefer their area to be recognized for its charming Victorian Gothic and saltbox houses.

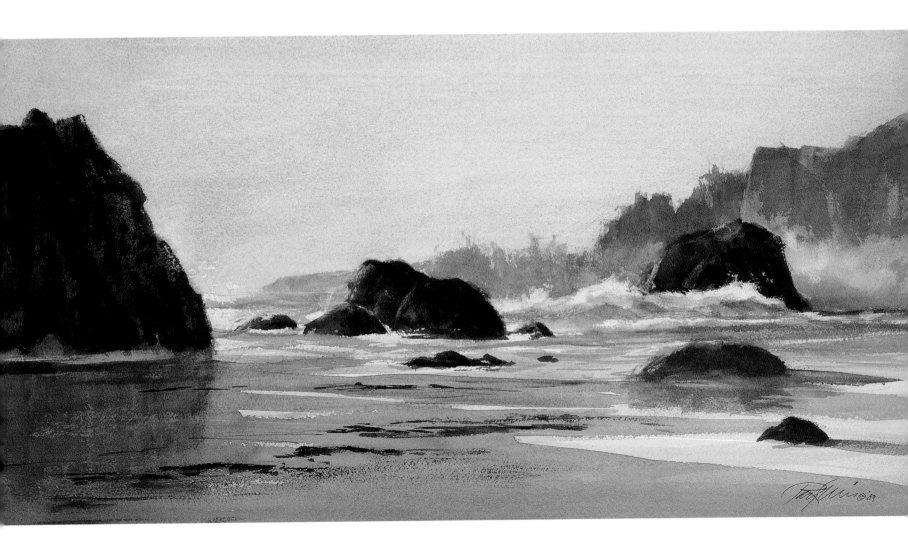

The rocks are mammoth and the surf is
strong on the coast of the Olympic Peninsula.
I chose a long, narrow composition to
emphasize the size of the rocks as well as
the power of the surf against them.
Surf, *1989.*
Watercolor, 12½ x 24 in. (31.8 x 61 cm).

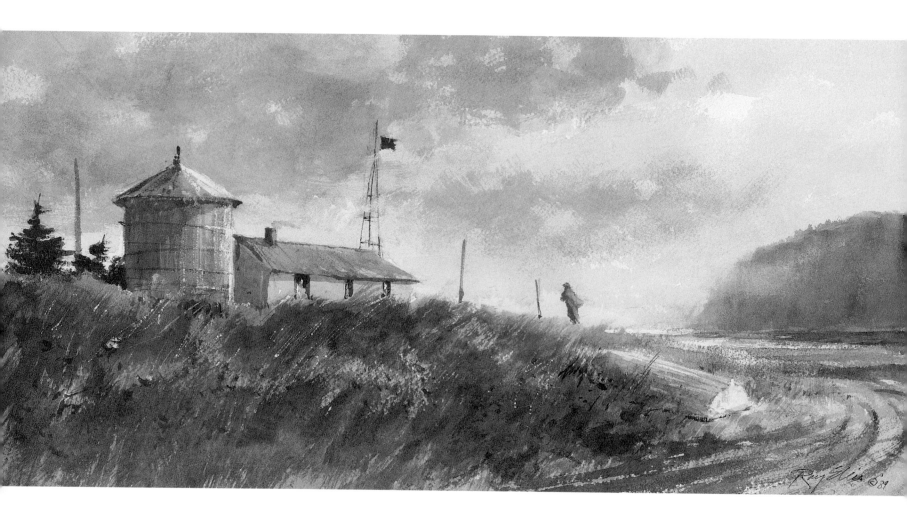

*The remote old Coast Guard station at
La Push inspired this watercolor, which
depicts a violent storm brewing. The ripped
flag warns sailors of the approaching
danger. This moody painting reminds me
of my years in the Coast Guard.*
Storm Warning, *1989.*
Watercolor, *9½ x 20¼ in. (24.1 x 51.4 cm).*

The more I saw these old and sometimes
abandoned fisheries on their stiltlike pilings the
more I realized their great potential as subject
matter. This small oil was a joy to paint.
Low Tide, *1987.*
Oil, 12 x 14 in. (30.5 x 35.6 cm).

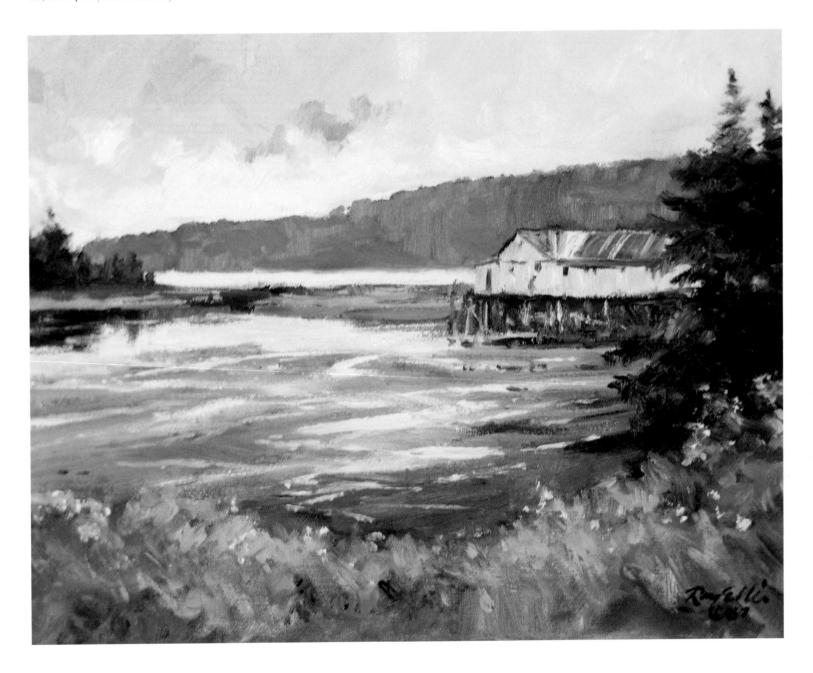

Abandoned canneries along the Columbia River are reminders of a bygone era. The various colors and shapes of corrugated siding surrounded by broken docks and rotted pilings combine to make an interesting painting.

Old Cannery, *1989. Watercolor, 17¾ x 26 in. (45.1 x 66 cm).*

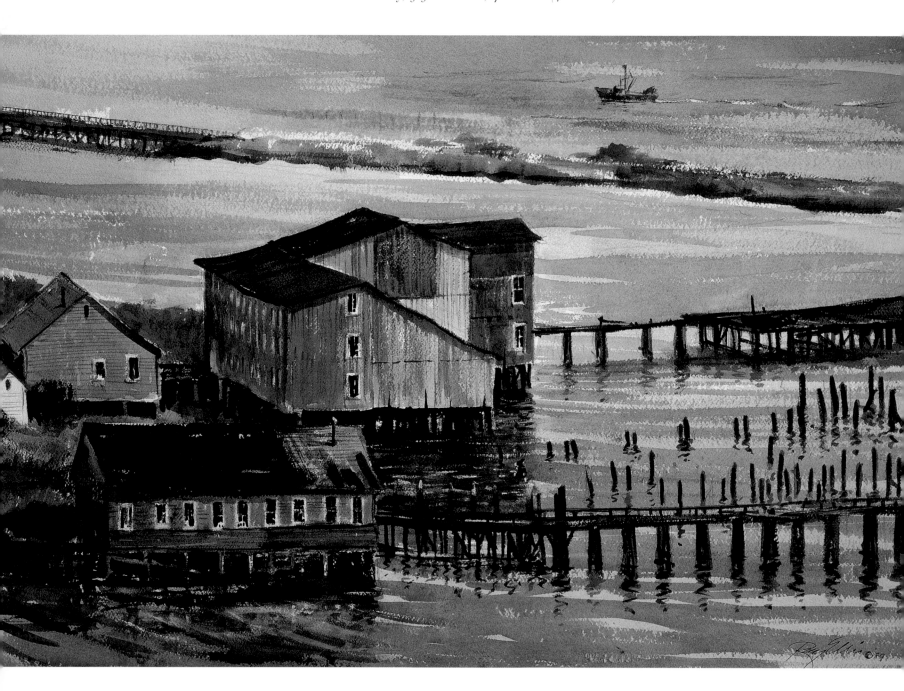

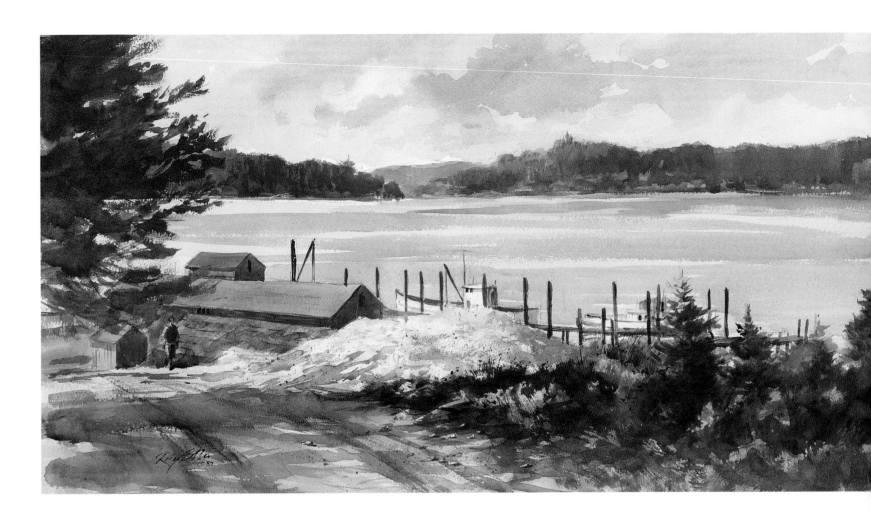

Gray's Harbor on Tillamook Bay, Oregon, is famous for its oysters. Here an oysterman, returning home, walks by piles of bleached oyster shells as late shadows fall across the whiteness of the shells.
Oysterman, 1987. Watercolor, 21 x 39 in. (53.3 x 99.1 cm).

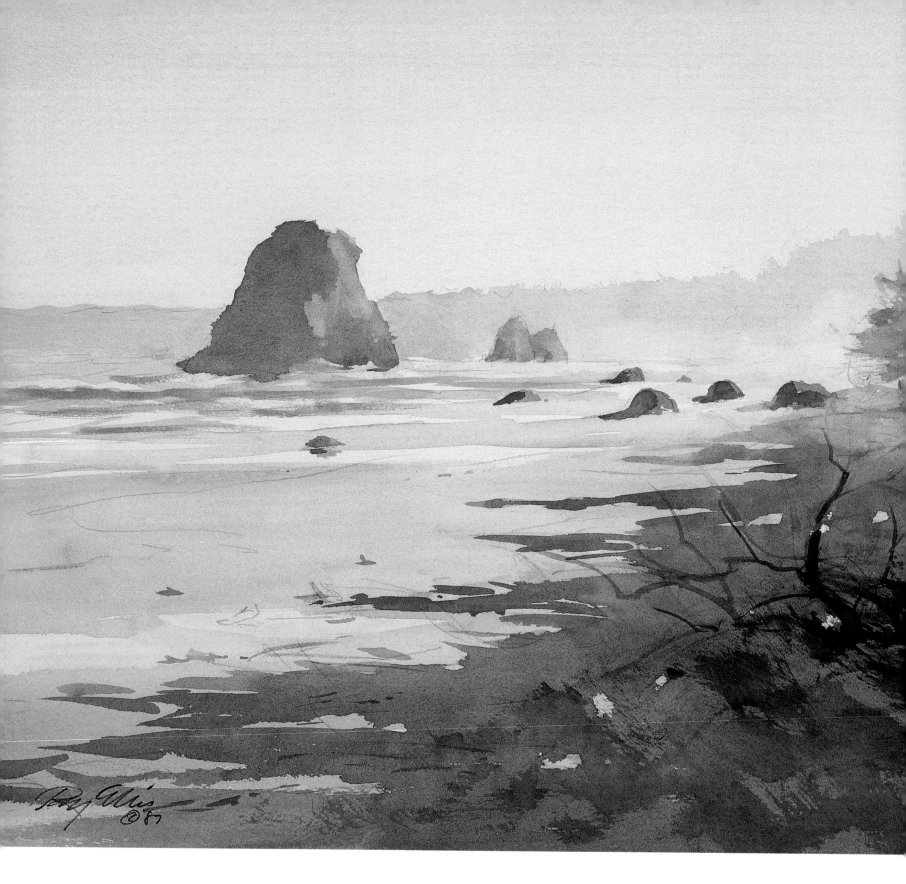

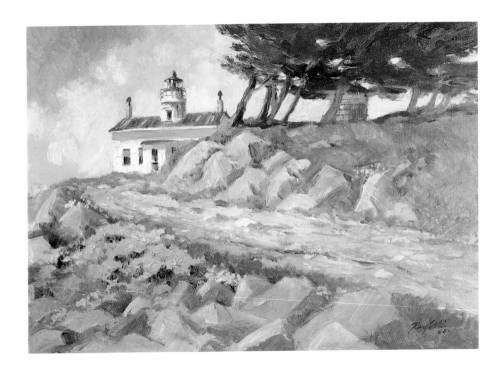

This light was on a peninsula until a tidal wave from an Alaskan earthquake made the point an island, which can be reached only at low tide.
Light at Point Saint George, *1987.*
Oil, 20 x 25 in. (50.8 x 63.5 cm).

One can feel dwarfed by an expanse of beach and by huge monoliths standing as sentinels. Here near Seal Rock, Oregon, an early morning mist casts a yellow-green haze.
Beach Mist, *1987.*
Watercolor, 17 x 25 in. (43.2 x 63.5 cm).

This small unprotected harbor is the home
port of many of the fishing vessels along the
northern California coast.
Morning in Trinidad Harbor, *1989.*
Oil, 20 x 25 in. (50.8 x 63.5 cm).

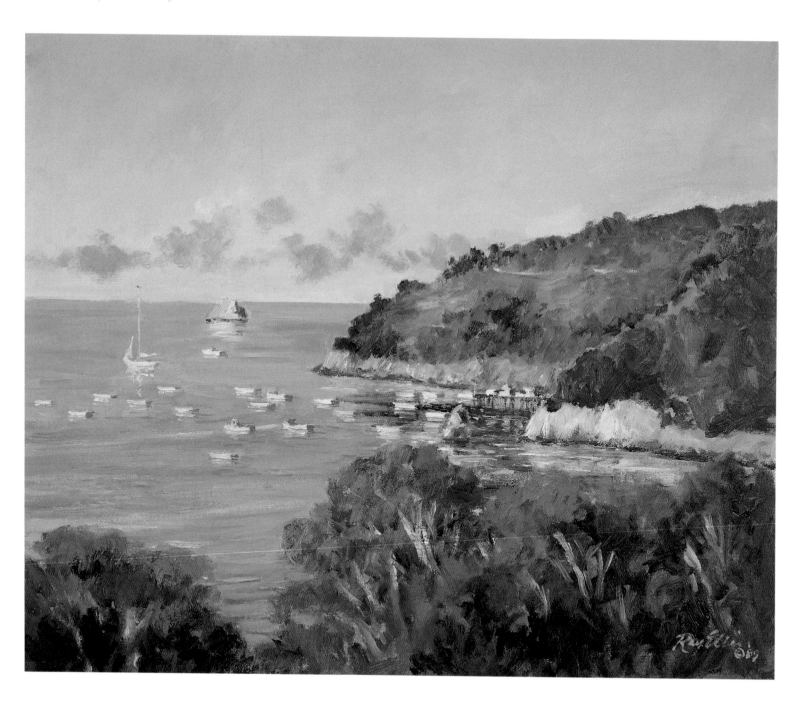

The best way to show the immense size of these overwhelming trees is to put a figure at the base of one of them. The light that filters down through the canopy creates shafts through the trees.
Redwoods, *1988.*
Watercolor, 24 x 14 in. (61 x 35.6 cm).

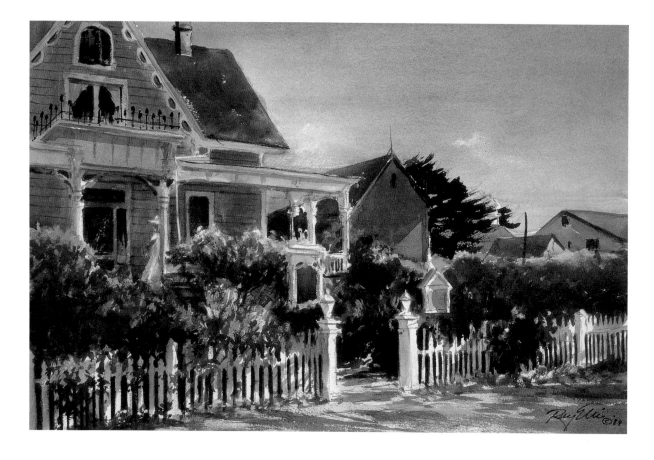

*One of the most attractive places we visited
was this inn and restaurant in Mendocino,
California. Roses and other flowers covered
the grounds and picket fence. The porch
overlooked the harbor.*
The MacCallum House, *1989.*
Watercolor, 13 x 20 in. (33 x 50.8 cm).

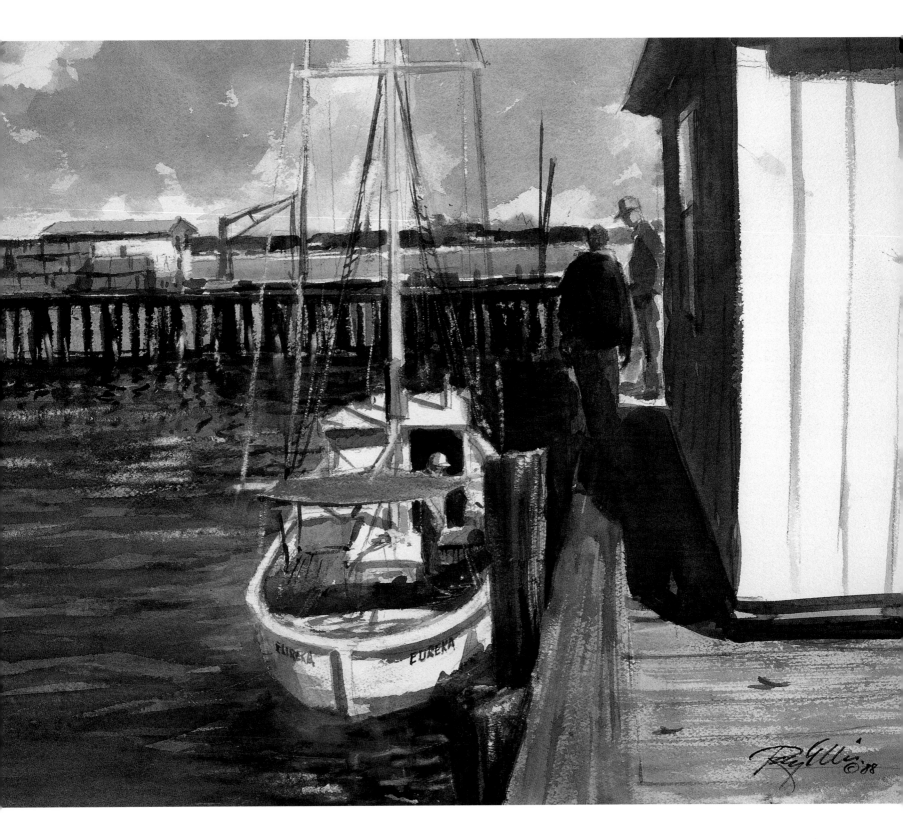

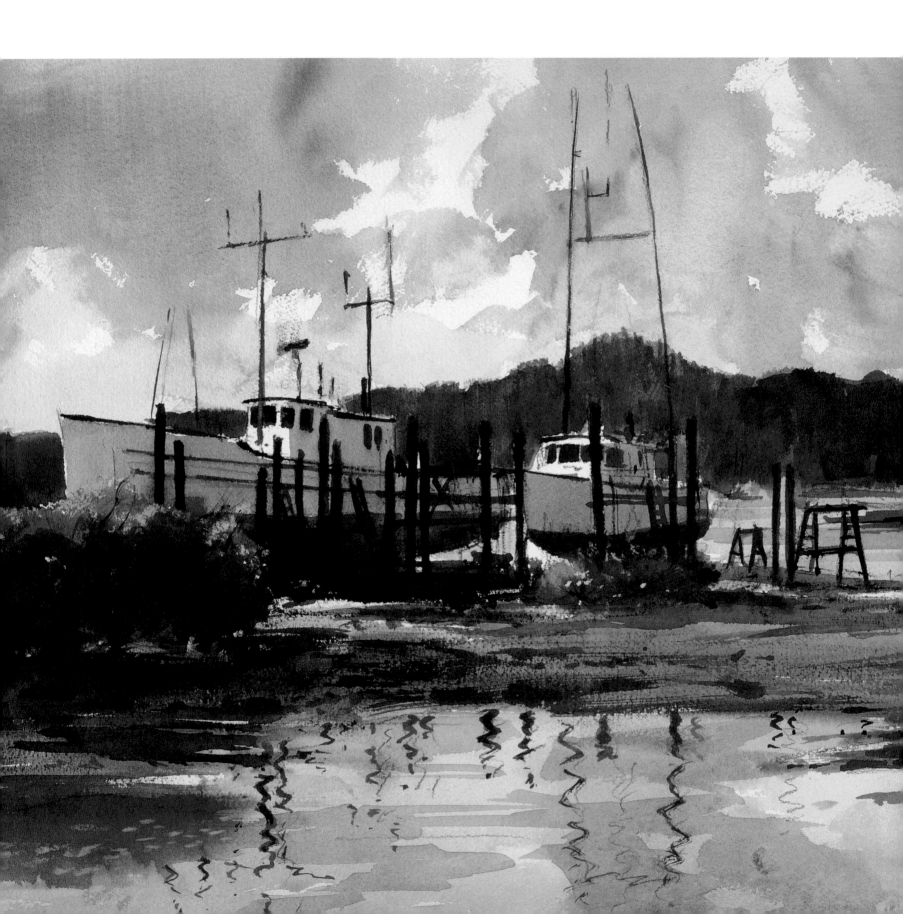

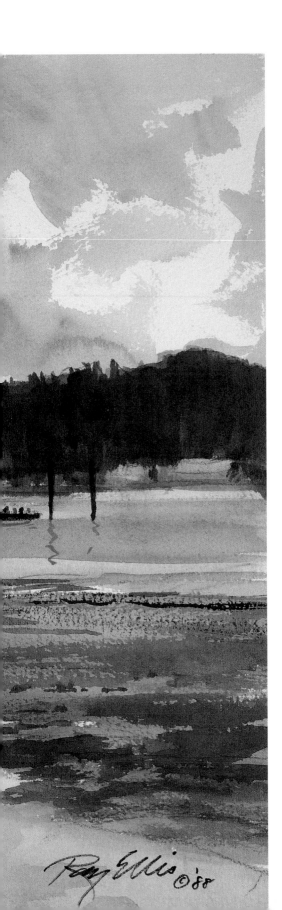

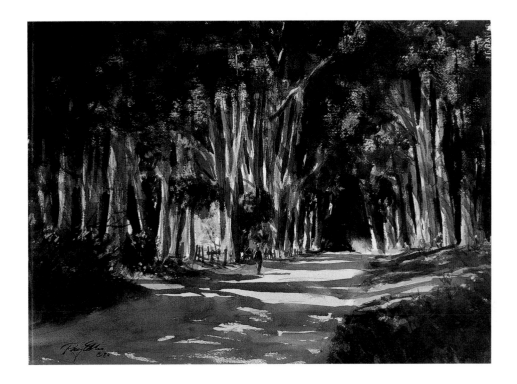

Roads like this along the California shore, lined with huge eucalyptus trees, often lead down to the water, as does this one in Montecito. The light hues of the tree bark contrast well with the shadows across the road.
Walk to the Sea, *1989.*
Watercolor, 15½ x 32 in. (39.4 x 81.3 cm).

Boatyards abound along the west coast, and this one, near Port Townsend, Washington, is shown with the reflections in a puddle after a shower.
Boatyard Reflections, *1988.*
Watercolor, 13½ x 19 in. (34.3 x 48.3 cm).

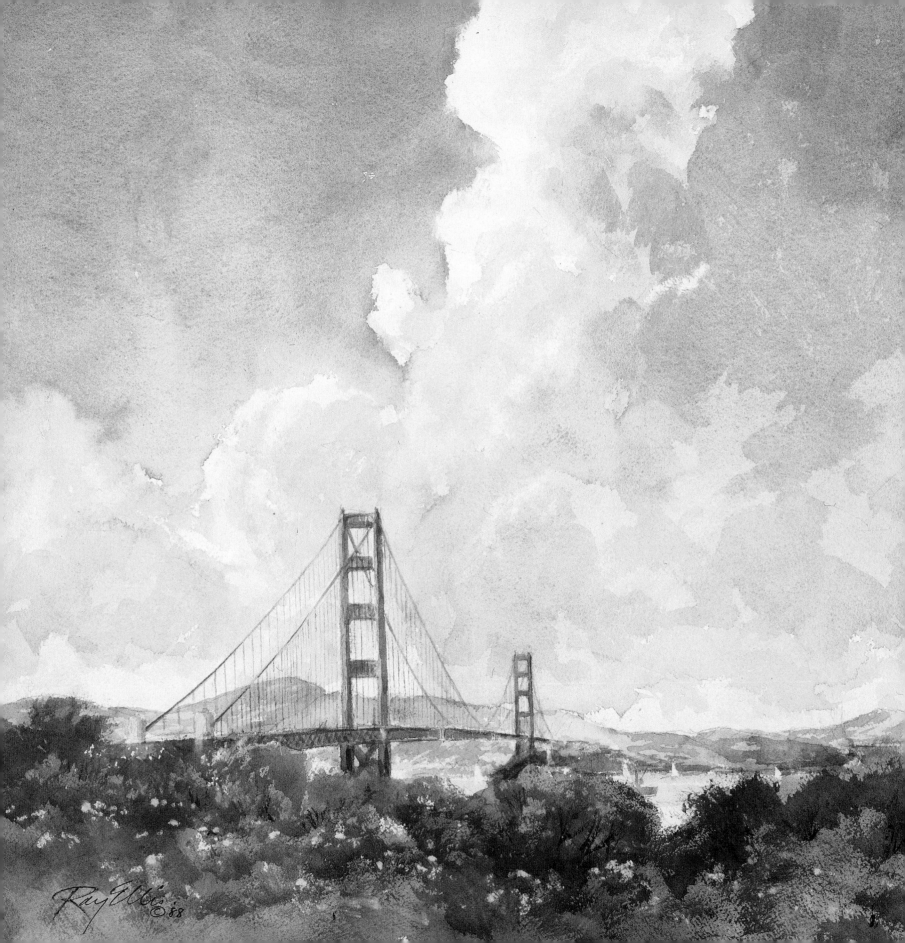

Ray Ellis ©88

San Francisco Bay
to Point Conception

Northern to Central California

California's coastline enters another world from Point Arena south as it bends sharply to the southeast, parallel to the trend of the San Andreas fault. To the north, America is trapped in its head-on collision with the floor underlying the Pacific Ocean. But to the south, these two crustal giants are grinding past one another, their boundary marked by fault-controlled topography, their landscape frequently shuddering from subterranean movements propagating earthquakes out in all directions.

It is believed that the first European to set foot on the shore of northern California was Sir Francis Drake. Aboard his ship the *Golden Hind*, Drake had been conducting raids on Spanish settlements in Central and South America, and in 1579 he landed in California—precisely where is still argued by historians. Many authorities believe Drake missed San Francisco Bay because of the fog and in fact landed near Point Reyes. Although a brass plate was discovered near San Francisco Bay in 1936, and is now on display at the University of California's Bancroft Library, that plate has been dubbed a fake, further contributing to the controversy.

Two hundred years later, in 1769, the Spanish claimed California for their king, and in November of that year Sergeant Jose Ortega became in all likelihood the first Spaniard to see the Golden Gate and the bay beyond.

In this painting a famous landmark is accented by a dramatic sky. I included the red anti-rust paint because I thought a colorful bridge added drama as well.
Golden Gate Bridge, *1988.*
Watercolor, 18½ x 20 in. (47 x 50.8 cm).

The Spanish were determined to make Monterey to the south the capital of their colony of Upper California. Perhaps it was the weather that sent them south away from San Francisco. It was Mark Twain who said that "the coldest winter I ever spent was a summer in San Francisco." For whatever reason, San Francisco grew slowly in its early days, but that changed dramatically when on January 28, 1848, James Marshall looked into the millrace at a sawmill on the American River and saw a bright shining object—gold.

In less than two years, San Francisco's population increased from nine hundred to twenty-five thousand, and by 1890 it had reached three hundred thousand. The forty-niners came overland and by sea. The cheapest way to San Francisco from the East was around Cape Horn, a journey that took four to eight months. More impatient forty-niners who were able to pay a premium could arrive in six to eight weeks after a voyage that took them to the Isthmus of Panama and on canoe and mule through malaria-infested swamps on paths used centuries earlier to haul Inca gold to Spain. Having survived the swamps, passengers then boarded a second ship for the final leg north.

Of all the events in its history, San Francisco is best known for the 8.3-magnitude earthquake that occurred on April 18, 1906, at 5:12 A.M. The fires that followed the earthquake destroyed three-quarters of San Francisco's houses, killed 452 of its citizens and left 250,000 people homeless.

Although earthquakes will forever threaten San Francisco, its citizens have never given up, expanding across the bay in all directions. In 1933 they began their most ambitious construction project, the building of the Golden Gate and Bay Bridges. For years before, engineers were convinced that the Golden Gate could never be spanned, since its waters reached depths of 318 feet (97 m) and tidal currents were strong. But when the bridge was finally completed in May 1937 at a cost of thirty-five million dollars, it covered a distance of seven miles with a suspension section of 6,450 feet and eighty thousand miles of cable. Every year more than seventeen million cars travel over the bridge, while its maintenance crews cover it with ten thousand gallons of paint.

In the nineteenth century, San Francisco's famous Fisherman's Wharf was home to a Genoese fishing fleet notable for its classic feluccas, boats with triangular sails. On the docks were metal canning sheds and warehouses, and the smell of fish filled the air. Today tourists come to the wharf to eat in its many seafood restaurants or to enjoy some Dungeness crab in a paper cup and window-shop on the boardwalk complete with wax museum.

The major fishing industry on the peninsula in the 1940s was to the south in Monterey Bay. Made famous by local author John Steinbeck, Cannery Row in its heyday was a thriving sardine fishery that supported eighteen canneries, a hundred boats, and four thousand workers. At its peak two hundred thousand tons of fish were harvested annually. On the beaches, covered with fish guts and flies, the stench was sickening.

The Cannery Row of today has lost its smell but not its charm. Here you will find the Monterey Aquarium as well as another Fisherman's Wharf. Tourists can learn about the great submarine canyon that lies offshore or watch the sea otters playing in kelp forests a short distance from shore. Kelp, incidentally, is harvested for iodine and has various uses, primarily as an emulsifier in paints, ice cream, and beer.

Like so many other micro-environments along the West Coast, the Monterey Peninsula is the only place in the world where the Monterey cypress is found. Gnarled and twisted by the constant wind blowing off the Pacific, the lone pine cypress—the most famous species—grows out of rocky cliffs along the famous Seventeen-Mile Drive.

Many people come to this part of the world to play on one of the area's equally famous golf courses. At Cypress Point and Pebble Beach, golfers are treated to spectacular views that may at times include grazing black-tailed deer or a passing pod of gray whales.

A favorite pastime for visitors and Californians alike is whale watching. They're hard to miss as they hug the coast, which helps them navigate. Mists of spray fill the air when each whale exhales just below the surface, revealing a pod of three to five animals, a common sight from the high cliffs of Big Sur. Each year between mid-December and early February, gray whales undertake a six-thousand-mile (9,660 km) migration from their feeding area in the rich cold waters of the Bering Sea to the warm lagoons of Baja California where they give birth. At birth, calves typically weigh a ton (907 kg) and are sixteen feet (4.9 m) long. After calving, adult animals breed again, then in March head north to feed. Calves are weaned seven months later, having by then reached a length of twenty-six feet (7.9 m).

Since the whales can live forty to fifty years, they know the way. But as they make this annual pilgrimage, the pod must be constantly on the lookout for their primary enemy in nature, the killer whale. But it was man who once truly decimated their numbers. Fortunately that slaughter

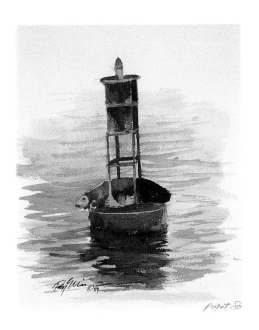

Seals always seem to find a good place to rest.
This channel buoy was a convenient spot.
Buoy and Seal, *1989.*
Watercolor, 10 x 8 in. (25.4 x 20.3 cm).

has been halted, and gray whales are now estimated to have reached a population of seventeen thousand.

Despite its natural beauty, few people live in Big Sur, once home of the condor that soared over the six-thousand-foot (1,830 m) peaks of the Santa Lucia Mountains and their canyons filled with wildflowers. One person, however, fell in love with Big Sur and purchased more than 275,000 acres. Atop La Cuesta ("The Enchanted Hill") he built a castle. When completed, after twenty-seven years of construction, William Randolph Hearst's castle in San Simeon had thirty-seven bedrooms and a zoo with ninety species of animals. Some of the most famous movie actors and actresses of the 1930s and 40s were frequent visitors at San Simeon. Clark Gable, Cary Grant, Mary Pickford, and Charlie Chaplin were but a few such luminaries.

Big Sur is perhaps best seen from the ocean, although sailing this coast can be difficult, especially when fog rolls in or when storm winds send waves crashing against the sea cliffs and rocky outcrops. For many people, however, the charm of Big Sur is to be found in the solitude of its beaches—walking the sand on the outgoing tide, listening to the sounds of circling seagulls and pounding surf.

Farther down the coast stands Morro Rock, "the Gibraltar of the Pacific," a 575-foot high rock dome first sighted by the Spanish explorer Juan Cabrillo. A spit of sand connects with the shore, and peregrine falcons now nest in this giant's formerly quarried cliffs.

Along this stretch of the California coastline, less traveled than other areas, hard-packed sand beaches are in spots accessible by car. One such place is Pismo Beach, which became famous in the 1930s and 40s for the "Dunites" who came here to enjoy magnificent sand dunes as well as nude beaches. Actually, this cool, fog-covered beach is more hospitable to the Pismo clam than to sunbathers. Weighing as much as one and a half pounds (680 g), this mollusk must be at least four and a half inches (114 mm) in diameter to be a "keeper," but one such animal is sufficient to make clam chowder for an entire family.

Point Conception is generally considered the separation point between northern and southern California. Frequently cloaked in fog, it was a dangerous passage in the early years of coastal sailing, when its rocky outcrops claimed many ships. Today it is better known for the missiles launched from Vandenberg Air Force Base, for its thousands of acres of flowers, and for La Purisima Mission, the best restored of California's twenty-one Spanish missions.

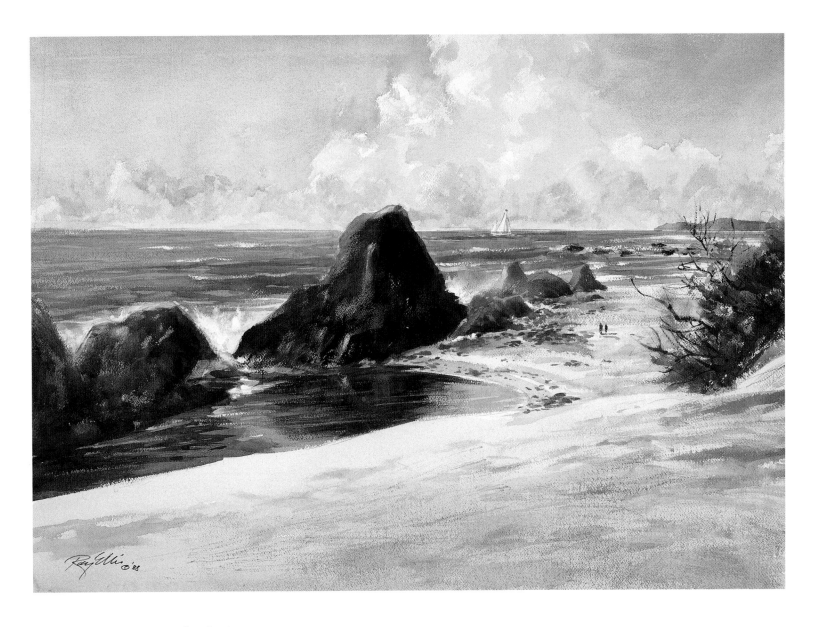

In this painting I was interested in showing
the immensity of the rocks protecting the
beaches and how treacherous it can be to sail
off this northern California coast.
Beyond the Reefs, *1988.*
Watercolor, 21 x 29 in. (53.3 x 73.7 cm).

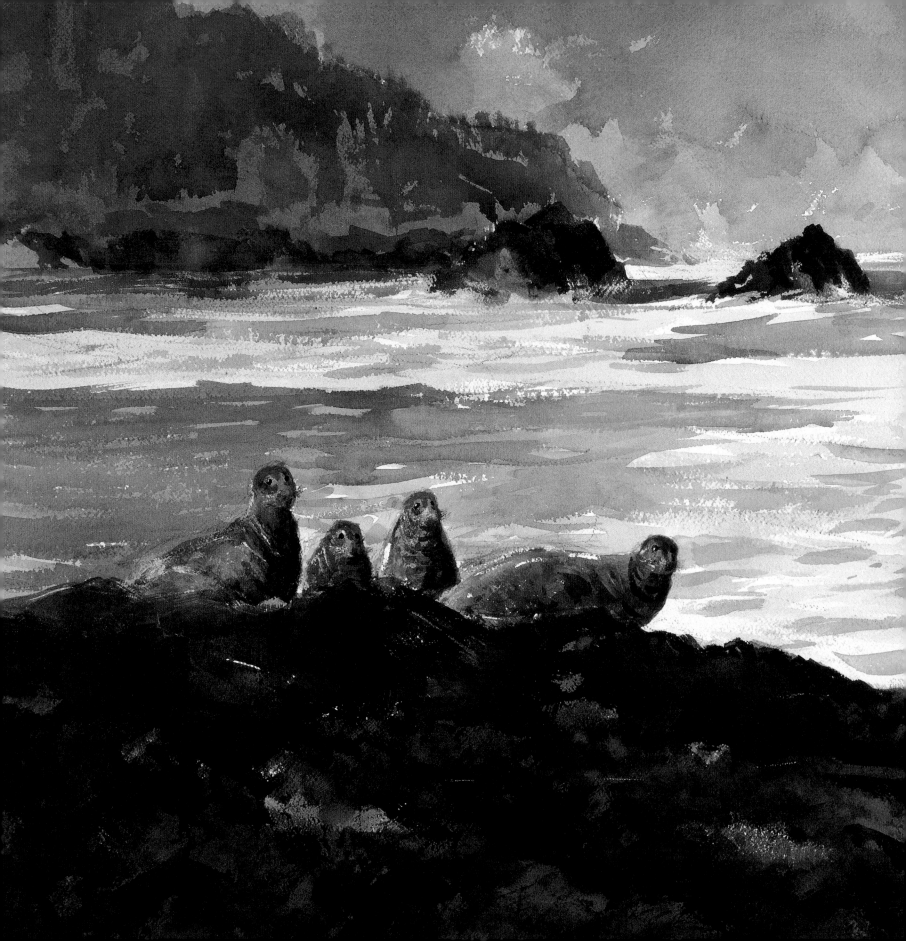

These inquisitive creatures can be seen in groups on rocks up and down the west coast. I was excited about the dark, crusted rocks against frothy, green surf.
Seals, 1989.
Watercolor, 18 x 27 ½ in. (45.7 x 69.9 cm).

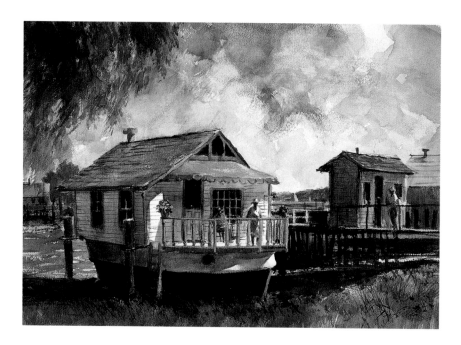

There is no other place quite like Sausalito.
Houseboats of every color of the rainbow line
the harbor, and each one has its own character.
This one — with its front porch, pink awning,
and railing — especially intrigued me.
Houseboat in Sausalito, *1989.*
Watercolor, 16 x 23 in. (40.8 x 58.4 cm).

For many generations of artists this area on
the West Coast was comparable to Gloucester,
Massachusetts, north of Boston. Here, dozens
of fishing boats line the wharf, the mostly
white hulls reflected in the milky green water.
In addition, the smoke from the exhausts
provided the atmosphere I was looking for.
Fisherman's Wharf, *1987.*
Oil, 12 x 18 in. (30.5 x 45.7 cm).

ABOVE:

When I made this painting in 1989 I had no idea that this would be the site of such destruction in a subsequent earthquake. The sloop sailing by is reminiscent of happier days.
By the Bay Bridge, *1989.*
Watercolor, 12 x 15½ in. (30.5 x 39.4 cm).

OPPOSITE:

To achieve the varied colors of the water, the surf rolling in past the rocks, and the shadows cast from the cliffs, I applied many wet-into-wet watercolor washes.
Monterey Coast, *1989.*
Watercolor, 18½ x 28 in. (47 x 71.7 cm).

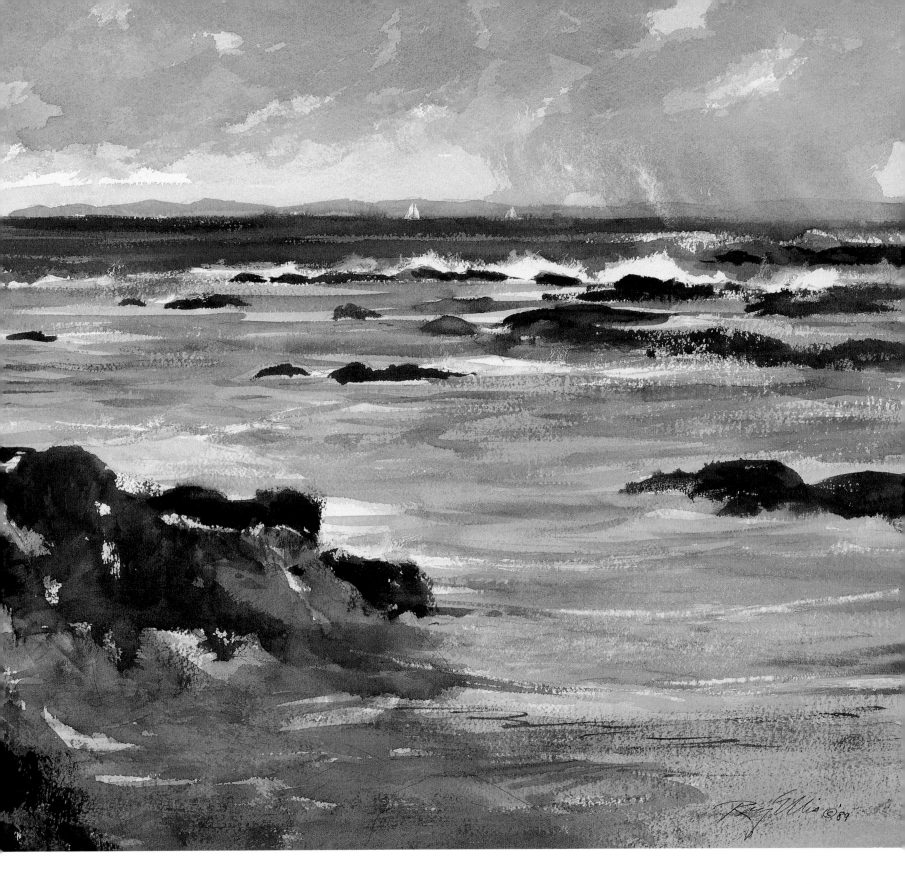

Some of the most beautiful landscapes can be found on golf courses, such as this one from the seventeenth hole at Cypress Point.
Cypress Point, *1991.*
Watercolor, 17 x 28½ in. (43.2 x 72.4 cm).

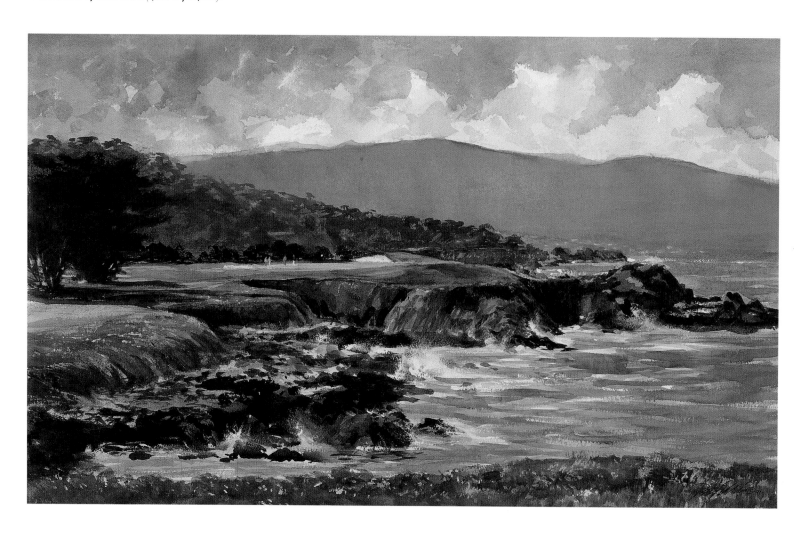

Overlooking an incredible setting on Monterey Bay, this weathered tree has become a well-known landmark.
Lonesome Pine, *1989.*
Oil, 20 x 30 in. (50.8 x 76.2 cm).

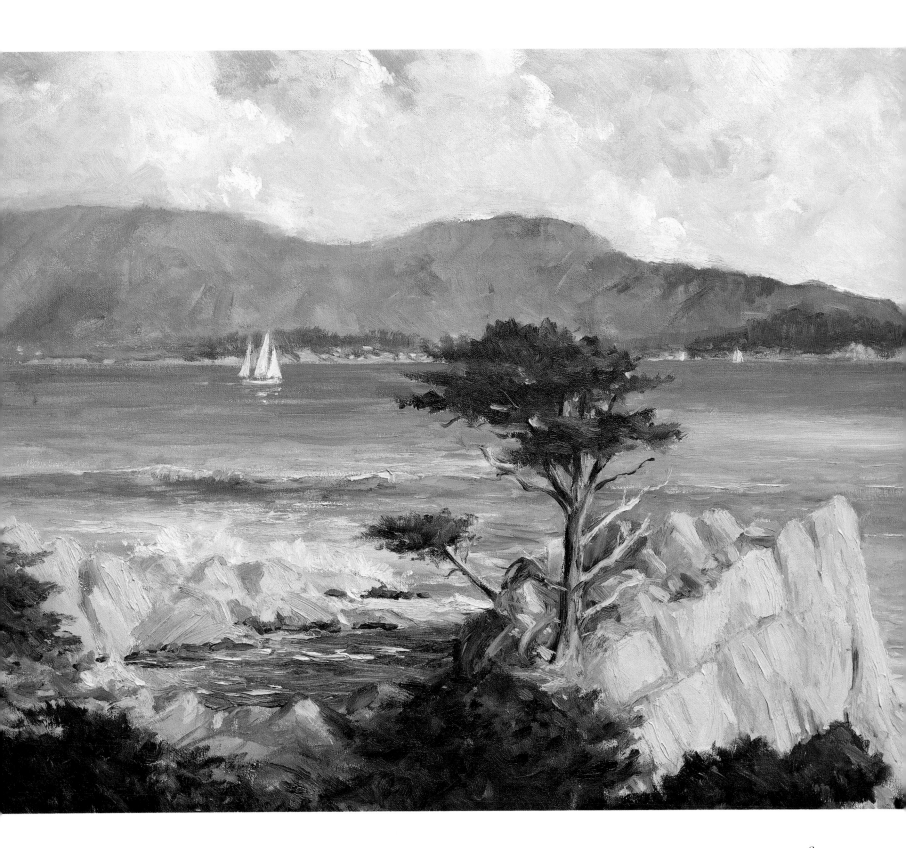

*These cedar trees seem to be growing right out
of the sea. Their roots are exposed and their
limbs twist among rocks and crevices.*
Weathered Cedar, *1988.*
Watercolor, 24 x 39 in. (61 x 99.1 cm).

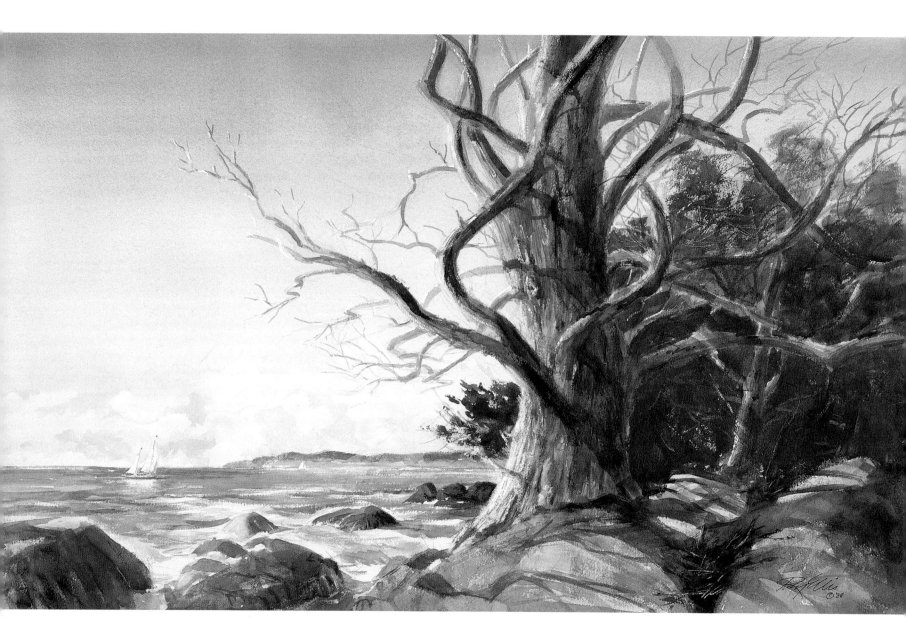

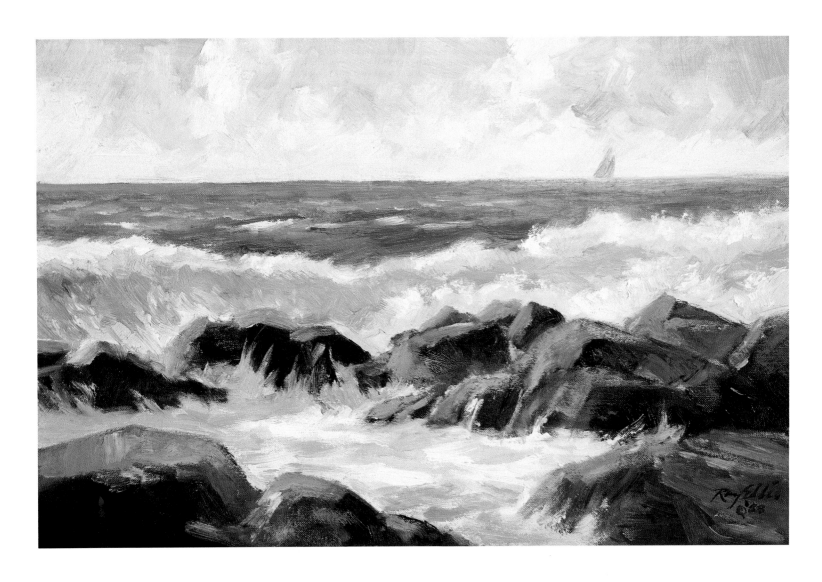

Some of the rocks along the coast near
Monterey take on a reddish color and in the
right light can become a brilliant orange—
quite a contrast to the foaming bluish greens
of the pounding surf.
Off the Rocky Coast, *1988.*
Oil, *12 x 18 in. (30.5 x 45.7 cm).*

In this scene a schooner rounds a point off Big Sur.
Moonlight Off Big Sur, *1989. Oil, 24 x 30 in. (61 x 76.2 cm).*

Whales "sounding" is a familiar sight off the west coast, but seeing these animals from a close vantage point never ceases to be a thrill.

Humpback Whales Off Big Sur, *1989. Watercolor, 13 x 39 in. (33 x 99.1 cm).*

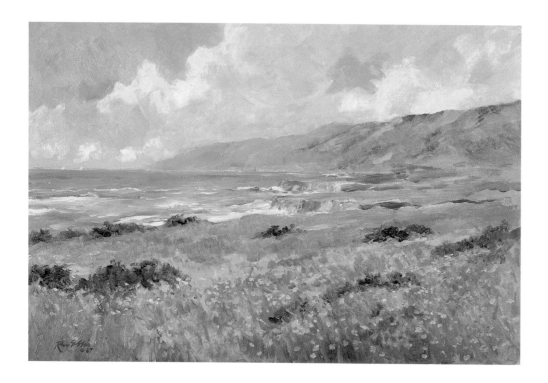

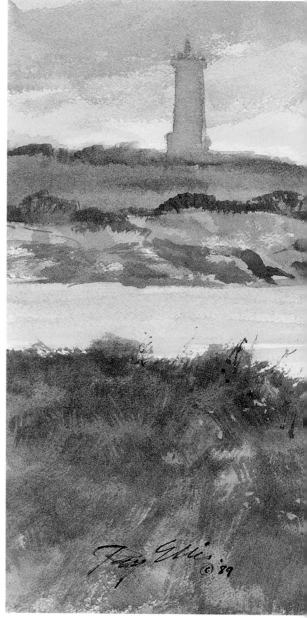

Above the cliffs that protrude over the sea,
fields are ablaze with wild mustard, daisies,
and many other flowers. On the day I made
this painting the hills seemed almost to blend
with the sky.
Spring on Big Sur, *1987.*
Oil, *24 x 36 in. (61 x 91.4 cm).*

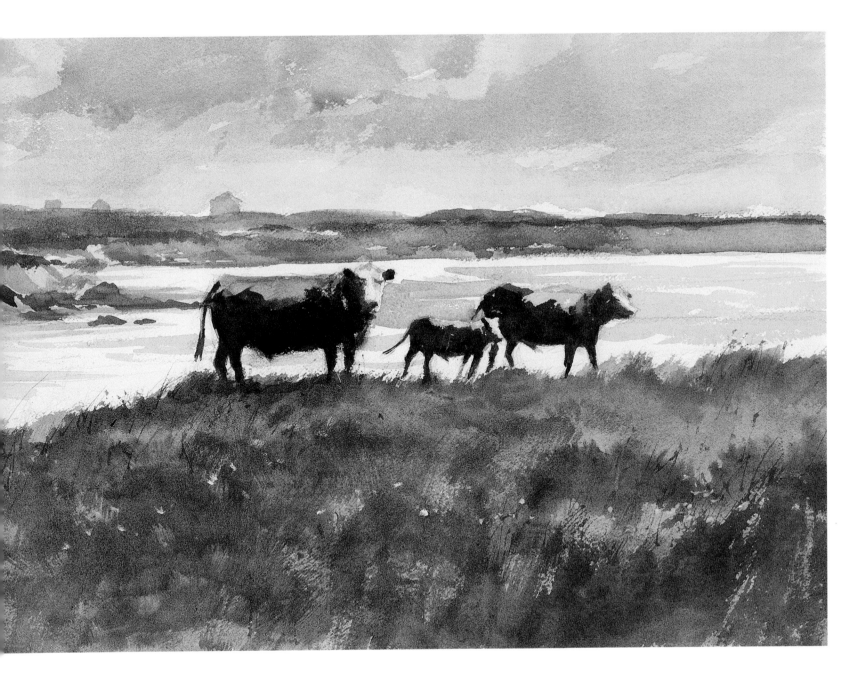

Cattle graze right down to the water's edge along this rocky coast. The animals made interesting silhouettes against the surf.
Grazing on Big Sur, *1989.*
Watercolor, 13½ x 25 in. (34.3 x 63.5 cm).

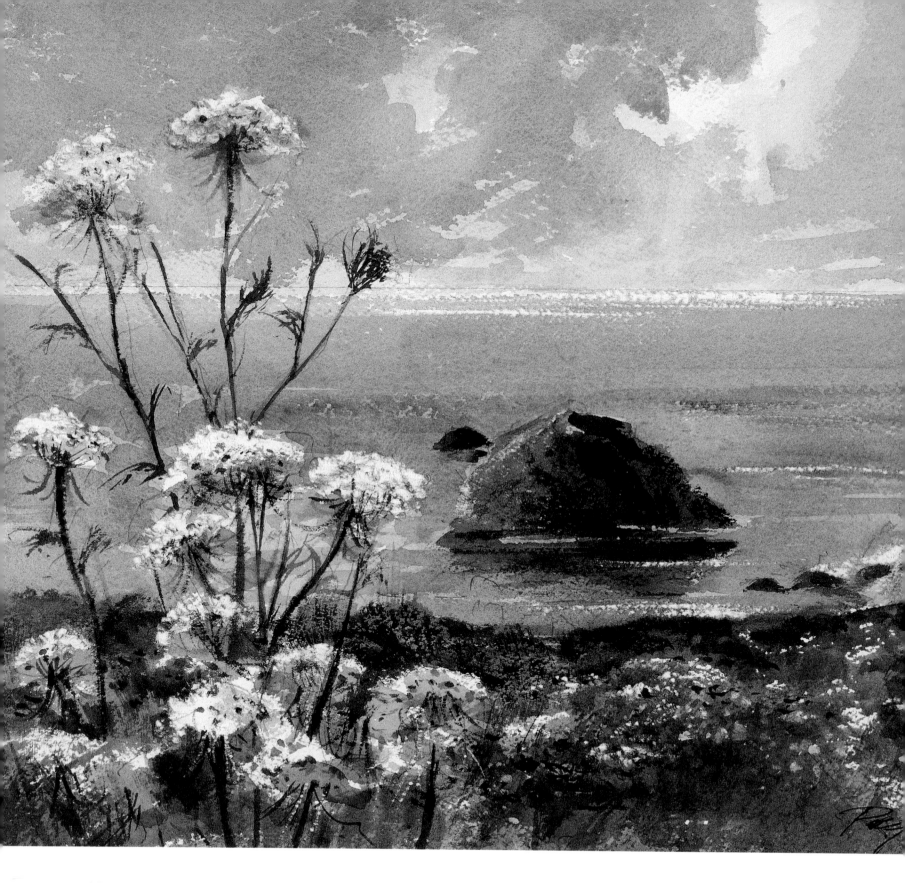

Queen Anne's lace has always been my
favorite weed. I've included it in landscapes
as well as in still lifes.
Queen Anne's Lace, *1989.*
Watercolor, 10⅝ x 13 in. (27 x 33 cm).

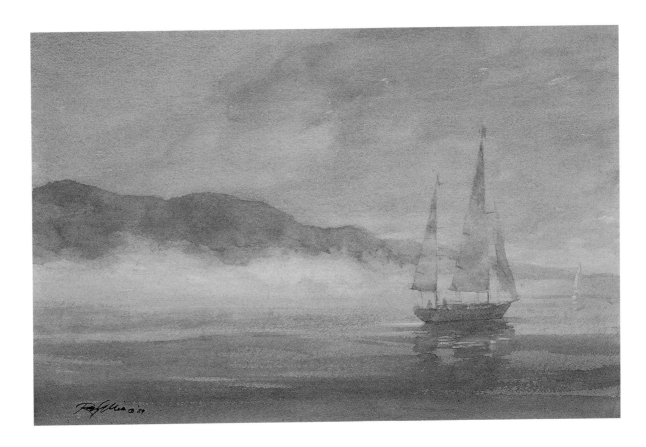

Out of sea mist ghostlike ships suddenly appear
then, just as quickly, disappear.
Ground Fog, *1989.*
Watercolor, 16 x 24½ in. (50.6 x 62.2 cm).

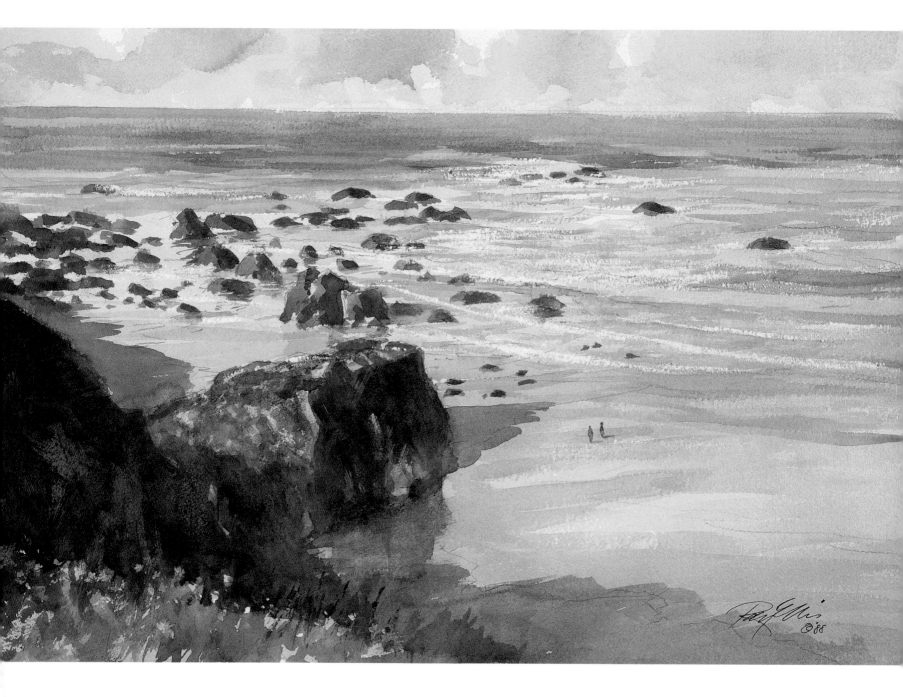

Two figures walking are dwarfed by an
expanse of beach with smashing surf.
Beach Walkers, *1988.*
Watercolor, 14½ x 20 in. (36.8 x 50.8 cm).

*This dramatic view of a rock-strewn shoreline
typifies many along the California coast.
In this scene I especially liked the reflections
in the wet sand.*
Rocky Point, *1987.*
Oil, 24 x 30 in. (61 x 76.2 cm).

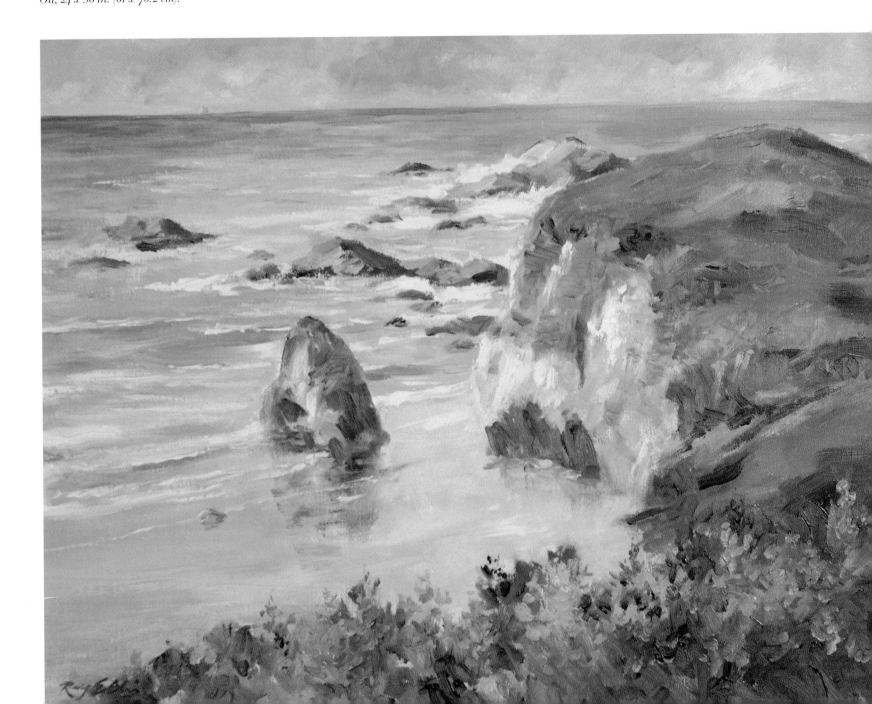

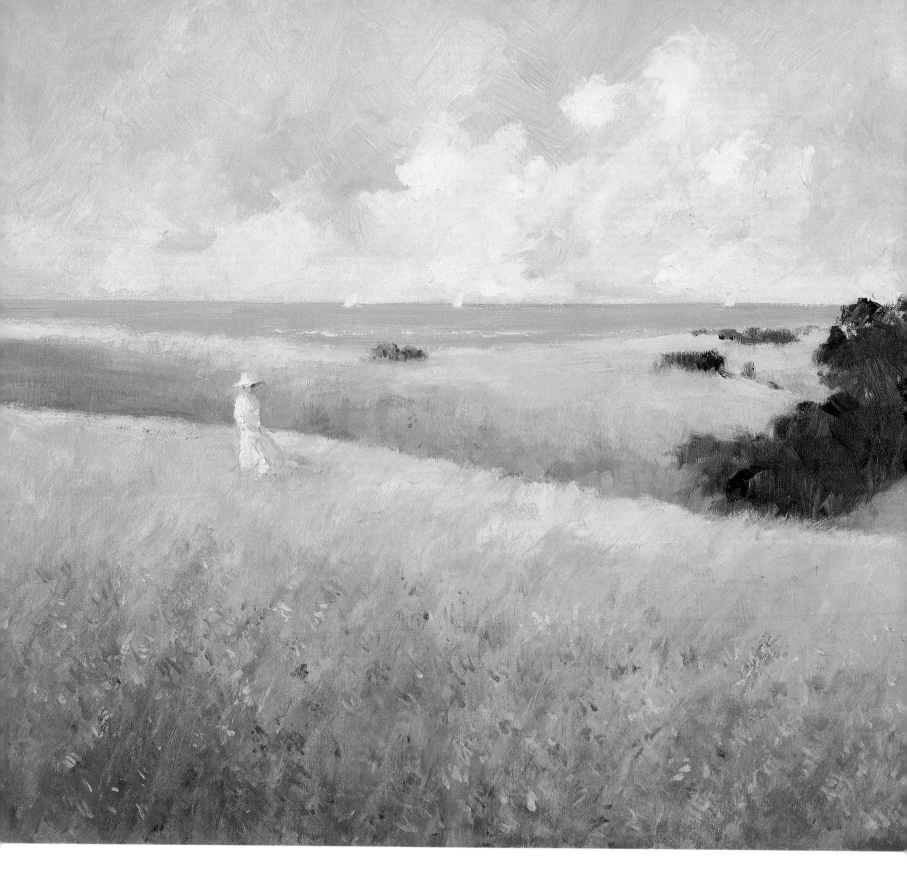

Just below the Hearst Castle are rolling hills
of soft grasses blowing in the wind off the sea.
I tried to capture the softness of this beautiful
day and hope the viewer can smell the fresh
salt air.
The Hills of San Simeon, *1988.*
Oil, 20 x 28 in. (50.8 x 71.1 cm).

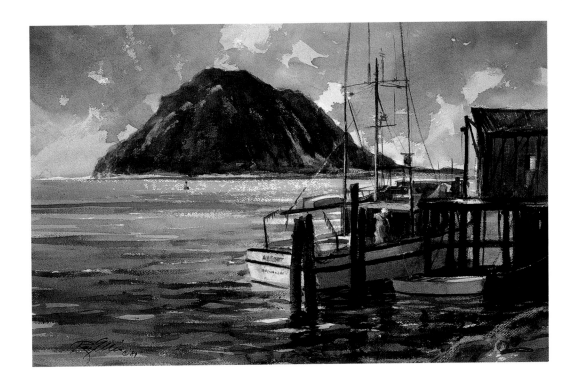

Morro Bay is one of the few harbors on
the northern coast of California protected
enough to be a well-used haven of fishermen
and yachtsmen. The harbor is easily recog-
nizable by the 576-foot-high (176 m) rock at
its entrance.
Morro Bay, *1989.*
Watercolor, 16 x 24½ in. (50.6 x 62.2 cm).

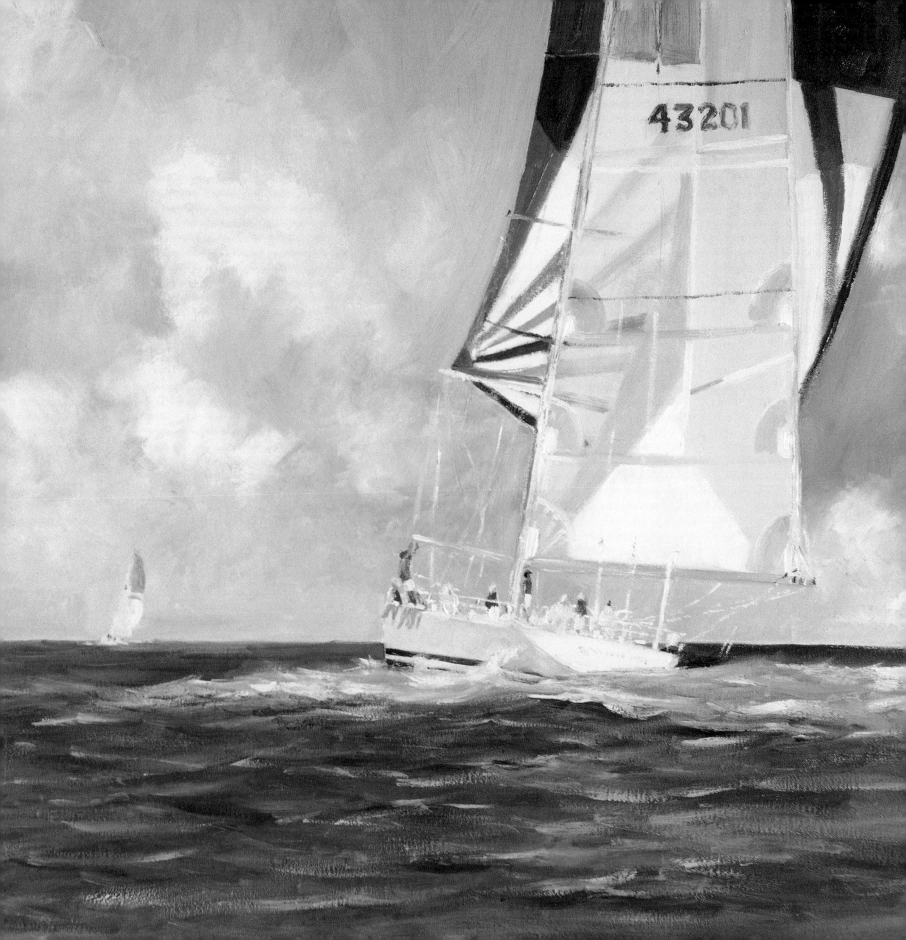

Santa Barbara
to San Diego

Walking the water's edge north of Santa Barbara can be a sticky matter. Underlying the seafloor is a rock strata saturated with oil that over time has migrated upward through a maze of faults, flowing out of cracks in the bottom of the ocean. There the oil quickly turns into tar, which floats to the surface and is washed ashore.

Native Americans were the first to discover this black gold. They used it to seal their canoes. Now the channel between Santa Barbara and the offshore islands is dotted with mobile exploratory drilling platforms from which pipes are sunk deep into the submerged dome trapping the oil reserves. Interestingly enough, the pumping of oil and gas out of this anticline has lowered the natural hydraulic pressure within the formation, and so the amount of natural oil seepage, which forms the tar on the beach, has been reduced.

Tar or no tar, the long, straight beaches south of Point Conception are the popular haunt of surfers who every day can be found at Refugio, Campus Beach, Rincon, or El Capitan, always looking for the perfect wave to "hang ten."

Tall cliffs rising above the sandy beaches expose vestiges of ancient

As a boy I took great pride in drawing and building models of J-boats such as Enterprise *and* Shamrock. *I still find the America's Cup race exciting, although the boats are much smaller than the old J boats. Even so, maxies are great to sail and fun to watch.*
Maxie Race *(detail), 1989.*
Oil, 24 x 40 in. (61 x 101.6 cm).

shorelines. If you like looking for fossil seashells, the beach near the University of California at Santa Barbara is the place to go. Millions of fossil clams hidden beneath an ancient beach can be seen in the walls of the seacliffs.

Each year, winter storms sandblast the beaches, reducing some to bare rock and undercutting the seacliffs, which collapse onto the beaches and resupply their depleted ranks. In the spring and into the summer, longshore currents rework the sands, building the beaches back up.

Unlike in the north, the seafloor off Santa Barbara and stretching down to the border with Mexico is complex. It is referred to by marine geologists as the continental borderland. Instead of having a simple continental shelf like that found off the coasts of Oregon and Washington, where the bottom slopes continuously offshore until it reaches abyssal depths, the seafloor of southern California consists of alternating basins and banks. It is as if this offshore area were a series of boxes, some of which have been filled to the surface to form islands or banks, while others have been left empty to create deep basins.

Eight of these "boxes" rising above sea level and lying eleven to forty miles (18 to 64 km) offshore form the Channel Islands. On many of these islands—Santa Cruz and Santa Catalina, for example—are artifacts of Native American settlements.

Catalina was originally inhabited by the Gabrielinos Indians, named after one of the Spanish missions in California. Juan Rodriguez Cabrillo, who first encountered them during his expeditions in 1542, is thought to be buried on San Miguel Island. The Indians lived on Catalina for approximately 4,000 years before being evicted by Europeans in the early nineteenth century, when pirates and smugglers used the island.

Once upon a time on Catalina there was a herd of four hundred bison— then the largest in America. Today, foxes, black antelopes, and mountain goats still live in the island's rugged inland mountains.

In 1911, chewing gum millionaire William Wrigley, Jr., purchased Catalina and constructed a magnificent seven-thousand-square-foot (650 sq. m) Georgian Colonial mansion and, having discovered a loophole in California's antigambling laws, built the grand Avalon Casino. Its Art Deco design attracted countless tourists, who took boats and seaplanes to the island to hear big bands like Glen Miller's.

Today, while gambling is gone, the mansion is an inn for tourists who visit the island to ride in glass-bottomed boats, to admire flying fish, to explore hidden coves, and to take advantage of the island's incredible diving.

It is hard to believe that Los Angeles is just twenty-six miles (42 km) away, but on a crystal-clear day the cliffs of Palos Verdes seem to be within reach of Catalina. With its steep cliffs, marine terraces, and scenic rocky shoreline, Palos Verdes is without a doubt the prettiest section of coast near Los Angeles. As the peninsula of Palos Verdes continues to rise from the sea, some of its elegant houses and paved roads regularly slide down the hill and into the water, despite some of the most complicated and expensive attempts to halt the inevitable. At night the view of city lights is truly spectacular. By day one can see sailing ships racing with the wind and a long line of waves rolling in on Redondo and Hermosa Beaches to the north.

Evidence of southern California's love affair with the water's edge can be found from Malibu and Santa Monica down through Long Beach, Seal Beach, and Huntington Beach, where sunbathers hoping to achieve the perfect tan pack the beaches in the summer.

Every wave that rolls in seems to be carrying a host of bodysurfers trying not to be run over by someone on the latest surfboard design. Anyone not riding a wave or lying on a beach towel is likely to be people-watching or playing volleyball until they become so hot and sandy that the only relief is to jump into the water and begin the cycle again. The mecca for yachtsmen is farther south—at Balboa, Newport, and Dana Point, where yachts pack tightly into marinas while their owners visit the local yacht club.

Fabulous and expensive homes crowd the shoreline, clinging to every available cliff, positioned to watch the sun as it sinks below the vast Pacific horizon. The Mediterranean climate of southern California is echoed in its Spanish—and pseudo-Spanish—architecture.

Nearby Mission San Juan Capistrano, famous for its swallows, is a unique hideaway complete with gardens, ponds, and the ruins of the old stone church, which was destroyed in the 1812 earthquake. If you are lucky you will see the swallows that make their annual migration to and from Argentina, arriving around March 19.

When many people think of southern California they imagine a huge elongated city running from Los Angeles to San Diego. Contrary to this impression, there are vast stretches of shoreline between these cities that

Probably the most playful among all the creatures of the sea, the sea otter, with its huge whiskers, resembles an old relative of mine.
Sea Otters, *1997.*
Watercolor, 5¾ x 12 in. (14.6 x 30.5 cm).

are sparsely populated. One reason for this is the existence of Camp Pendleton, the large Marine Corps training area that includes twenty miles (32 km) of coastline, where it is not unusual to see thousands of Marines storming ashore in tanks attacking a hypothetical enemy. It is here that many movies about the Second World War starring John Wayne were filmed.

Oceanside is another haven for the yachts that run up and down the coast. It is also a place where elevated terraces with water views and carpeted with fields of flowers can be seen. The same can be said for San Clemente, site of President Nixon's western White House and near the present location of the Nixon Museum.

La Jolla, as its Spanish name implies, is a "jewel," a lovely rocky peninsula that juts into the Pacific, its headlands pocked with caves and coves. La Jolla Cove is an extremely dangerous area to swim in, as it is known to be frequented by sharks, including the great white.

From a grass-covered mesa atop La Jolla Cove there is a commanding view of Scripps, the largest oceanographic institution in the world. Its long curving beach transports sand offshore to magnificent submarine canyons cutting deeply into the continental margin where scientists have studied for decades.

South of La Jolla, San Diego is also a city with close ties to the sea, particularly through the U.S. Navy. The city's large harbor has been home port for many ships of the Pacific fleet. Active aircraft carriers and submarines can be seen at the dock, as well as such replicas of bygone eras as the *Star of India*, America's oldest iron-hulled merchant ship still afloat.

The island of Coronado is a study in contrasts that parallels San Diego's own duality. At the north end of the island is the massive Coronado Naval Air Station. Jets booming overhead create a mood contrasting starkly with that of the center of the island where one finds the elegant Hotel Del Coronado. Opened in 1888, the hotel is renowned for its orange gables, cupolas, and window peaks. Here by the pool of Hotel Del Coronado the duke of Windsor met his future duchess.

What is also wonderful about San Diego, for admirers of the sea, is Mission Bay. Encompassing 4,600 acres (1,862 h) of protected islands and lagoons as well as twenty-seven miles (43 km) of sandy beaches, this is the largest aquatic municipal park in the world. It is, by the way, a haven for windsurfers, who might find the open sea a little too rough.

There are many stretches of beach on the
California coast with huge waves that attract
surfers from far and wide.
Surfer's Beach, *1989.*
Oil, 24 x 36 in. (61 x 91.4 cm).

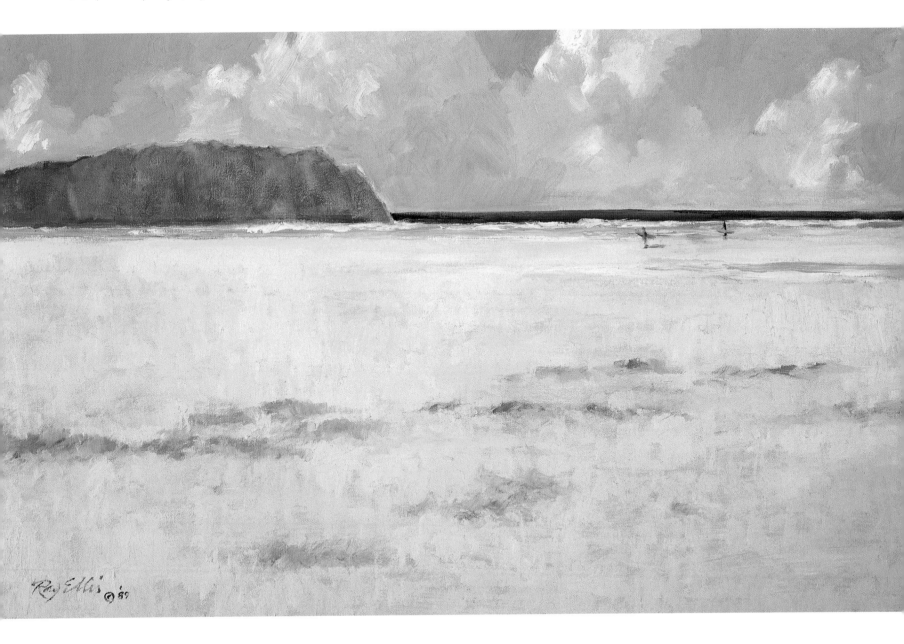

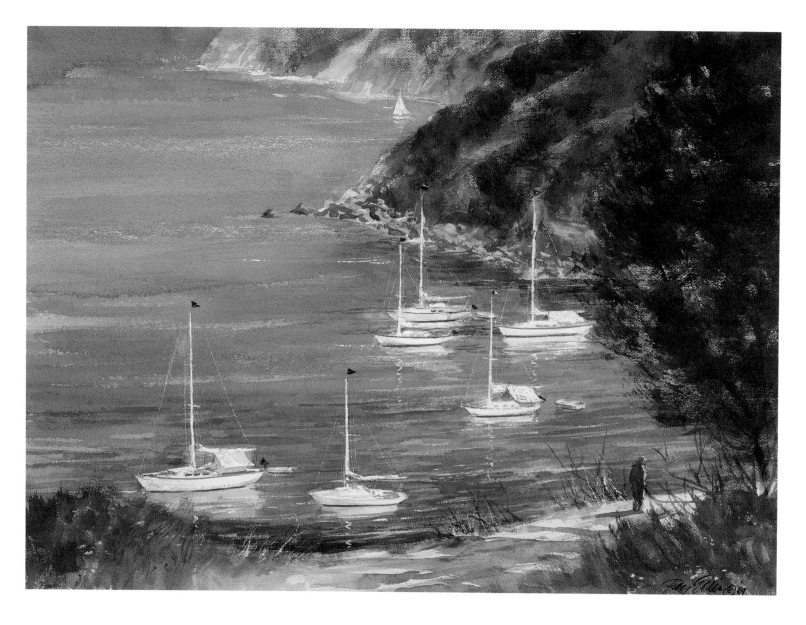

A favorite site of yachtsmen from southern California ports is Catalina Island. It is so popular, in fact, that docks and moorings can be scarce, and many visitors choose to anchor. Nestled under picturesque cliffs, Big Finger Cove is a prime spot.
Big Finger Cove, 1989. Watercolor, 21 x 28½ in. (53.3 x 72.4 cm).

In 1925 my mother took me to Catalina Island, then owned by William Wrigley, Jr. It was a great treat to return after so many years and to paint the great vistas I had seen as a child.
Catalina Cove, 1989. Oil, 24 x 30 in. (61 x 76.2 cm).

OVERLEAF:
Hundreds of sailboats of all sizes and shapes participated in the race from Newport Beach to Ensenada, Mexico. I had never witnessed anything like this race, nor had I ever experienced anything like the celebration at the end of it. Sailors practically took over the town of Ensenada in a weekend of total fun and madness.

The Start, *1989. Oil, 17 x 36 in. (43.2 x 91.4 cm).*

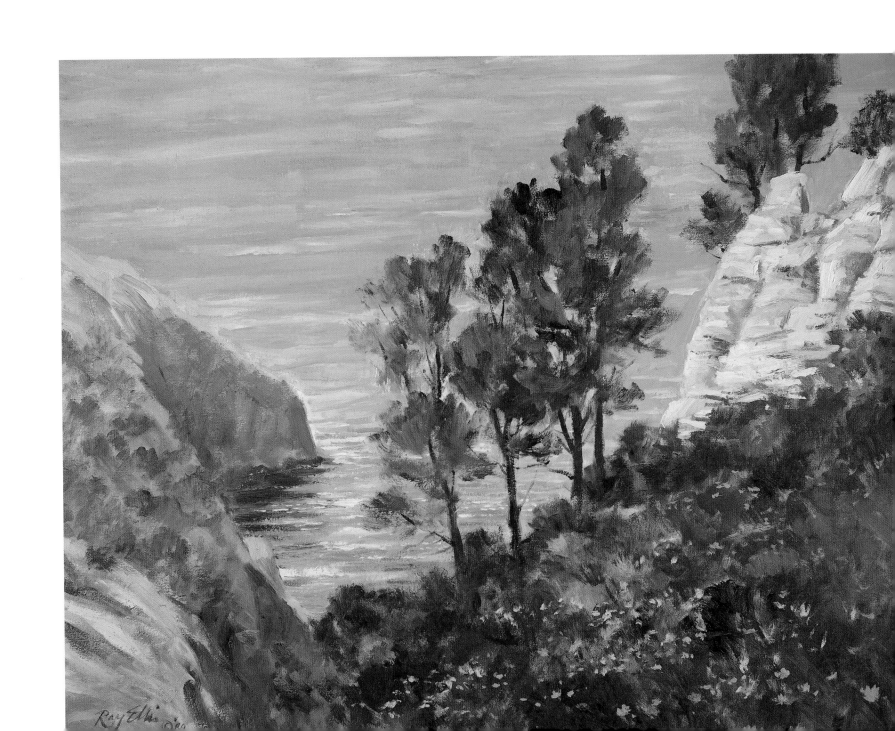

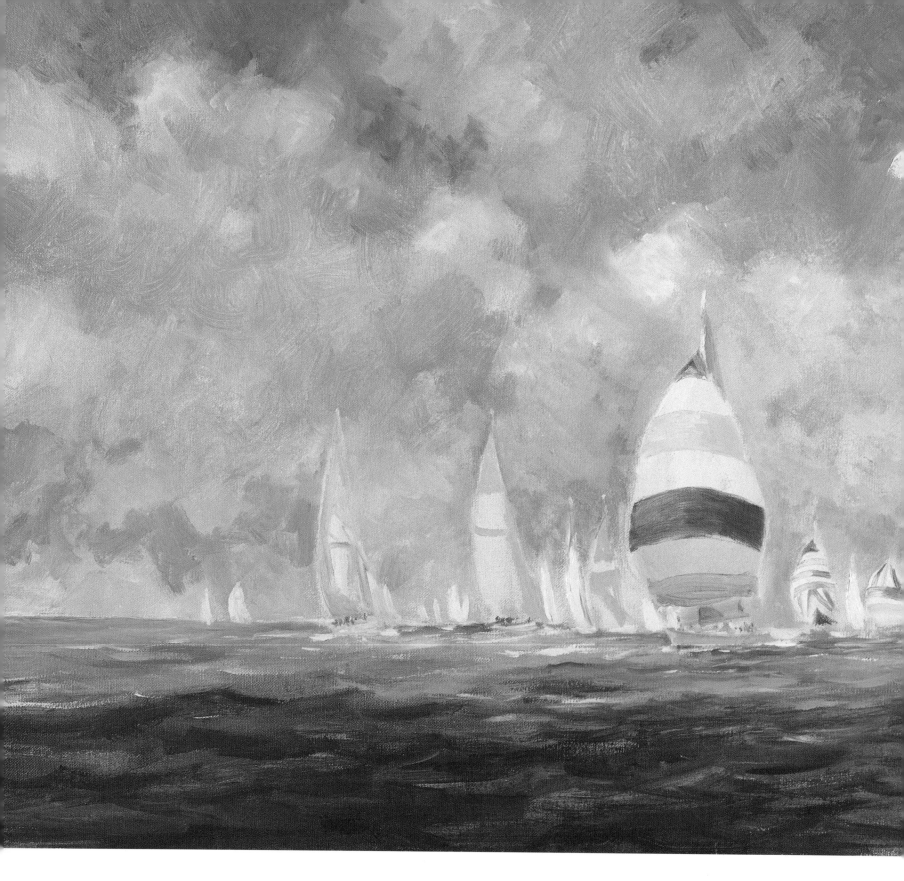

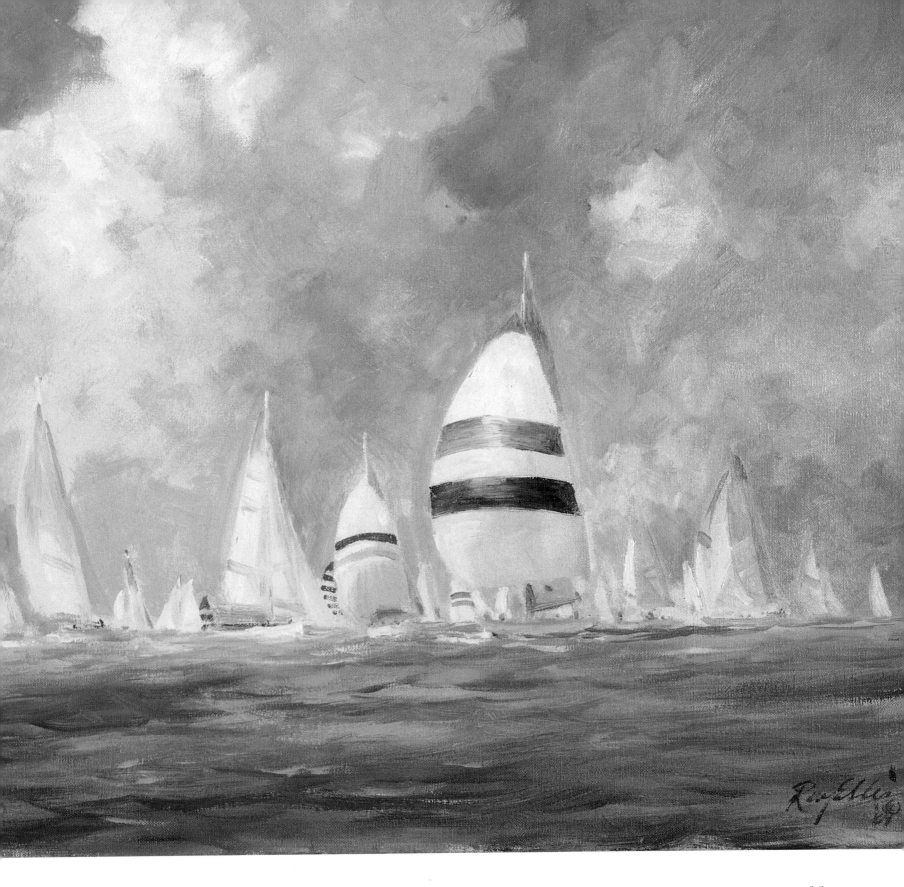

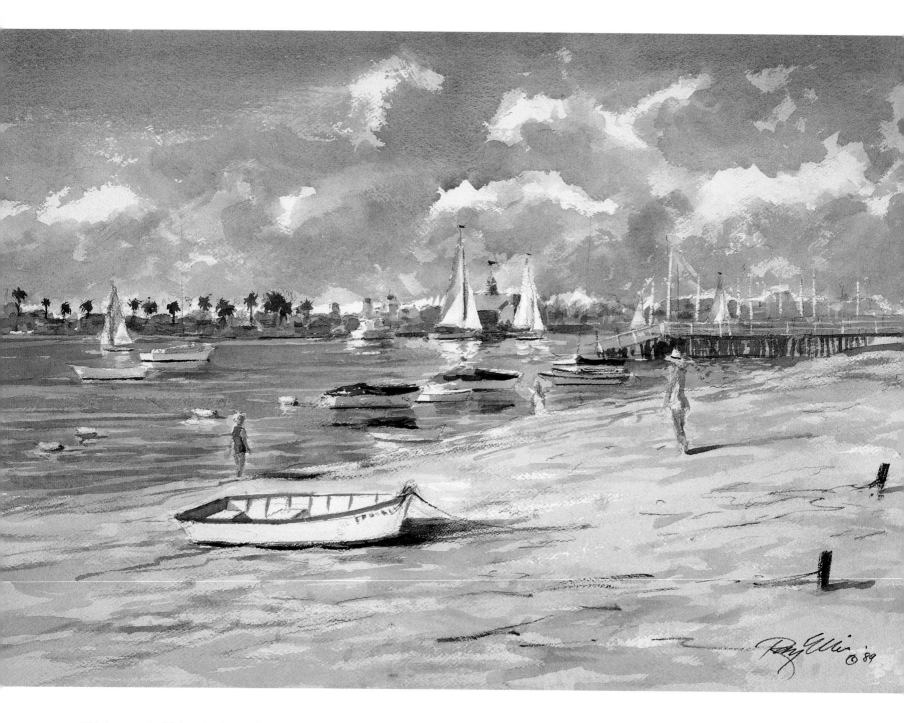

This is a wonderful, busy harbor and a haven for small craft. It is also the home of Balboa Yacht Club.
Balboa Harbor, *1989. Watercolor, 15 x 22 in. (38.1 x 55.9 cm).*

As I was doing a sketch for this painting, sailboats were making a dash for the protected harbor to escape a sudden squall so violent that it had already ripped the mainsail from one of the sloops. In from the Squall, *1987. Oil, 16 x 20 in. (40.6 x 50.8 cm)*.

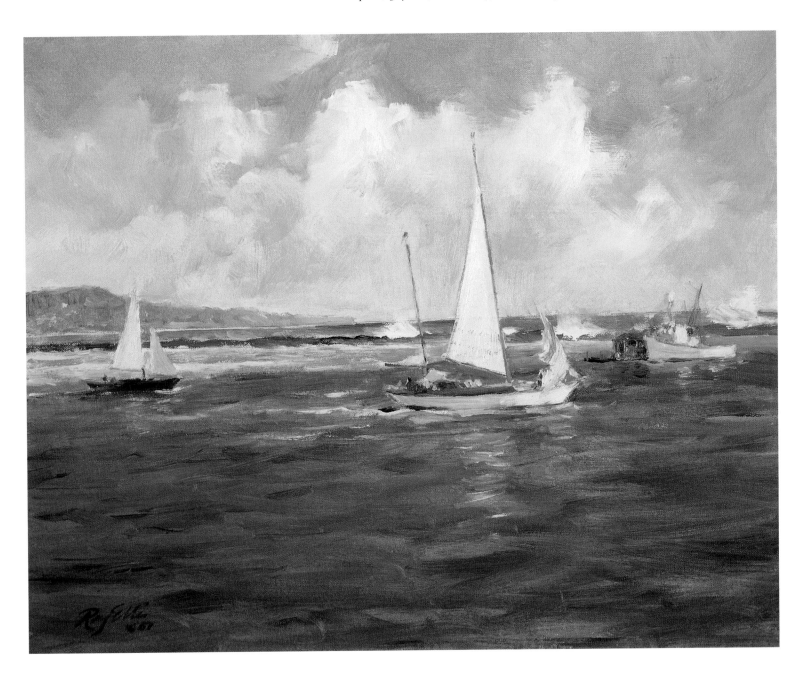

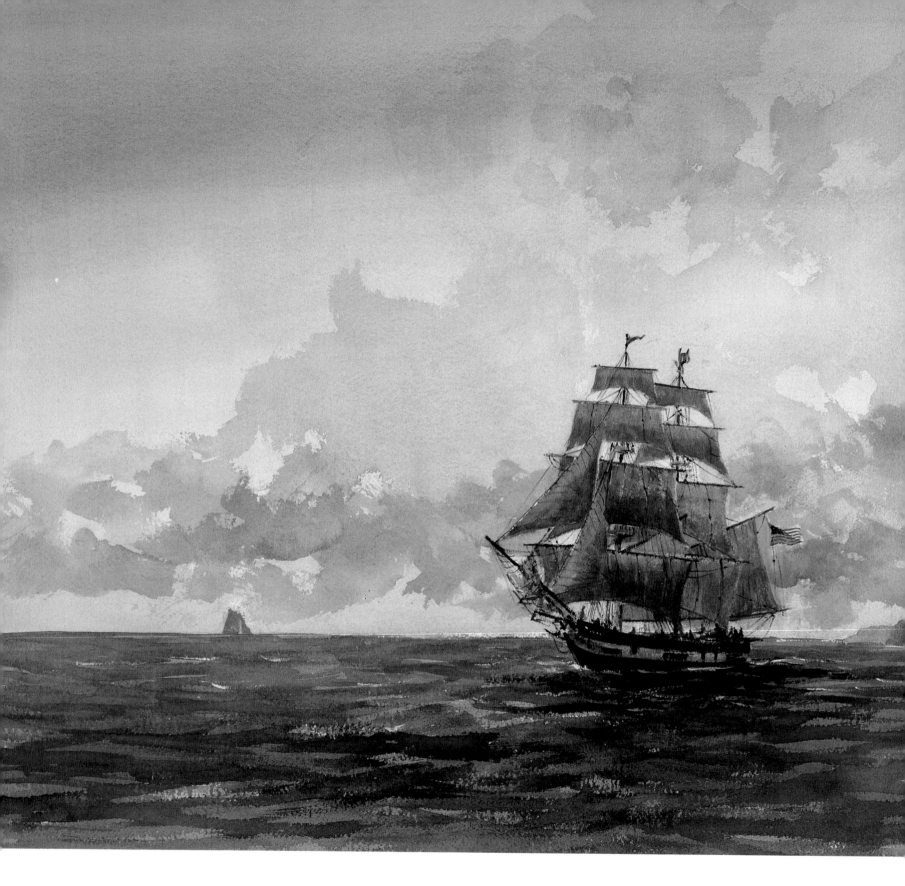

The famous mission at San Juan Capistrano has always fascinated me. I wanted to paint the wonderful texture of the old walls and arches and also to capture the quietness and serenity of the place.
The Mission, Capistrano, *1987.*
Watercolor, 16 x 24 ½ in. (40.6 x 62.2 cm).

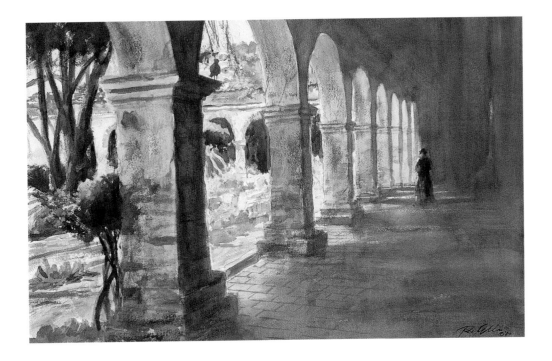

While on the west coast I met Ray Wallace, the designer and builder of the replica of the Pilgrim, *which was described in Richard Dana's* Two Years Before the Mast. *Here she is rounding the headlands of Dana Point.*
Pilgrim Off the Headlands, *1989.*
Watercolor, 18 ½ x 26 in. (47 x 66 cm).

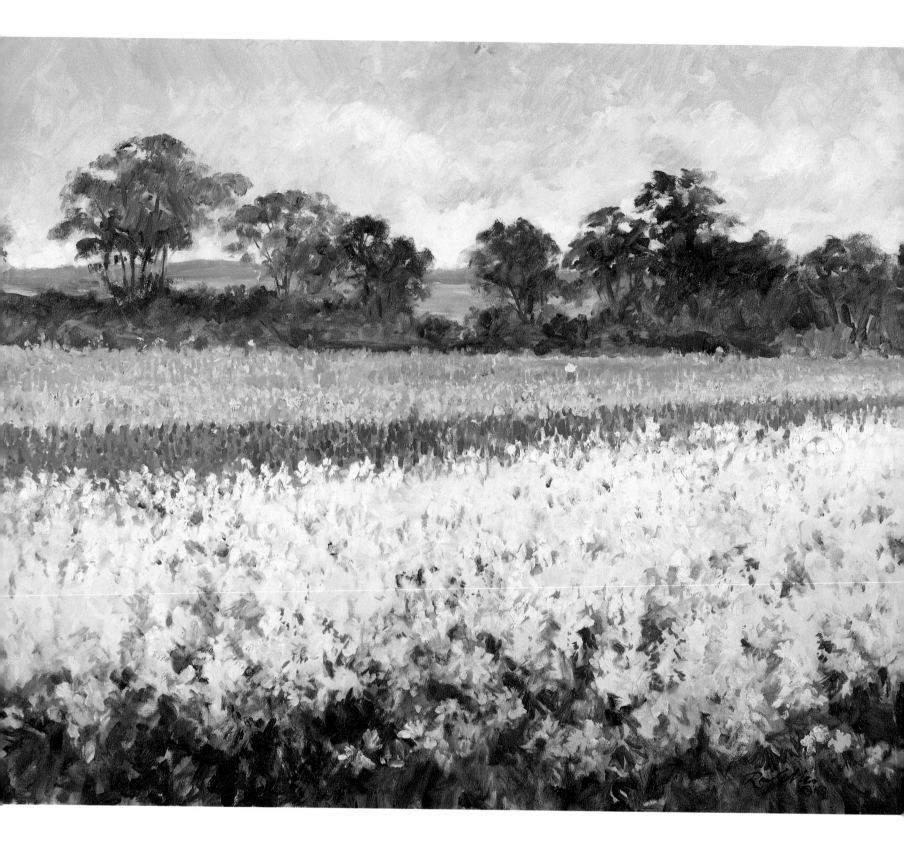

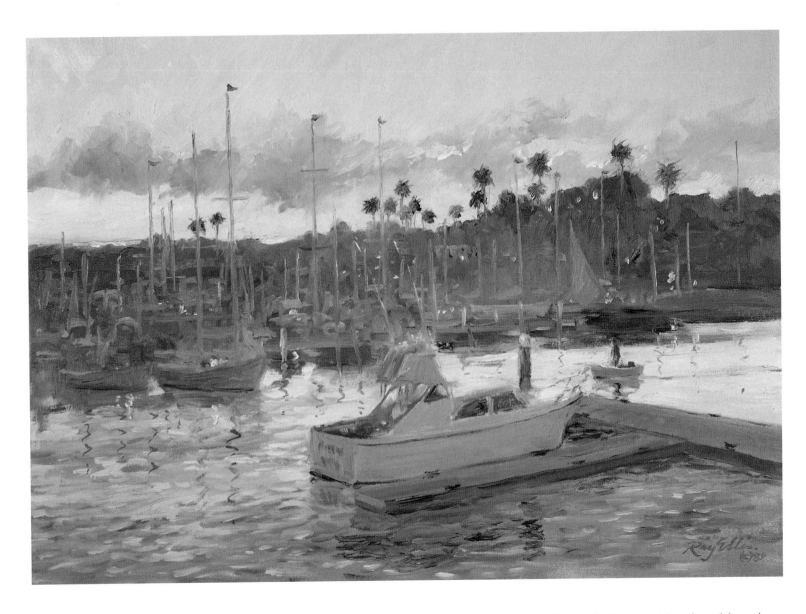

Sitting at dinner one night, overlooking the harbor at Oceanside, I witnessed the colors of the early evening become a visual symphony of pinks, lavenders, and blues. The light was incredible.
Twilight, *1989. Oil, 20 x 28 in. (50.8 x 71.1 cm).*

While driving along the coast between San Diego and Los Angeles, we came upon these fields of stock. Had their colors been mixed in the field, I might not have painted this. What interested me was the abstract pattern created by the separate ribbons of color.
The Flower Fields, *1988. Oil, 29 x 37 in. (73.7 x 94 cm).*

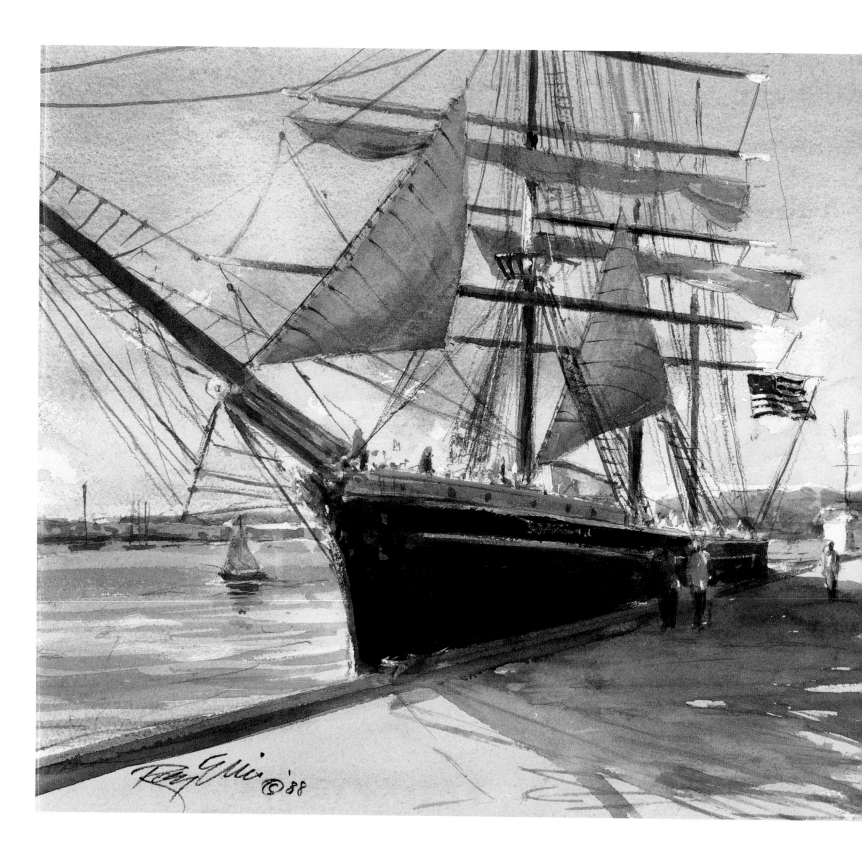

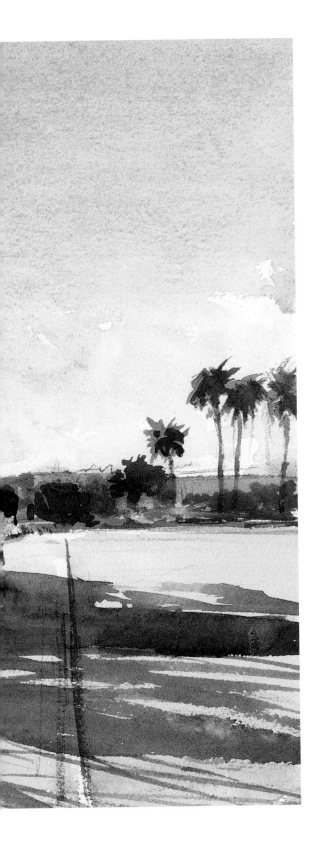

The city of San Diego has done a superb job with its waterfront area. Parks are filled with people flying kites, bicycling, or simply relaxing.
In the Park by the Sea, *1987. Watercolor, 15½ x 25 in. (39.4 x 63.5 cm).*

I am a tall-ship enthusiast, and San Diego has the Star, *one of the finest and the last of those great ships to sail commercially.*
Star of India, *1988.*
Watercolor, 11 x 16 in. (27.9 x 40.6 cm).

The architecture of this unique building in Coronado attracted me, and the red roof added a wonderful touch of color to the composition.
Balboa Yacht Club, *1989.*
Watercolor, 14 x 20 in. (35.6 x 50.8 cm).

I love to see the colorful sails and the wild-patterned wakes of windsurfers. The agility of these talented sailors and the speeds they attain always amaze me.
Windsurf Patterns, *1989.*
Watercolor, 11½ x 22 in. (29.2 x 55.9 cm).

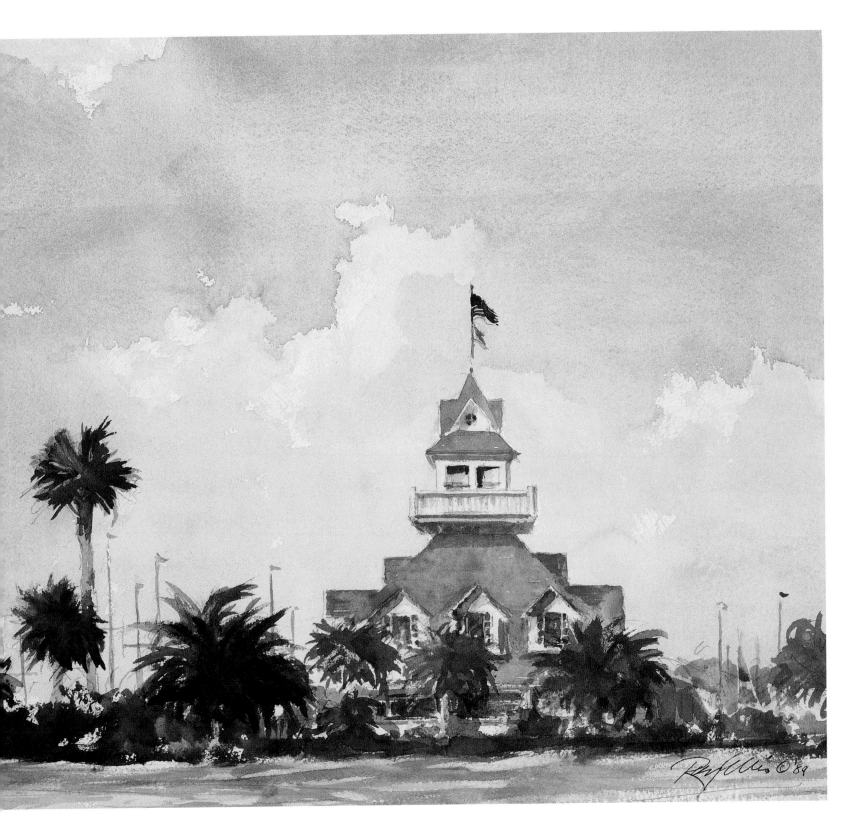

Acknowledgments

There were many people involved in and dedicated to the task of publishing this book, which has been a dream of mine for many years. My sincere thanks and appreciation go to:

Susan Costello, whose faith and confidence got things started.

Bob Ballard, my co-author, who graciously joined forces bringing his usual enthusiasm and tremendous knowledge.

Treesa Germany, my gallery director, who spent long hours gathering photographs and cataloging my paintings.

Molly Shields, who used her great talents to design this handsome book.

Owen Dugan, who was a great help in keeping things moving.

Walter Cronkite, who has been such a good friend over the years and inspired me to do this book.

John Logue, who gave my career such a boost with publication of the first three books by Oxmoor House.

Teddie, my wife, who gives me faith and constant help.

Index

Page numbers in *italics* refer to paintings.

All paintings are reproduced courtesy of anonymous private collections except the following, which are courtesy of Compass Prints, Inc., Savannah, Georgia, and the artist (numerals refer to page numbers): 2, 4, 8, 14, 26, 36, 38, 39, 48, 50, 82, 83, 85, 88, 98, 101, 102, 107, 109, 116, 122, 124, 127, 129, 131, 132, 135, 137, 138, 139, 140, 141, 142, 143, 147, 151, 153, 154, 156, 158, 159, 163, 165, 166, 167, 170, 173, 177, 179, 180, 181, 184, 185, 186, 188, 189, 190, 191, 192, 193.

Pacific Oc[ean]

Point
Reyes

San
Francisco

Monterey

Carmel

Big Sur

Santa
Barbara

Los
Angeles

San
Diego Oceanside